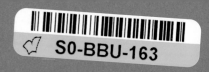

TO MARY!
 WITH GREAT ADMIRATION FOR ALL

ENGELS...

 Fondly
 Cornell Capa

CORNELL CAPA
P H O T O G R A P H S

OCT. 5, 1994

P.S. LOVED RUTH...

*Igor Stravinsky, Venice, 1951.

CORNELL CAPA
PHOTOGRAPHS

Cornell Capa *Richard Whelan*

EDITED BY **CORNELL CAPA** AND **RICHARD WHELAN**

A BULFINCH PRESS BOOK
LITTLE, BROWN AND COMPANY
BOSTON • TORONTO • LONDON

First Edition

Library of Congress Cataloging-in-Publication Data

Capa, Cornell.
 Cornell Capa : photographs / edited by Cornell Capa and Richard
Whelan.—1st American ed.
 p. cm.
 "A Bulfinch Press book."
 Includes bibliographical references and index.
 ISBN 0-8212-1777-1
 1. Photojournalism. 2. Capa, Cornell. I. Whelan, Richard.
II. Title.
TR820.C345 1992
779′.092—dc20 92-6533

Bulfinch Press is an imprint and trademark of Little, Brown and Company
(Inc.)
Published simultaneously in Canada by Little, Brown & Company (Canada)
Limited

PRINTED IN ENGLAND

To my family, my friends, and
all those whose lives I touched
and who touched mine.

ACKNOWLEDGMENTS

This book would never have come into being without the loving and tireless efforts of my sturdy, devoted, and modest wife, Edie. Among the others who made this book a reality are Richard Whelan, whose understanding of my eye, mind, and spirit was vital in selecting the pictures and in shaping the text; Igor Bakht, a true artist of the darkroom who has printed my work for some forty years; and Arnold Skolnick, a brilliant graphic designer who has brought keen insight and the visual equivalent of perfect pitch to our many collaborations over the years. I also want to give my sincere thanks to my agent, Melanie Jackson; to Ray Roberts, my editor; to Amanda Freymann, the production manager of Bulfinch; to Deborah Jacobs, who copyedited the text; and to Balding & Mansell, with whose fine duotone printing I have been very impressed.

This entire book amounts to one continuous acknowledgment of my deep gratitude to the people whom I was privileged to photograph, to the editors who believed in me and made it possible for me to devote my life to photojournalism, and to the many people—colleagues, friends, and family—who influenced the course of my life and work. Among those to whom I give special thanks are Yale Joel, Ralph Morse, John G. Morris, Edward K. Thompson, and several decades of Magnum staff members and *Life* magazine personnel. I equally thank my coauthors on various books: Elisabeth Elliot, Jerry Hannifin, Matthew Huxley, Maya Pines, J. Mayone Stycos, and William Cameron Townsend ("Uncle Cam"), all of whom generously gave their friendship and shared their knowledge.

Of course, it all began with my supportive family—and, above all, with my extraordinary brother Bob, who showed me the way.

CONTENTS

Cornell Capa. New York, 1983. © Petr Tausk.

PREFACE

CORNELL CAPA

Documentary photojournalism has always been my major preoccupation. In its derivation from Greek, the word *photography* means writing with light, and I have always striven to write with light, to inform, to enlighten, to be fair—but with passion and incisive understanding. I have always thought of myself not as a reporter but as a commentator, a visual narrator whose personal integrity is vital. I have aimed to be a credible eyewitness, one who cares about the world he inhabits. My aim has been to share my vision with the world.

Many photographers find that to make a living they have to shoot pictures as "professionals," producing work classified as commercial, about which they don't really care beyond the obvious; they pursue their personal work, the photographs that engage their feelings and that provide satisfaction, "on the side." I have been very fortunate. The photo essays that I shot for *Life* and other magazines not only gave me a steady, albeit modest, income but also were my personal work. For me there was never any distinction between commercial and personal. I worked on stories that interested and excited me, stories about which I had strong feelings and high hopes, and I directed all my talents and energies into that work.

I am not an artist, and I never intended to be one. I hope that I have made some good photographs, but what I really hope is that I have done some good photo stories with memorable images that make a point, and perhaps even make a difference.

When you look at my work, you will note the absence of still lifes and landscapes. I am interested in human beings, their lives, their habitats, their behavior, and their relationships, familial and beyond. During my career as a full-time photographer (1946–1974), I was most deeply involved with stories about politics and social concerns. During two decades I covered American presidential campaigns. Over an even longer period I made many trips throughout Latin America, documenting politics and socioeconomic conditions. Of my domestic stories on human problems, the ones that have meant the most to me dealt with old age and mental retardation. In the 1950s I became engrossed in stories about religion—one on Judaism and one on Russian Orthodoxy. At the same time, I began to document the efforts of Christian missionaries in the jungles of Latin America. That work led me to a photographic study of tribal rituals, ranging from those of peoples who still maintain Stone Age cultures to the familiar tribal rituals (often unrecognized as such) of our own sophisticated, modern lives.

I feel blessed to have been born in my time, of my parents, and to have had such a loving and inspiring brother as Robert Capa. And I am thankful for all the many wonderful people whose paths I crossed and who have given me rich opportunities, memories, and good feelings.

As for my life companion, my wife, Edie, words will never express the goodness, generosity, and tender loving care she has lavished not only on me but also on my family and on our many friends for more than half a century. She deserves so much of the credit for whatever I have accomplished.

Cornell Capa with his wife, Edie, and their poodle, Yofi,
New York, 1983. © Alison E. Wachstein.

FOREWORD

RICHARD WHELAN

During the course of his life, Cornell Capa has had three major and interrelated careers: as a photographer who worked extensively for *Life* magazine and who has long been a member of the influential Magnum agency; as the champion and editor of his brother Robert Capa's work; and as the founder and director of the International Center of Photography, in New York.

Since the opening of ICP, in 1974, Cornell Capa has had no time to pursue his own career as a photographer. Furthermore, his modesty and ethics have prevented him from using his position to promote the photographs that he made during nearly thirty years with *Life* and Magnum. Thus Cornell Capa the photographer has been overshadowed—indeed, almost completely hidden—by Cornell Capa the founder of ICP and by Cornell Capa the brother of Robert.

I first encountered Cornell Capa's photographs in the fall of 1978, when I was assigned by the magazine *ARTnews* to write a profile of the director of ICP. The pictures came as a revelation to me, for here was an extraordinary body of work that was virtually unknown. I felt as though I had just discovered buried treasure. This was a lifework that would create a sensation if it was published and exhibited. But Cornell had something else in mind. He asked me whether I would be interested in writing a full-scale biography of his brother—and, of course, I jumped at the opportunity. During the years I worked on the Robert Capa book, I retained the hope that I would eventually be able to edit Cornell's work for publication and exhibition. But Cornell was always busy with projects at ICP. Even when I went on to write a book about the Korean War, I kept my hopes up. Finally, early in 1989, Cornell said he was ready.

Since then I have had the tremendously rewarding experience of going through all of Cornell's contact sheets, his many prints, and his published articles and books. Together, Cornell and I have made a selection of his best pictures, spanning his entire career and his full range of subjects. It is deeply satisfying to me to know that this important and moving body of work will at last receive the exposure and recognition that it deserves.

Cornell Capa coined the phrase "concerned photographer" to signify a photographer who is passionately dedicated to doing work that will contribute to the understanding or the well-being of humanity— work that focuses with compassion, with intelligence, with warmth and generosity of spirit, upon the human condition. Cornell Capa is himself

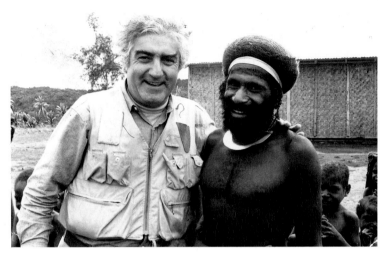

Cornell Capa with a Kewa tribesman, New Guinea, 1973.

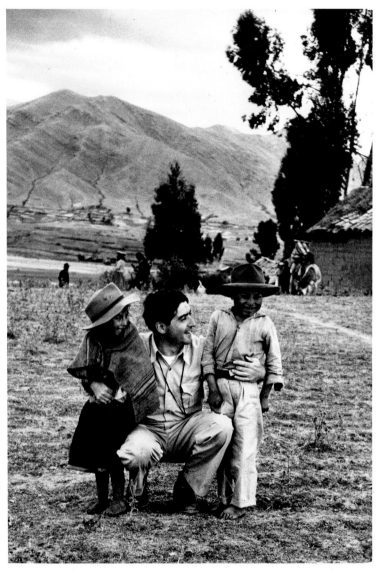

Cornell Capa with Quichua Indian children.
Chincheros, Peru, 1956.

a deeply concerned photographer. To all his work he brings his love of people and his profound concern for the plight of humanity.

Robert Capa never photographed war as a dispassionate observer but rather always as a partisan. He used his camera to make an accurate record yet also to help the side in whose cause he believed. Cornell Capa has done the same as a photographer of peace. He has photographed, as a partisan fighting for the cause of humanity, what he loves and what he hates. He often quotes the words of reformer-photographer Lewis W. Hine: "There were two things that I wanted to do. I wanted to show the things that needed to be corrected. And I wanted to show the things that needed to be appreciated." That is precisely what Cornell has dedicated his life to doing.

As a teenager, Cornell wanted to become a doctor so that he could help people. Instead, he became a humanitarian photographer. It is very revealing that he became deeply involved in photographing the work of missionaries in Central and South America, for he himself is a kind of missionary, dedicated to advancing the cause of human decency through the power of photographic images to change the ways in which people look at their world.

Cornell Capa is above all else a photographer of people. No landscape or cityscape interests him unless it is populated. Robert Capa once remarked that the best advice he could give to other photographers was: "Like people and let them know it." That phrase could easily serve as the motto for the entire professional career of Cornell Capa. Without any doubt, the quality that characterizes and unites all of Cornell's work is his extraordinary rapport with the people he photographs. As his brother did, Cornell puts his subjects at ease with his friendship, his sensitivity, his sympathy, and his enthusiasm. They sense that they can trust him. Cornell never exploits his subjects to make a sensationalistic picture; to him a good picture is one that does justice to its subject.

All this enables Cornell to photograph as an insider. Covering Adlai Stevenson's presidential campaigns, for instance, he was not simply carrying out *Life* assignments. While still based in London, Cornell had been very impressed by Stevenson's speeches and asked *Life* to transfer him back to the United States so that he could photograph the candidate. Because he believed so deeply in Stevenson's cause, the two men soon became friends, and as a result Cornell was able to make many wonderfully candid and sympathetic photographs. Similarly, Cornell was an enthusiastic supporter of John F. Kennedy's. After having covered JFK's campaign, he was so moved by the new president's inaugural address that he conceived—and was able to put into immediate execution—a project for nine Magnum photographers to cover every aspect of the administration's first one hundred days.

Cornell himself covered the White House, where he was warmly accepted by Kennedy and his wife. (In fact, Jacqueline Kennedy Onassis became one of the original trustees of ICP.) In a completely different area of experience, Cornell's *Life* photo essay about an elderly woman living with her son and daughter-in-law in Philadelphia certainly derived much of its effectiveness from Cornell's great sympathy with the old lady. His own beloved but demanding mother had lived for many years with him and his wife, Edie, and he was thus well aware of the difficulties on both sides of such a situation.

When *Camera* magazine asked Cornell in 1963 to make a selection of his own photographs for publication, he replied, "Single photographs are not what I do best. My most effective work is groups of photographs which hang together and tell stories. My pictures are the 'words' which make up 'sentences' which in turn form the story.... I hope that as often as possible my pictures may have feeling, composition, and sometimes beauty—but my preoccupation is with the story and not with attaining a fine-art level in the individual pictures." Nevertheless, although Cornell nearly always set out to shoot groups of pictures that would cohere to form a factual and revealing narrative, the fact remains that within most of his photo essays certain pictures stand out so strongly—because of the feelings that they capture, because of the effectiveness of their composition, and because of the beauty or the impact of the subject as seen and recorded on film by the photographer—that they sum up the entire story and even transcend it. They remain imbued with the very essence

Cornell Capa. Venezuela, 1955.

Cornell Capa with presidential candidate Adlai Stevenson on board a campaign plane, 1952.

13

of the specific situation or person that they portray, and yet they simultaneously resonate with universal human experience. In other words, they are art.

Most of the photographs that we have selected for this book fall into that category. We have included a few sequences in which the individual images do indeed function as words that compose sentences. But the majority of photographs here are those that even in isolation speak whole sentences, and indeed whole volumes. They stand very solidly on their own and engrave themselves permanently in the memory.

Cornell Capa, 1959.

INTRODUCTION

Cornell Capa. Budapest, c. 1923.

I am truly a lucky fellow. I was born in Hungary, a nation whose language is spoken only by Hungarians. If you wanted to communicate with the rest of the world, you needed other means—like Esperanto. But who understands Esperanto? On the other hand, in this century everyone has come to understand photography, the most universal of all languages. I am known to make exaggerated claims, so I shall make another one. I think that photography was invented for Hungarians!

The way out of Hungary was pioneered by my elder brother Robert. It came from another piece of luck: we were born to non-practicing, assimilated Jewish parents living under the anti-Semitic regime of the Hungarian dictator Admiral Miklós Horthy. His police chief was not amused by Bob's leftist student activities and suggested that he might do well to leave the country, regardless of the linguistic difficulties that his departure might bring him. The year was 1931 and Bob was seventeen years old.

I was only thirteen when Bob left home. I didn't fully understand why he had had to leave in such a hurry, but I knew that I missed him. Like him, I was very idealistic and energetic. But at that time my idealism and energy were not directed toward politics. I played Ping-Pong passionately, and my ambition was to become a doctor and cure the ills of the world. I knew I would have to study hard to gain admission to a Hungarian university, since there was a strictly enforced and very low quota for Jewish entrants.

Bob was clever and fortunate in choosing his place of exile. He decided on Berlin, because he wanted to attend the excellent journalism school there. At that time he was still planning to become a reporter, a writer, but he soon discovered that the most exciting form of journalism in Germany was photojournalism—of which Berlin was then the world capital. This had much to do with the fact that the first 35-millimeter camera, the Leica, had recently been invented in Germany. Because the Leica was small, used fast film, and was relatively unobtrusive, you could easily take it anywhere and make candid pictures. It made possible a very personal and yet universal mode of communication, with which the many competing German photo magazines were experimenting daringly.

Bob understood that the Leica was a providential gift. No matter what European country an exile like himself was to live in, he would never be able to get an official working permit, but one profession in which one could manage without a permit was that of free-lance photojournalist. One needed only brains, eyes, a heart, and human

Cornell Capa's parents, David and Julia Friedmann.
Budapest, 1910.

empathy. Bob was richly endowed with all of them. And so he became a photojournalist. It really was as though the profession had been invented for him.

Bob's luck held. In 1933 the rise of Hitler and Nazi persecution of Jews forced him to flee Berlin for Paris, the mecca for thinkers, artists, filmmakers, and photographers from all over the world. It was also a fertile field for new picture magazines. There Bob photographed the social and political ferment of the Popular Front period—the street theater of constant demonstrations and parades. In the midst of that excitement he met two young photographers as passionate and talented as himself: David Szymin, a Polish refugee who signed his work "Chim" (and who later changed his surname to Seymour), and Henri Cartier-Bresson, a Frenchman who had come to photography by way of Surrealist painting. Out of that triangular friendship would grow, after World War II, the international photographers' cooperative that took the name Magnum, from the oversize bottle of champagne—which symbolized both excitement and success.

The Spanish civil war broke out in 1936, and Bob was among the first and most daring to cover it. Conveniently, picture magazines had recently begun to proliferate not only in France but also in England and the United States. They soon began to publish the extraordinary pictures that he regularly sent back from the front.

Back to my own luck. In 1936 I graduated from high school, but without any particular brilliance and certainly without the excellence necessary for a Jew to be admitted to a Hungarian university. Therefore I decided to join Bob in Paris, in the hope that eventually—once I had learned French—I would be able to enter a French university to pursue my medical studies. Soon after I arrived in Paris, however, I realized that it was going to take me quite some time to learn the language. In the meantime, I would have to earn my living. I was, in any case, being drawn to the possibilities offered by photography. I had no camera, but I watched and learned the rudiments of technique. From talking with my brother and his friends, and from looking at their photographs, I became excited about the prospect of helping them with their work.

At night, in the darkroom that we had improvised in my hotel bathroom, I developed and printed Bob's, Chim's, and Henri's pictures. Every morning I carried the wet prints, wrapped in newspaper like a package of fish, to my job in the lab of a commercial photographic studio, where my pay consisted of the right to use the electric print dryer on my lunch hour. I was finally fired for using too much electricity.

Despite this setback, my luck continued. By early 1937 I had

given up all thought of becoming a doctor. I was now determined to follow my brother's example and become a photojournalist. But one camera-wielding Capa was enough for Paris, so when the opportunity to move on presented itself, I grabbed it. Four of our mother's sisters had settled in New York after World War I, and early in 1937 Mother joined them. (László, my eldest brother, had died of rheumatic fever in 1935. Then my parents' business in Budapest collapsed. When my mother went to New York, my father remained alone in Budapest, awaiting developments. He intended to rejoin his family, but he became ill and, in 1938, died.) In the spring of 1937, I followed my mother to New York, and that summer Bob came over for a visit. While he was in New York, he established a good working relationship with the Pix photo agency, which represented a number of European exiles. He also reached a loose contractual understanding with the new, brilliant, and opulent American weekly photo magazine *Life*, whose editors wanted to meet the daring young photographer who had taken those sensational pictures of the Spanish civil war.

With Bob's help, I got a job in the Pix darkroom, where, besides developing and printing his reportages from Spain and China, I could translate his captions from a mixture of Hungarian, French, and German. I was also in a position to advise Bob on various technical matters and to pass on to him all the American photographic chit-chat. Soon I moved to the *Life* darkroom, where I performed the same functions and was also able to learn much from the great *Life* photographers whose work I handled and whom I came to know personally.

The Second World War disrupted all that. Bob, although technically an enemy alien, became a legendary *Life* correspondent accredited by the U.S. Army, and I joined the U.S. Air Force Photo-Intelligence Unit, in which I served without great distinction.

In 1946, a year after the end of the war, I joined *Life*'s staff as a very junior photographer. One thing that *Life* and I agreed on right from the start was that one war photographer was enough for my family; I was to be a photographer of peace.

The next year Bob, Chim, and Henri—together with an Englishman, George Rodger, and an American, Bill Vandivert—founded Magnum, the first international cooperative photo agency. Nevertheless, I decided to remain on the *Life* staff. This was a crucial turning point in our mutual and separate careers.

Bob, who had established himself as the outstanding war photographer of his time, now had to face the challenges of peace. His well-concealed romance with Ingrid Bergman tempted him to settle down, but he resisted. Although the formation and nurturing of Magnum occupied him for a while, he had no interest in becoming

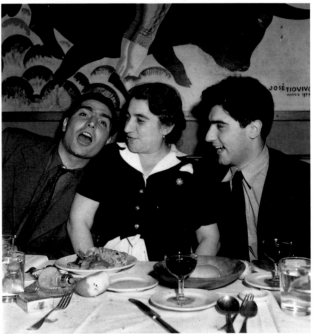

Cornell Capa (*right*) with his brother Robert and their mother. New York, c. 1940. © Eileen Darby.

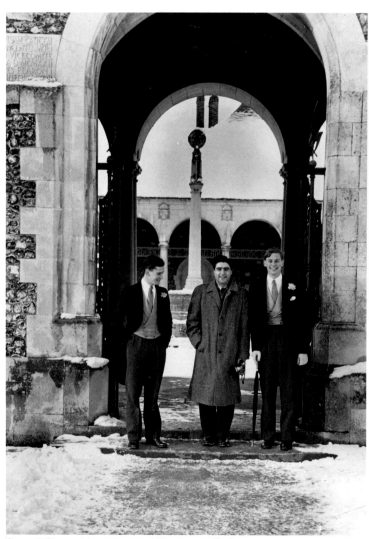

Cornell Capa with students at Winchester College. England, 1951.

a businessman. And when he tried his hand at directing documentary films, he found that he didn't particularly enjoy the group experience; furthermore, the results were far from gratifying. For *Life* and other magazines, he pioneered picture stories about films made by such friends of his as John Huston and Howard Hawks. He traveled in the Soviet Union with his friend John Steinbeck; the book they produced juxtaposed Steinbeck's text with Bob's pictures. Bob enjoyed a similar collaboration with another writer-friend, Irwin Shaw, in Israel. But of all the different things he tried in the years after the war, it was his own writing that seemed to give him the most satisfaction. He wrote a truly amusing book about his World War II experiences and called it *Slightly Out of Focus*. For *Holiday* magazine he wrote a number of articles—about skiing in the Alps, about such glittering French resorts as Deauville and Biarritz, and about his travels and adventures in countries ranging from Norway to Hungary. He delighted in his new byline: "By Robert Capa, with photographs by the author."

In effect, Bob's interest in still photography was waning just as my own career as a photographer was beginning. My luck held up. He encouraged me, and whenever *Life* published one of my stories, he seemed as pleased with my progress and as proud of my work as if it had been his own.

Throughout the postwar years Bob's main base of operations was Paris, while I was working in the United States during the late 1940s. Bob got to New York for occasional visits, but most of the time the Atlantic Ocean separated us. Thus I was very pleased when, in 1950, *Life* assigned me as its resident photographer in England, and I and my wife, Edie, moved to London. During our two years in England, I saw more of my brother than during any other period since childhood. Magnum business frequently brought Bob to London, and from time to time Edie and I were able to get to Paris, where Bob was always a warm and generous host.

One high point of this time was a holiday we shared in Bob's favorite ski resort, the little Swiss village of Klosters. Ensconced there in his fiefdom at the Chesa Grischuna Hotel, he was surrounded by many of his friends—his wonderful American companion Jemy Hammond, close chums like Irwin Shaw and screenwriter Peter Viertel, and pals from the movie world, including Gene Kelly, whose newly discovered skill as a skier gave much amusement to all assembled.

During those two years, while I was based in London, I came to feel that Bob no longer regarded me simply as his younger brother, but that he respected me as a colleague. He made me feel like an equal in our shared field of photojournalism, and we even had a few opportunities to work on joint assignments. We were no longer just brothers; we were now brothers in photography.

Alas, time was very short. Our golden period ended in 1952, when Edie and I returned to America and I began my long coverage

of Adlai Stevenson's political campaigns. The following year was a terrible one for Bob. This was the heyday of McCarthyism, and Bob's U.S. passport was suspended for several months. He was stuck in Paris and could not travel to carry out his various assignments. His income dried up, and he had to pay a small fortune to a New York lawyer to intercede with Washington. In the end, it turned out to be a case of mistaken identity, and he got his passport back. But by then the stress of the episode had led to crippling back pain, which laid him up for months—further diminishing his income and adding to his bills.

At last, in the spring of 1954, it looked as though Bob's various troubles were over and he was to get a fresh start. The Japanese newspaper publisher Mainichi was launching a new photography magazine and made him a very generous offer for six weeks in Japan. Bob was pleased, for the trip seemed to provide an opportunity for a new beginning in photography; it would enable him to visit two old friends, Hiroshi Kawazoe and Seiichi Inouye, whom he had not seen since their adventures in Paris in the 1930s; and the money would pay off his bills. He had a few marvelous weeks in Japan, but then *Life* contacted him in Tokyo. The magazine needed someone for a few weeks to replace its correspondent-photographer in French Indochina, where the war with the Vietminh seemed to be coming to an end; since, as fate would have it, Bob was already in Japan, he seemed like the natural person for the assignment. Although he had said at the end of World War II that he wished to remain an unemployed war photographer for the rest of his life, he accepted *Life*'s offer. On May 25, 1954, on a dusty road to the unimportant town of Thaibinh, brother Bob stepped on an antipersonnel mine and was killed. His mission as a chronicler of man's inhumanity to man was finished.

Bob's sudden and tragic death totally changed my life. Both as a gesture of loyalty toward Bob and as a means of perpetuating his work, my first moves were to resign from the *Life* staff and to join Magnum, of which I became president in 1956. It was a great pleasure for me to collaborate closely with that international group of talented and kindred spirits. Furthermore, working with *Life* as an independent contributor, rather than as a staff photographer, felt like a liberation of spirit. I began a very strong phase of my work, which included studies of politics, old age, and mental retardation, as well as my involvement with missionaries and jungle Indians, an incredibly productive trip to the Soviet Union, and my discovery of Latin America, with all its sociopolitical human problems.

I was determined that Bob's work wouldn't die with him. The death of Magnum photographer Werner Bischof, also in May 1954, increased the responsibility, and the death of Chim two years later, in the Suez, enlarged it still further. Eventually, together with my mother, Bischof's widow, and Chim's sister, I established a fund in memory of the three photographers. It sponsored monographs of their work and awarded prizes to young photojournalists. But I gradually realized that more was needed.

In 1967 I organized an exhibition entitled "The Concerned Photographer," which opened at New York's Riverside Museum and then traveled widely in the United States, Europe, and Israel. The exhibition included works by six photographers: André Kertész, a grand old master—at that time still very much alive but out of fashion and embittered—who had helped and influenced my brother in Paris in the 1930s; the three photographers whose deaths had begun it all: Bob, Chim, and Werner Bischof; an American, Dan Weiner, who had died in 1959; and finally a promising young photographer, Leonard Freed, whose work was perpetuating their spirit.

The Concerned Photographer exhibit touched an important nerve. It drew great crowds and, together with the accompanying book, seemed to prove that, on a gallery wall as well as on the printed page, photojournalistic images can speak to a large audience if the work is genuine and deals with the human condition.

The exhibition was remarkably successful, but when its travels eventually came to an end, I asked myself whether I had only delayed, but not ultimately prevented, the disappearance of my brother's lifework and that of his departed colleagues. Something more permanent was obviously called for.

By 1974 I had worked for nearly thirty years as a well-published photographer, a full and rich career. I was ready for a change. Moreover, I felt that by then there were many outstanding young

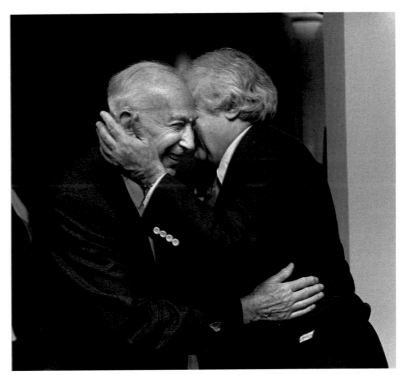

Cornell Capa (*right*) with André Kertész. New York, 1983.
© Chester Higgins, Jr.

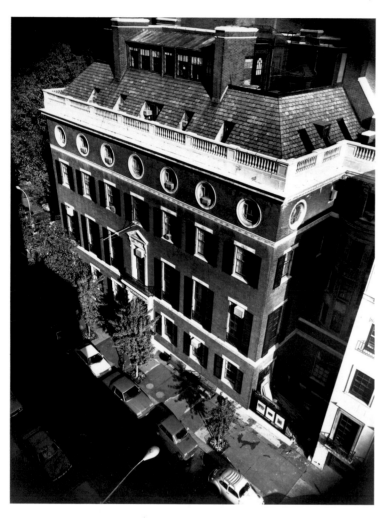

The International Center of Photography, New York.
© Willis Hartshorn.

photojournalists who could and would continue my kind of photography. Where I could make a unique contribution was in the task of establishing and running a home for photography that champions human concerns. After a long search to find a space to house it, and a long struggle to raise funds, we were finally able to open the International Center of Photography, in a former mansion on the corner of New York's Fifth Avenue and Ninety-fourth Street, in November 1974.

Now, at last, documentary photojournalism—concerned photography—had a permanent home, and that home had room in it for every other variety of photography, from Pictorialism to abstraction, as well. During its first eighteen years, ICP has mounted some three hundred exhibitions, running the full gamut of styles, historical periods, and geography. ICP has also sponsored thousands of lectures, seminars, and master classes and maintains a full schedule of courses in photographic technique and history. ICP's success has inspired others to establish similar centers, both in this country and abroad.

The drawback to all this was that, as the founder of ICP, I had created a more than full-time job, which left me no time at all to pursue my career as a photojournalist. This I had not foreseen or planned. However, my work at ICP has not only given me great challenges and satisfactions but has also brought me into contact with many, many wonderful people all over the world who care as passionately about photojournalism as I do. I have no regrets.

I'm not sure that I would ever have gotten around to working on a book of my own photographs if it hadn't been for the persuasion and insistence of Richard Whelan, who wrote the biography of my brother and with whom I edited a volume of Bob's pictures. While working on those two books, Whelan became increasingly familiar with my work as well as Bob's. Then and after, he kept saying that he wanted to do a book of my photographs. What follows is the result of our collaboration.

An asterisk (*) preceding a caption indicates that there is more information about the photograph in the Notes.

Cornell Capa. Central Park, New York, 1971.
© Yvonne Kalmus.

AMERICA

When I arrived in New York, in 1937, I got a job in the darkroom of the Pix photo agency, which had an outstanding roster of European refugee photographers, most of them German or Hungarian. At the top of the list were Alfred Eisenstaedt, who would soon become the mainstay of the newly founded *Life* magazine, and my brother Bob. Among other Pix photographers at that time were Lucien Aigner, George Karger, and Hans Knopf. Looking at their contact sheets and making their enlargements provided the best learning experience one could hope for.

In the Pix lab, and in the *Life* darkroom to which I soon moved, my co-workers were a bevy of aspiring young American photographers, including W. Eugene Smith, Ralph Morse, and Yale Joel, all of whom became my lifelong friends. Together and separately we spent all our free time shooting pictures, hustling up occasional assignments and sales, and dreaming of features in *Life*. In the spring of 1939, for instance, Yale Joel and I set out to do a reportage on the opening days of the New York World's Fair. We two *boychiks* focused not on the great pavilions but on the visitors to the fair. My best picture shows a father protectively huddling his child as a storm approaches (see opposite page); the image seemed symbolic of the universal response to a far more violent storm, the threat of war, which was by then clearly on the horizon. Stefan Lorant, the great editor of the British magazine *Picture Post,* understood that and used the picture as the lead when he published our story. The photograph, one of my first to appear in print, announced a theme that would run throughout all the rest of my work, right up to my reportage on poverty in Central America nearly thirty-five years later: parents holding on to their beloved offspring, the most genuine concern known to all humankind.

During World War II, I served stateside in the U.S. Air Force, first interpreting aerial photographs and then assigned as a public relations photographer. At the end of the war, Ed Thompson, the managing editor of *Life*—who didn't know my pictures at all, but who liked my brother and the Capa clan—gave me a fantastic break and hired me as a full-time staff photographer.

Over the course of the next four years, from 1946 through 1949, I covered hundreds of crazy and trivial "cats-and-dogs" stories for *Life*: a lady plumber in Flushing, New York; a diaper derby in Palisades Park, New Jersey; Father's Day at a Texas school; the Phillips Petroleum basketball team (called, naturally, the Oilers); early television programs; and so on ad infinitum. Five-finger exercises, as it were.

Since I seemed to have a talent for capturing the spirit of a party on film, I became a regular for the section of the magazine entitled "*Life* Goes to a Party," for which I immortalized a Wall Street office party, a reunion of Ziegfeld girls, the Old Guard Ball, a DuPont family reunion, and a debutante ball in Harlem, to name only a few. Fortunately, not all of my assignments were of that ilk. Among the stories that really meant something to me personally were my coverage of Bill ("Bojangles") Robinson's funeral (see plates 19–22), my reportage on the arrival of European displaced persons in New York, a story about an anesthesiologist, and various political pieces.

For about a year and a half of this period, from late 1946 to early 1948, I was assigned to the new bureau that *Life* had opened in Dallas, to cover the nation's Southwest. That marked the real beginning of my education in American culture. In New York I had associated mostly with people who, like myself, were recent immigrants. Now, suddenly, my wife and I found ourselves living in a motel on the outskirts of Dallas (there was even a wagon wheel out front!) and having to drive fifteen miles each way for breakfast. This was the land of bourbon and barbecue, of bottle clubs and country clubs, of Shriners and quarter horses.

My two years in the Southwest were like a primary education, opening the doors to some understanding of how big and diverse America is. It was an enjoyable and fascinating time, but not very rewarding professionally. I was still doing mostly cats-and-dogs stories, a few of which ended up, at best, as page-and-a-half featurettes in *Life*. But, confronted with this radically unfamiliar world, I just couldn't seem to translate it into meaningful photo essays. There was, for instance, my experience when I went to Norman, Oklahoma. The University of Oklahoma, following the letter of the law ordering it to provide separate but equal education for blacks, had set up a whole department to teach just one black student. I photographed the student alone in a classroom, but I couldn't seem to make a story that would put things in perspective.

I felt that I was frittering my time away. Typically, in April 1947, I was photographing a "fashion rodeo" at a ranch in the middle of nowhere when disaster struck Texas City: the explosion of a ship carrying nitrates set off a chain reaction of fires and blasts throughout the city, killing more than five hundred people and injuring thousands. And there I was, stuck hundreds of miles away, missing one of the biggest news stories that had occurred in my territory in years.

During my stay in the Southwest, I kept seeing dried-up riverbeds with signs beside them saying "Watch Out for Flash Floods." The signs made no sense to me whatsoever. In retrospect, that lack of understanding seems like a metaphor for the whole experience. To a young Hungarian, America seemed terribly strange and exotic. I and my camera found this country puzzling, amusing—and perhaps just a bit crazy.

AT THE NEW YORK WORLD'S FAIR: *A Father of To-day Takes His Child to See the World of To-morrow*

He is an American. He is proud of his country, proud of New York, proud of the World's Fair—proudest of all of the son he is taking round with him. The theme of the Fair is the World of the Future. What does the future hold for this child—to live in poverty, to die in a war, or to enjoy peace and have a share in the world's riches and the world's happiness and beauty? If every statesman hung this picture in his office and looked at it every day, perhaps the world of to-morrow would be the world every father wants for his child to live in.

1. World's Fair, New York, 1939.

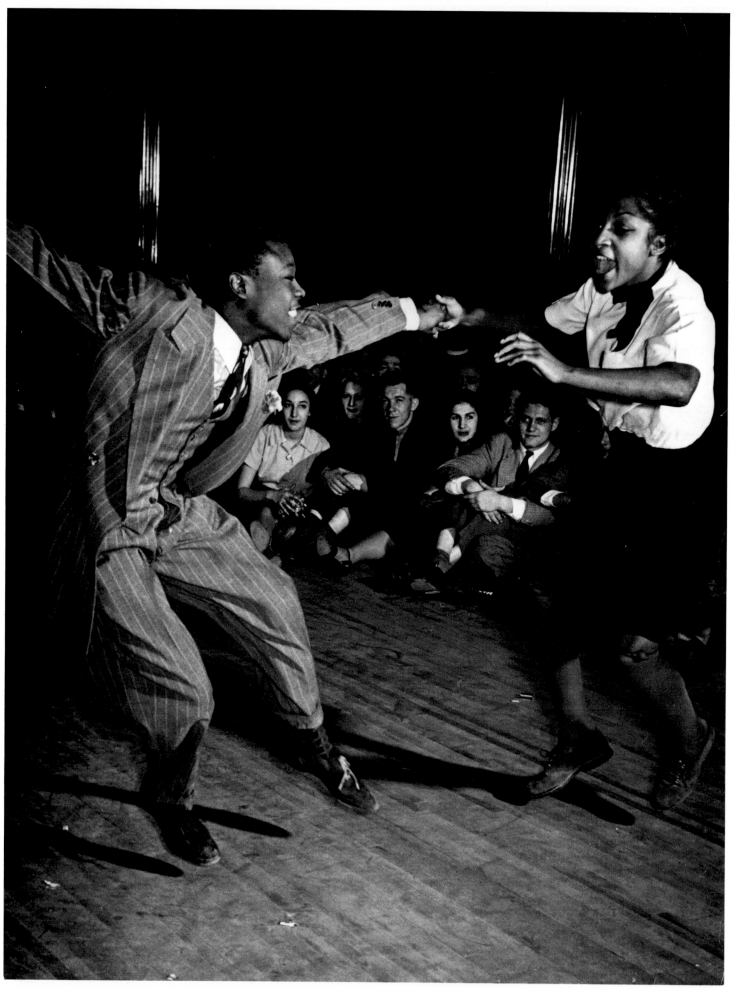

*2–6.
Savoy Ballroom,
Harlem, 1939.

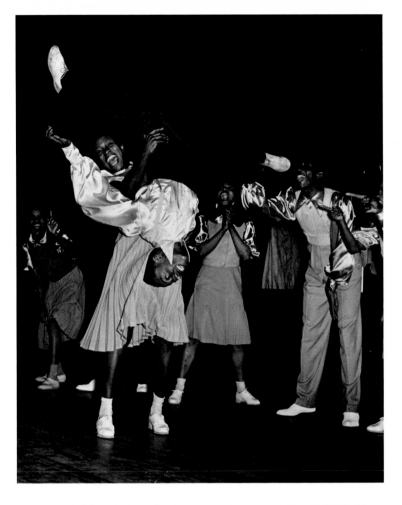

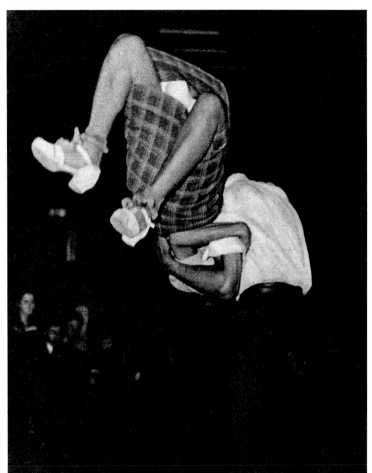

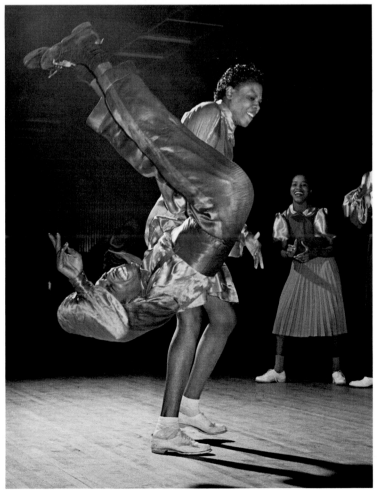

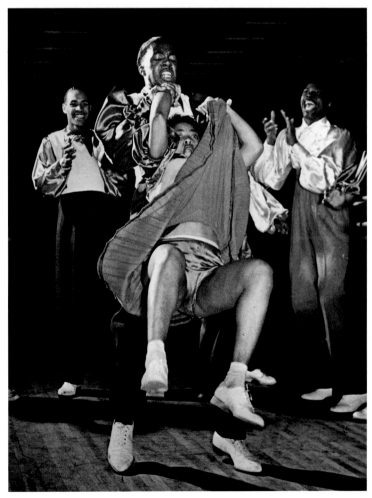

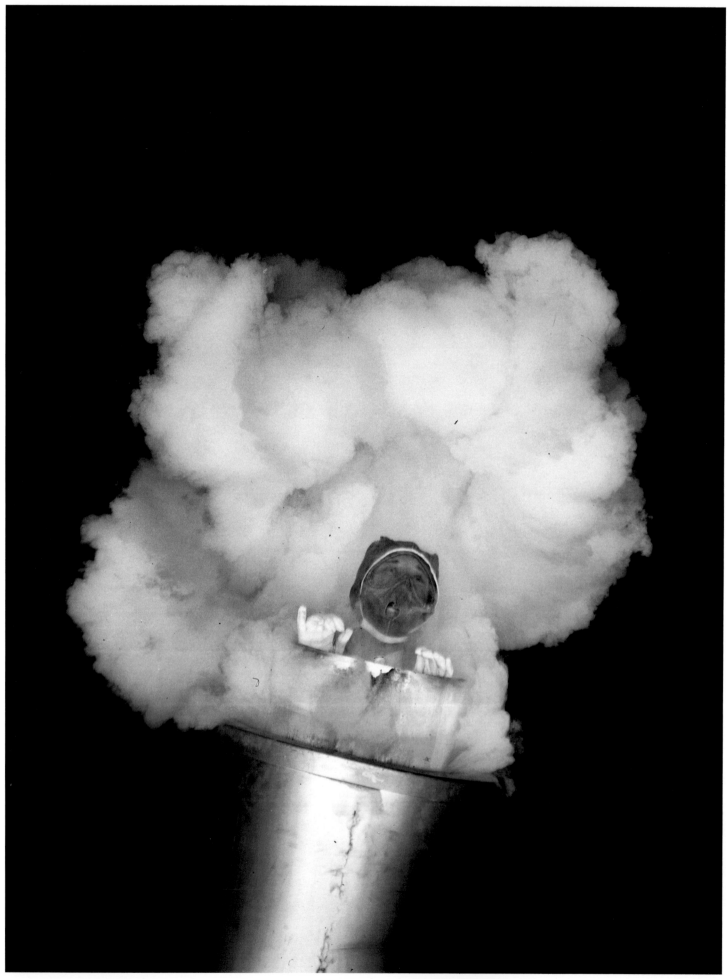

*7. Young woman being shot out of a cannon as a human cannonball at a circus in Texas, 1947.

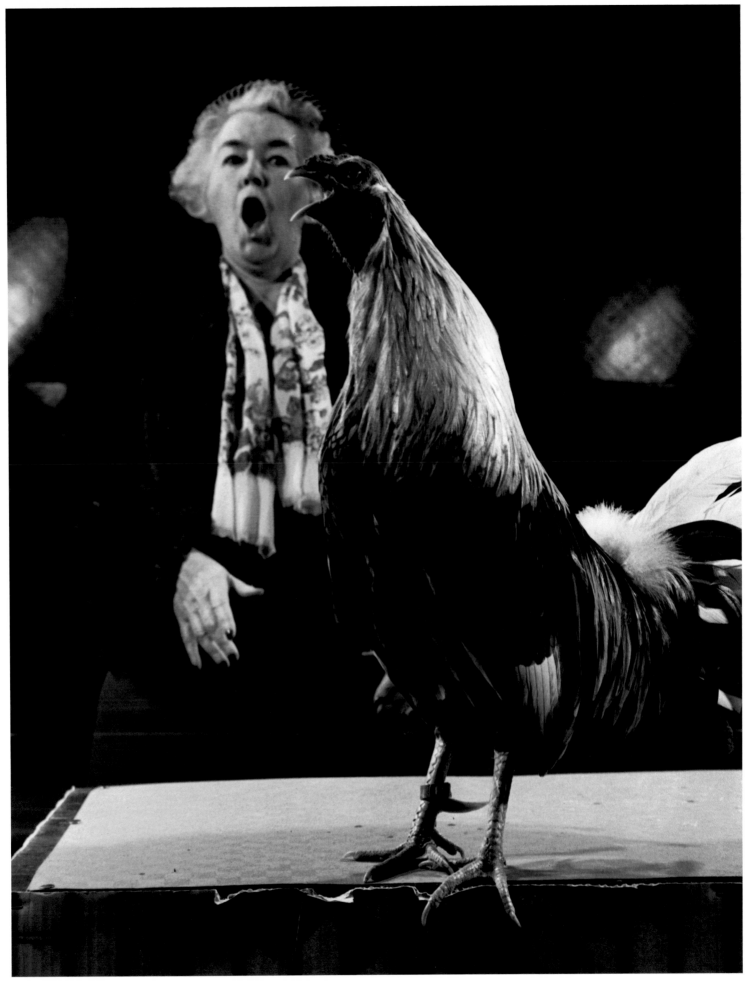

*8. Rooster-crowing contest, Oklahoma, 1947.

*9. Irénée DuPont on the golf course of his estate in Cuba, 1957.

*10. Part of the Miller Brothers Circus at its winter home in Hugo, Oklahoma, 1947.

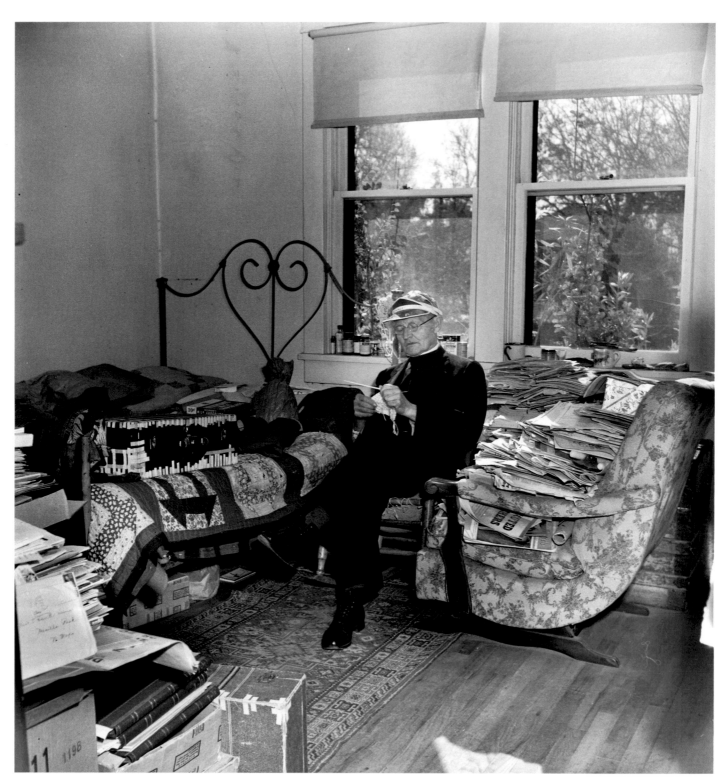

*11. A minister whose hobby was knitting, New Mexico, 1948.

*12. A traveling umbrella salesman in his hotel room, St. Louis, 1

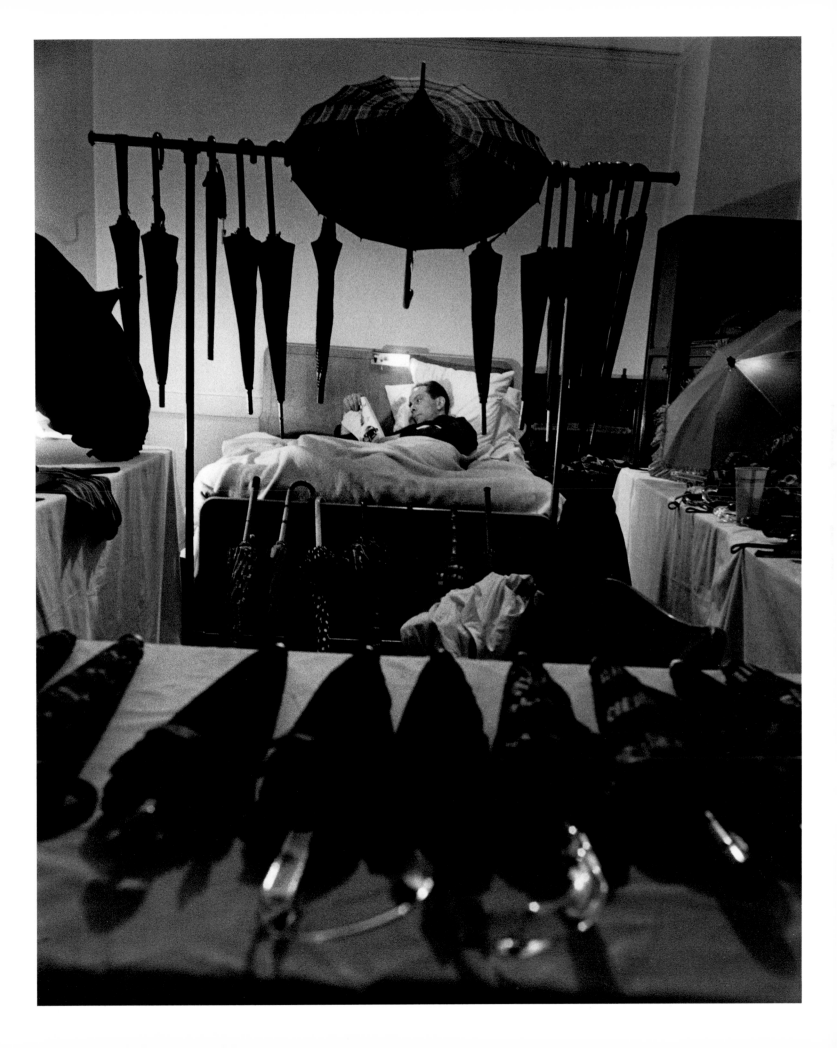

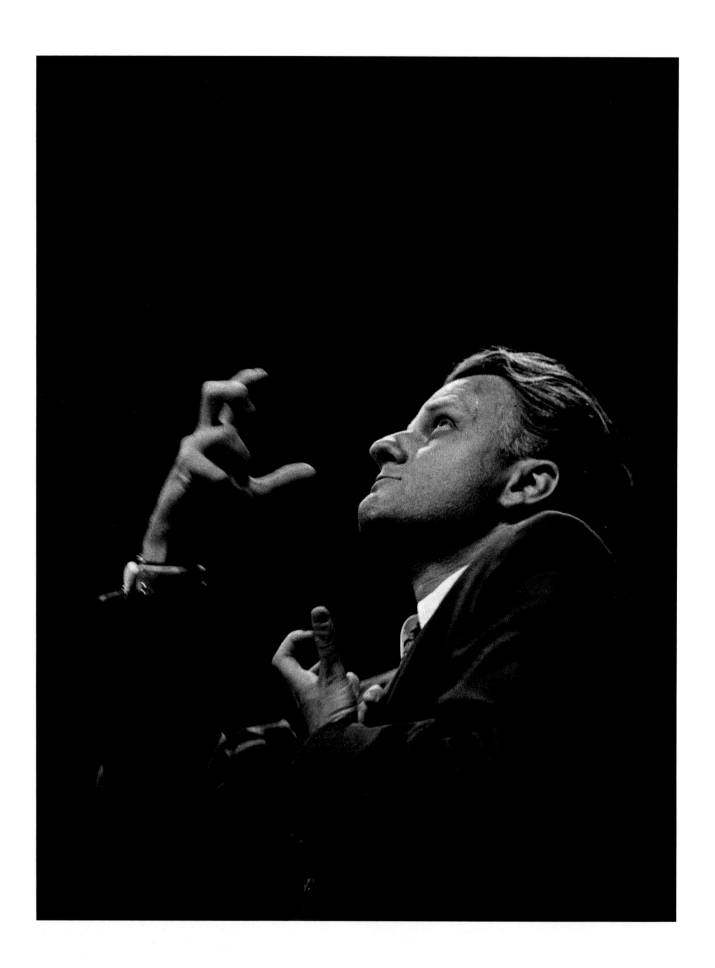

*13. Billy Graham, New York, 1957.

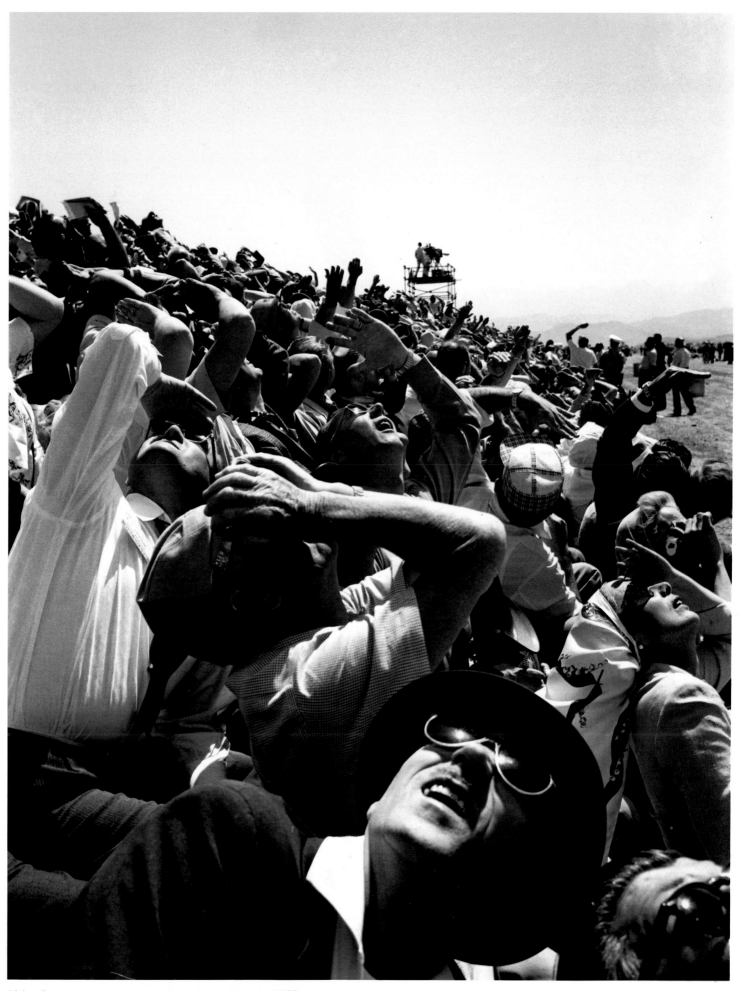

*14. Spectators at a space-age air show, Nevada, 1959.

*15. Seven thousand Ford Motor Company engineers who worked
on developing the Ford Falcon, Dearborn, Michigan, 1959.

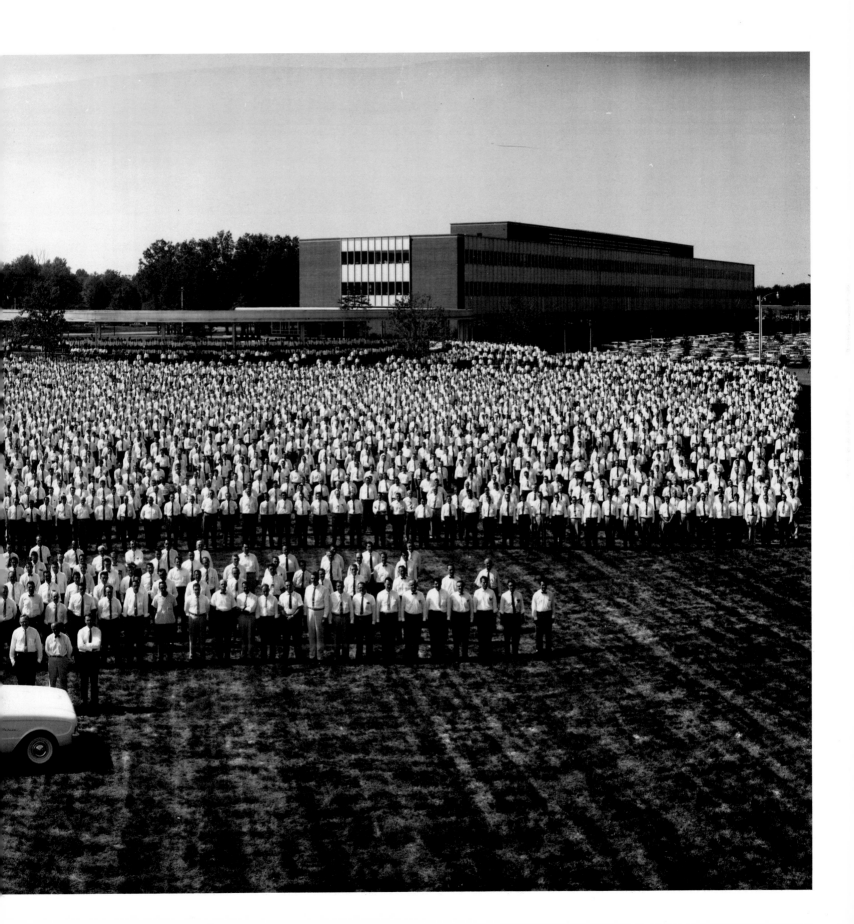

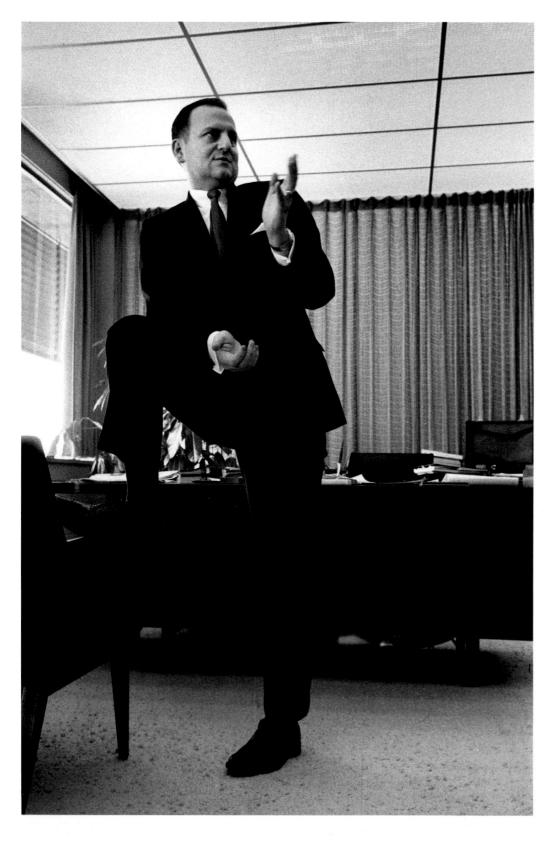

16. Lee Iacocca, then vice-president of Ford Motor Company, 1959.

*17. Ford Motor Company's Quality Control Center, Dearborn, Michigan, 1959.

*18. An elderly woman living with her son
 and daughter-in-law, Philadelphia, 1959.

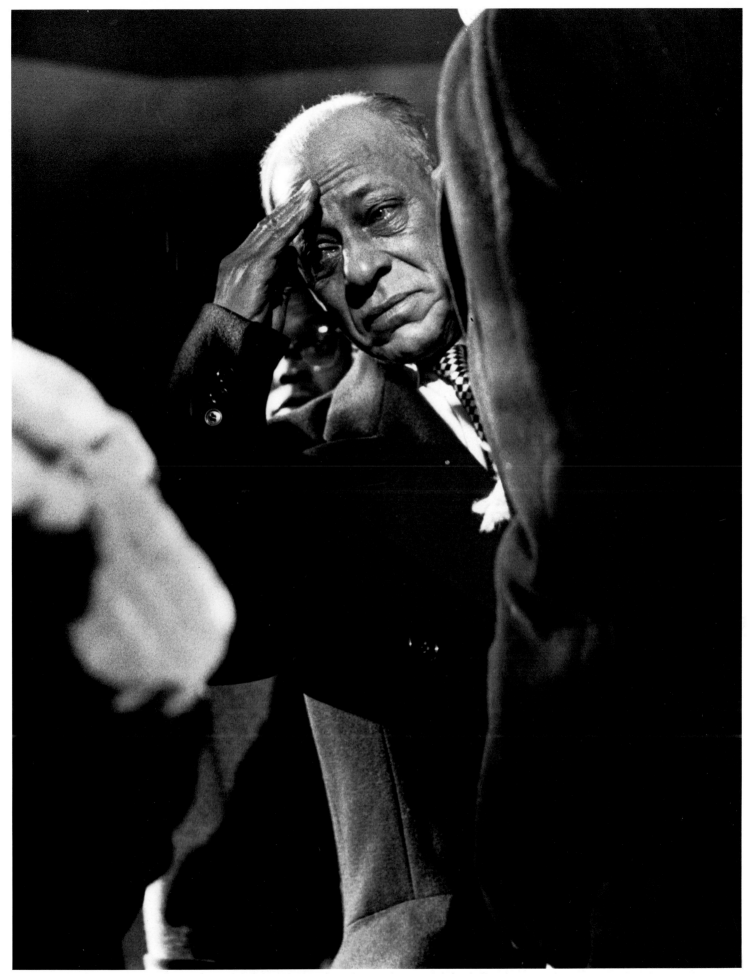

*19–20. Mourners passing by the open casket of William "Bojangles" Robinson, New York, 1949.

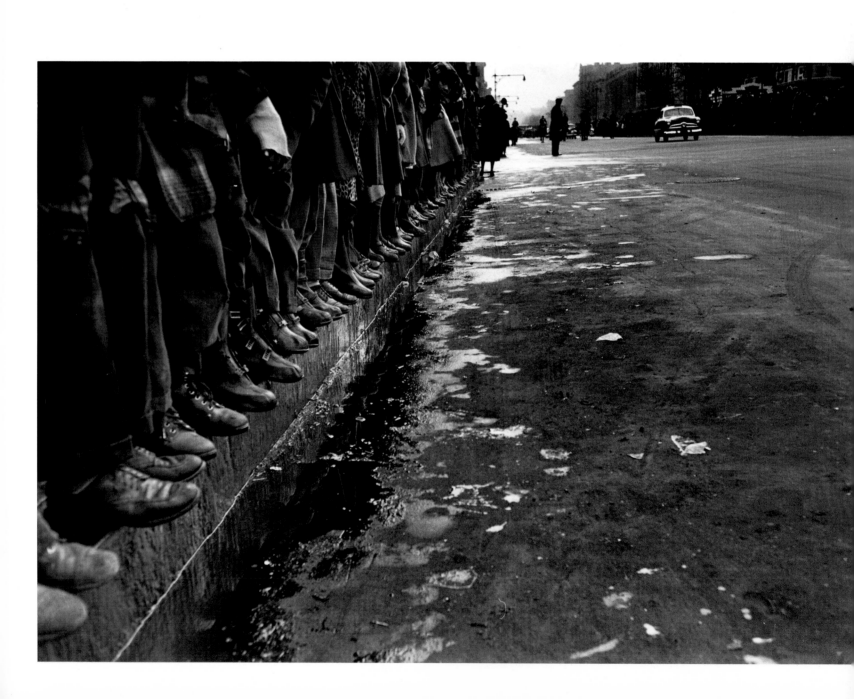

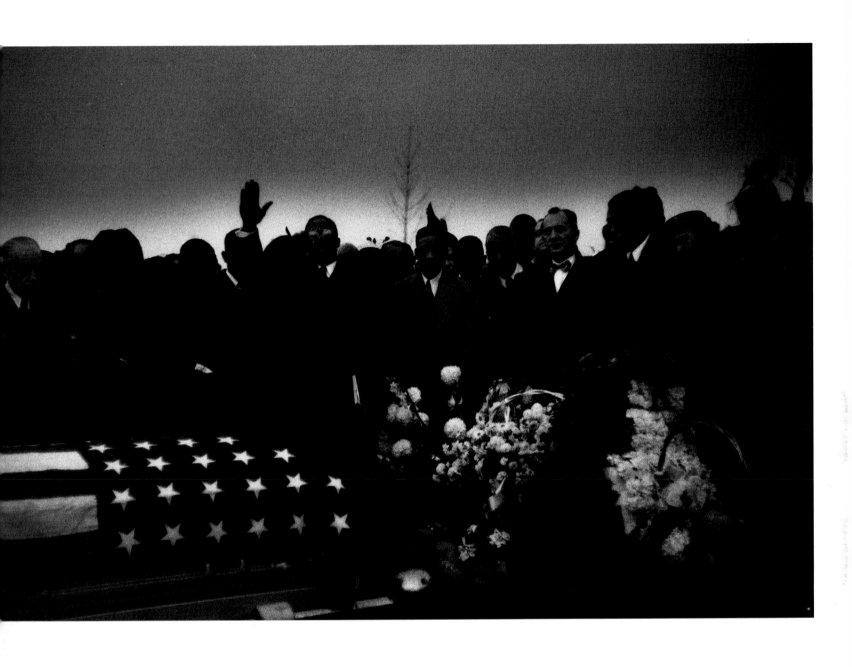

−22. The funeral of William "Bojangles" Robinson, New York, 1949.

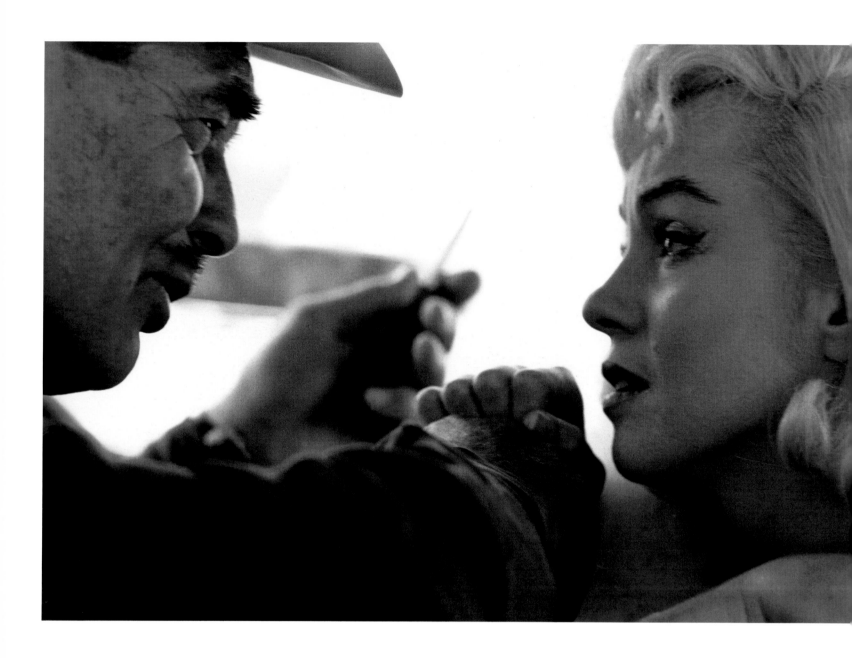

*23-24. Marilyn Monroe and Clark Gable during the filr
of *The Misfits*, in the Nevada desert, 1960.

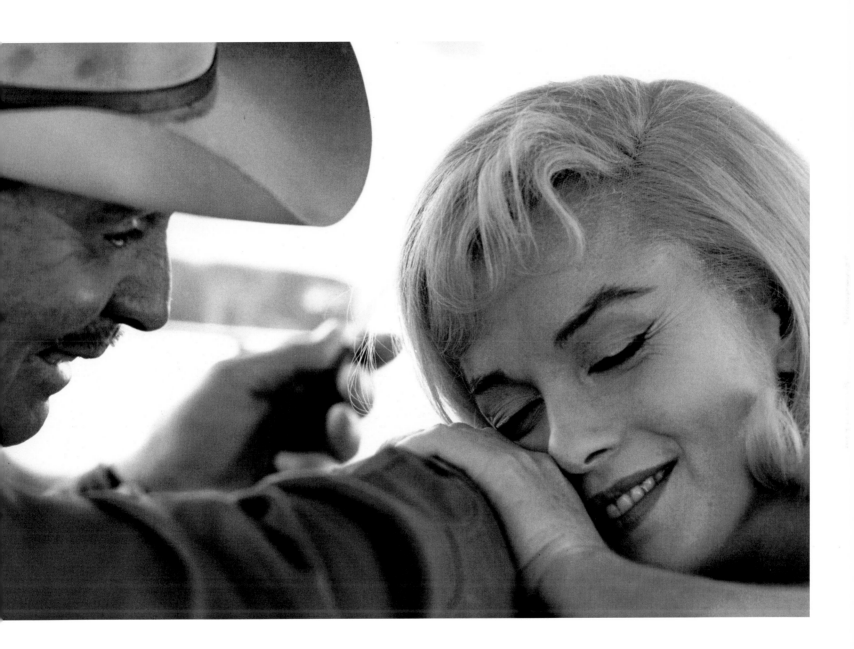

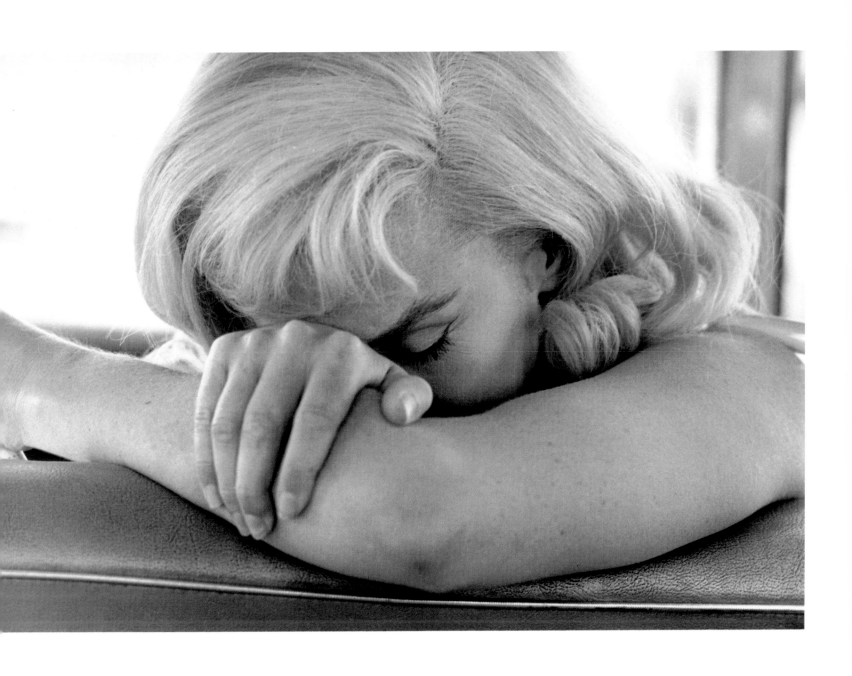

5. Marilyn Monroe during the filming of *The Misfits*, 1960.

*26. Harry Belafonte and his daughter Shari, New York, 1957.

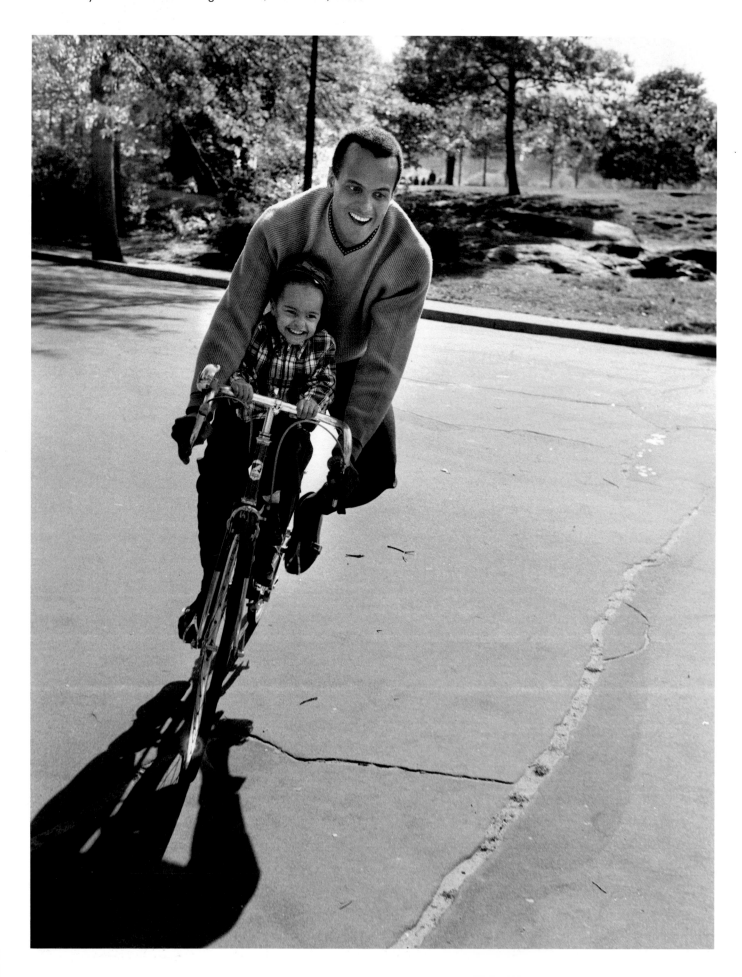

son, Alhambra
er, Brooklyn, 1949.

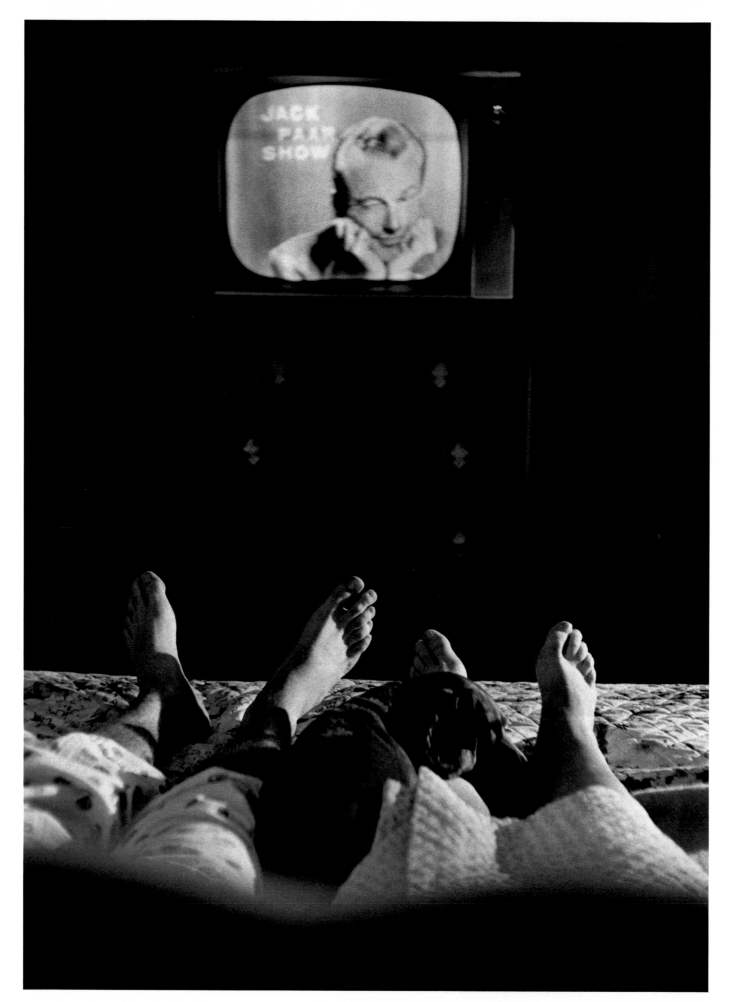

*29. Ralph Ginzburg just before he was to begin a prison term
for having published the "obscene" magazine *Eros*, which was
devoted to the classics of erotic art and literature, New York, 1966.

8. Jack Paar onscreen in a show taped earlier in the day, being
watched by Paar and his wife at home, Bronxville, New York, 1959.

*30. Harold Ross, editor of the *New Yorker*, New York, 1949.

*31. Brooks Atkinson, drama critic for the *New York Times*, New York, 19

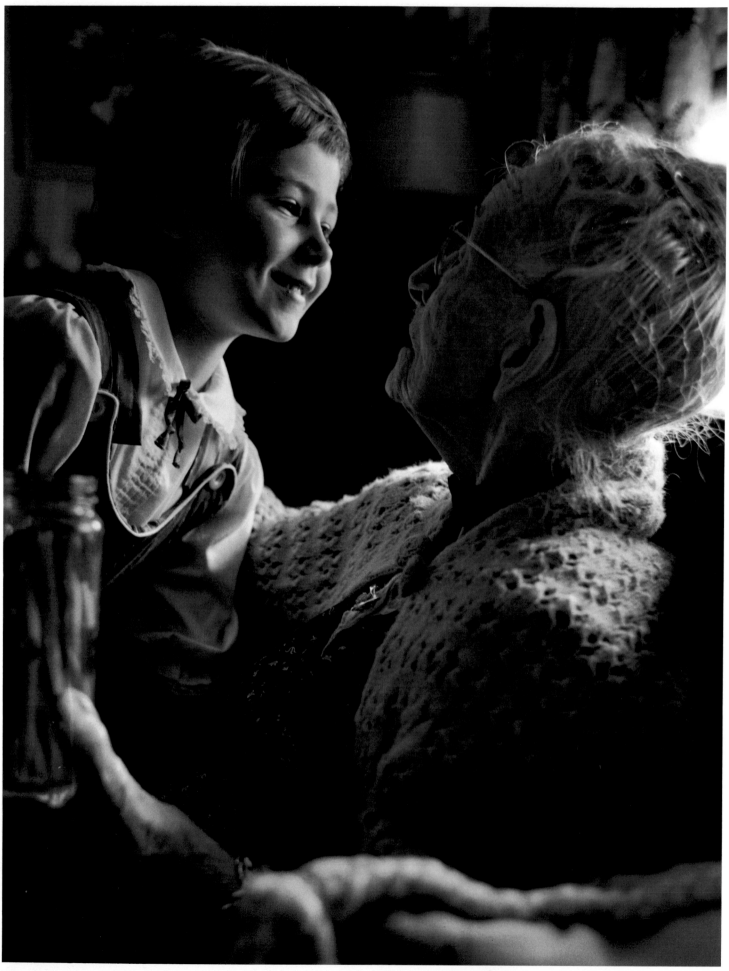

*32. Folk painter Grandma Moses with her great-granddaughter, Eagle Bridge, New York, 1960.

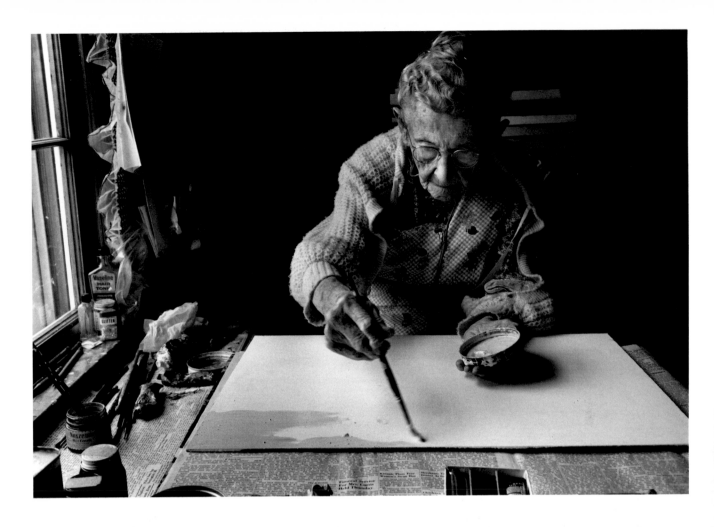

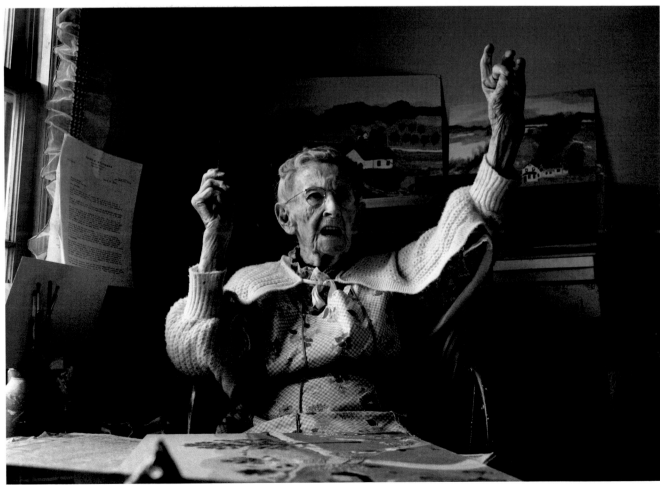

33–34.
Grandma Moses
on her 100th birthday,
Eagle Bridge, New York, 1960.

BRITAIN

Just before I was to enter the fifth grade at my gymnasium in Budapest, the classical curriculum was changed. Instead of the Greek that had always been mandatory, one would now be allowed to study a modern language—and I chose English. To add to my pleasure, the English teacher was a young and enthusiastic Anglicized Hungarian who loved literature. Rather than submitting us to the usual dry memorization of language classes, he emphasized conversation and provided us with a wonderful introduction to English literature and to the glories of the English language.

Knowing English already was, of course, a great advantage when I arrived in New York, in 1937. But New York English was and is very different from the British English for which I had developed a taste in school. And so, in 1950, when *Life* offered me the position of staff photographer stationed in London, I seized the opportunity. In England I rediscovered the joy of English as a marvelous spoken and living language. And I loved the people who spoke it.

It was in England that I first moved beyond cats-and-dogs work and really focused on making a coherent body of photographs. My ambition was to do a trilogy about the molding of great Englishmen. The first part was to deal with a great "public" (i.e., private) school, the second with the elite Queen's Guards regiment, and the third with the Foreign Office. I completed only the first two parts, but other assignments filled in more missing pieces than I had ever dreamt of.

For the first part of my trilogy I chose Winchester College, a distinguished boarding school that had been founded in 1382 (plates 50–55). I worked on the story on and off for three months, more on than off. I stayed at an old-fashioned inn in Winchester, and, in those days of severe postwar rationing, there was often not much to eat except Brussels sprouts—but at least they were homegrown. My consolation was that the inn had a cellar full of prewar wines. Its greatest glory was a 1937 Chambertin, which I enjoyed on every possible occasion. One day when I ordered a bottle of this superb vintage, a very sad-looking waitress returned from the cellar to inform me that I had drunk the last bottle. I took that as a divine indication

that my photo essay was finished, and I left the next day.

At one point I visited a Winchester don to ask him the question that underlay my essay: "How do you make an Englishman?" He replied, "It's their home that makes them—the love of literature and music with which they are surrounded, and their awareness of their heritage. We just continue the process." The official philosophy of the school was that "rugged discipline and a sound education, not noble birth, determine a man's stature," and the school's motto is "Manners Makyth Man."

Rugged discipline was also what transformed ragtag recruits into proper British officers, men who lived up to the Guards' ideal: "Graceful and manly in appearance, mild in demeanour, a gentleman in quarters, and a lion in the field" (plates 56, 57). For three months I haunted St. James Palace and its environs, where the men of the Queen's Brigade of Guards—the regiments of Grenadier, Coldstream, Scots, Irish, and Welsh Guards—lived, trained, and socialized. Whenever I would appear at the *Life* office early in the morning wearing my dark gray suit, the staff would snicker and say, "Aha! Cornell's wearing his Guards suit," a sure sign that I was going to St. James's for tea that afternoon.

Some of my fondest memories are of London's Hyde Park (plates 39–43). My wife and I were living in a wonderful garden apartment overlooking the Thames at Putney Bridge, and every morning I would drive my 1948 Studebaker Champion—then considered a small car in America, but surely the biggest car in London at the time—to the Time-Life office on Dean Street, in Soho, cutting through Hyde Park along the way. Watching this beautiful, people-filled park change with the seasons made this habitual detour quite literally a daily joyride. Hyde Park seemed to me an enchanted garden.

My two years in England were a grand adventure. I loved hearing people speak "the King's English." I loved the dry English sense of humor and the sporting attitude of fair play. I loved the English theater, English literature, English culture, and English ritual. It was one of the most wonderful periods of my life. There, at last, I found the magic key to translate ideas into good photographic essays.

*35. Glyndebourne Opera Festival, Sussex, 1

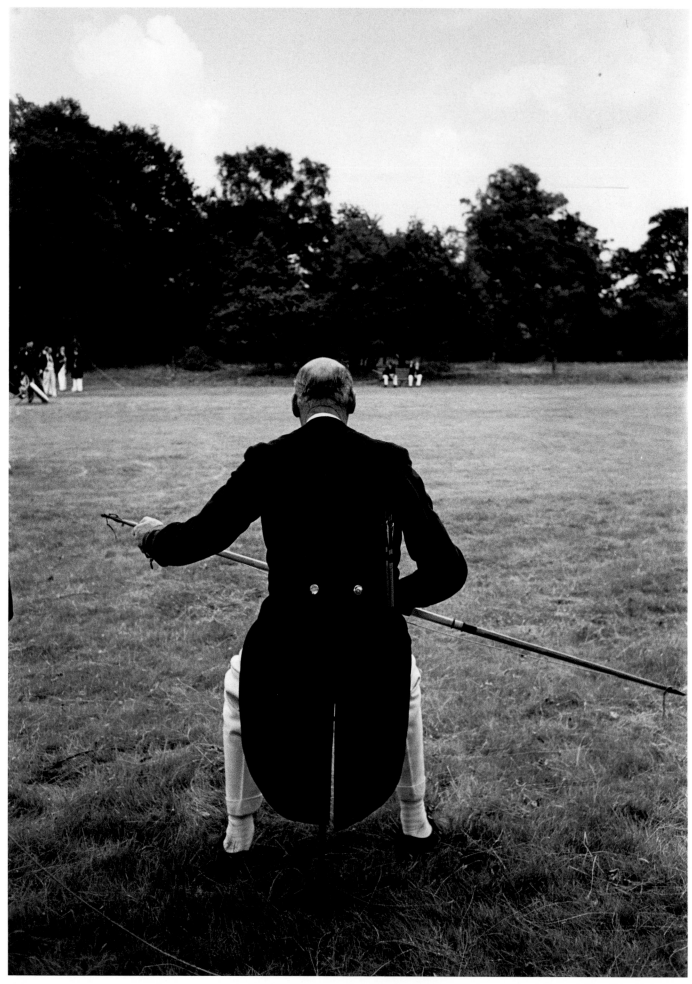

*36. A contestant at an archery match in the Forest of Arden, Warwickshire, 1950.

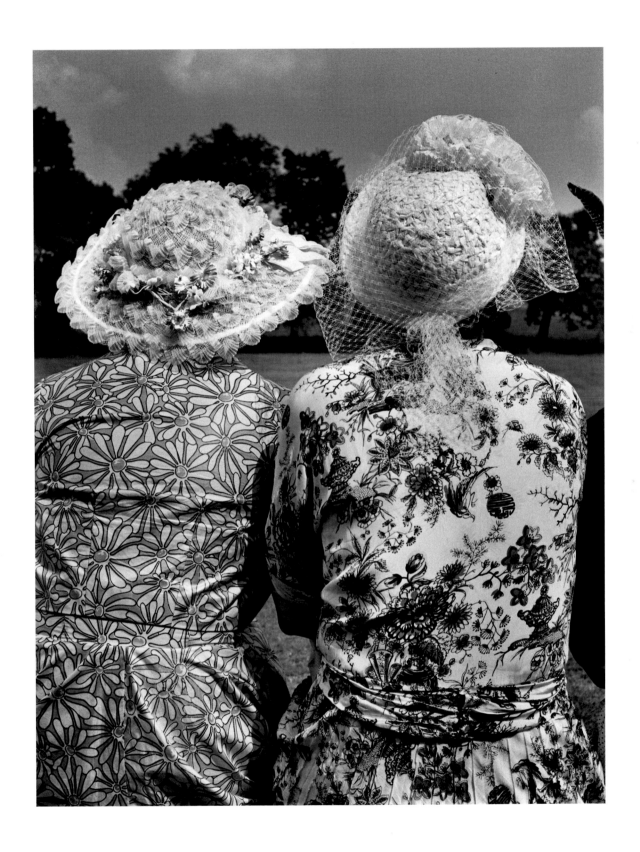

37. Spectators at an archery match in the Forest of Arden, Warwickshire, 1950.

*38. J. C. Christie, founder of the Glyndebourne Opera Festival, Sussex, 1951.

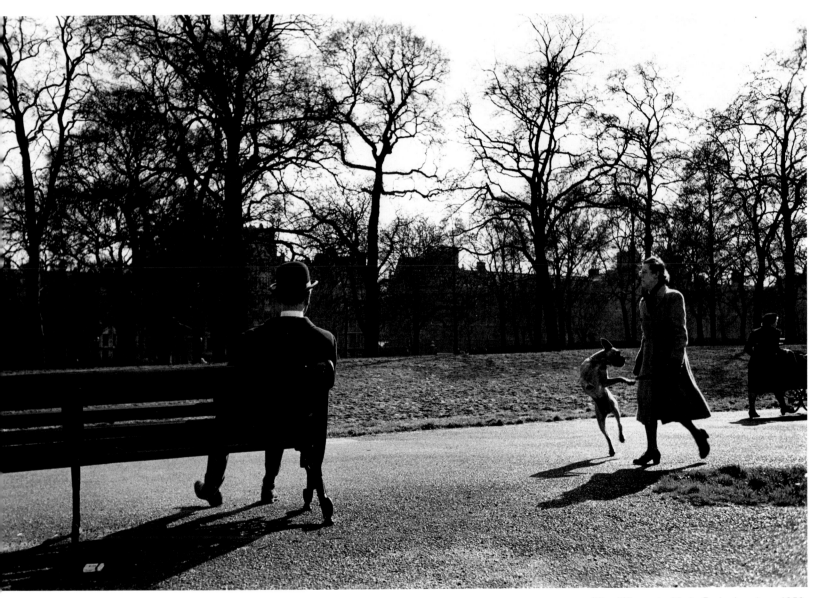

39. Winter in Hyde Park, London, 1952.

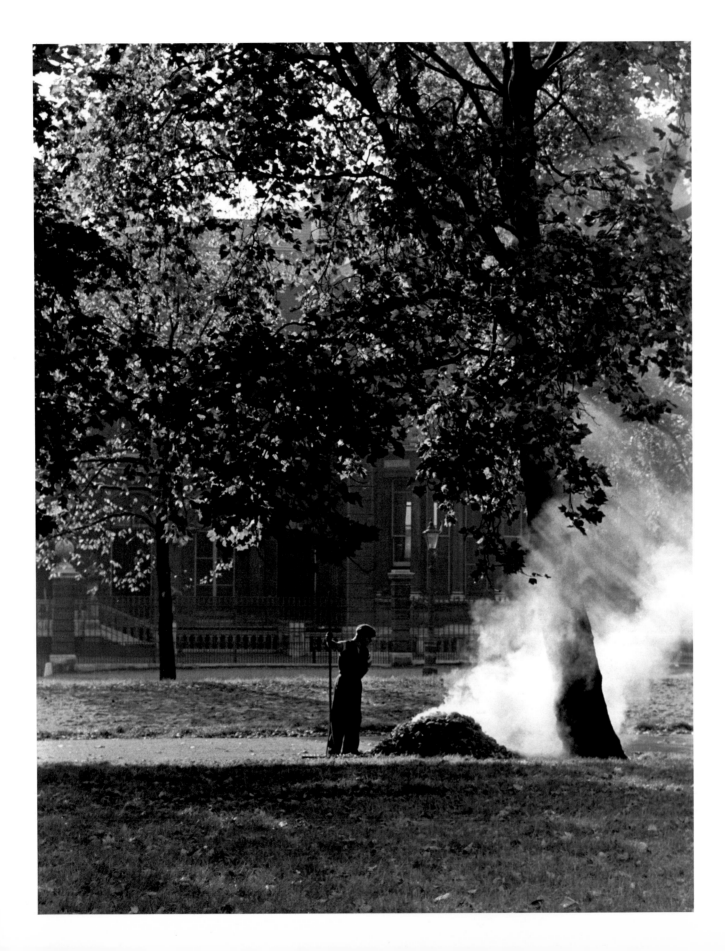

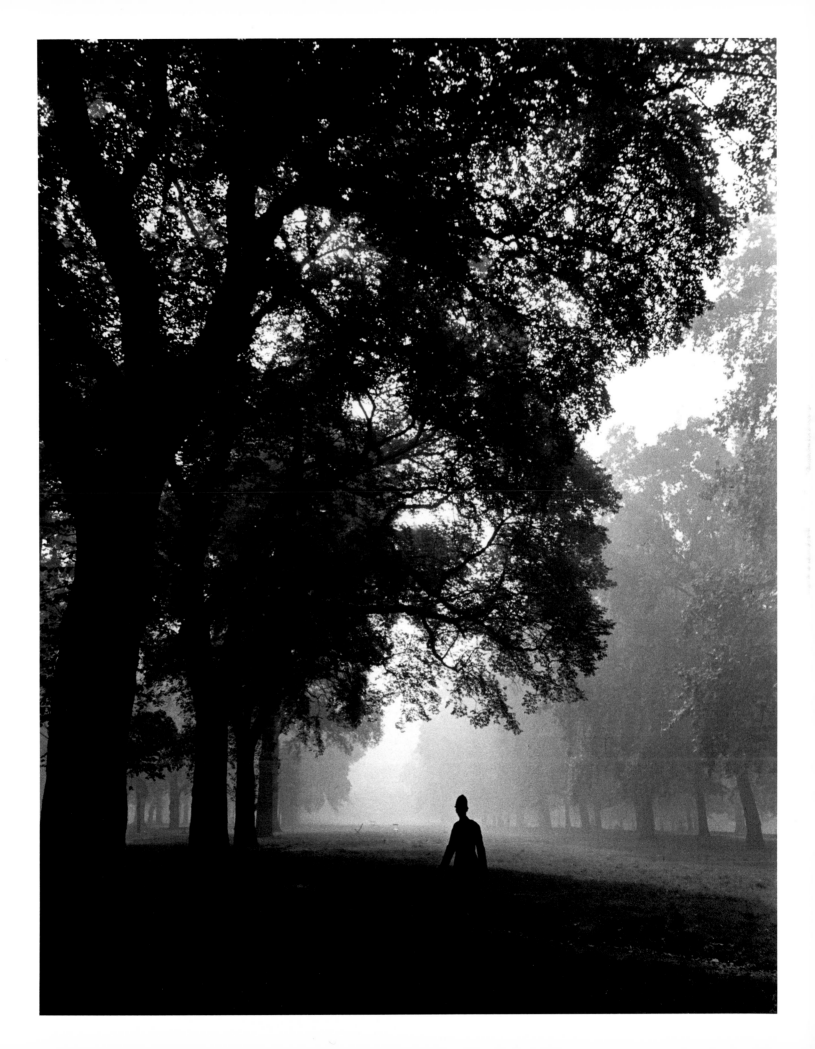

42. Spring in Hyde Park, London, 1951.

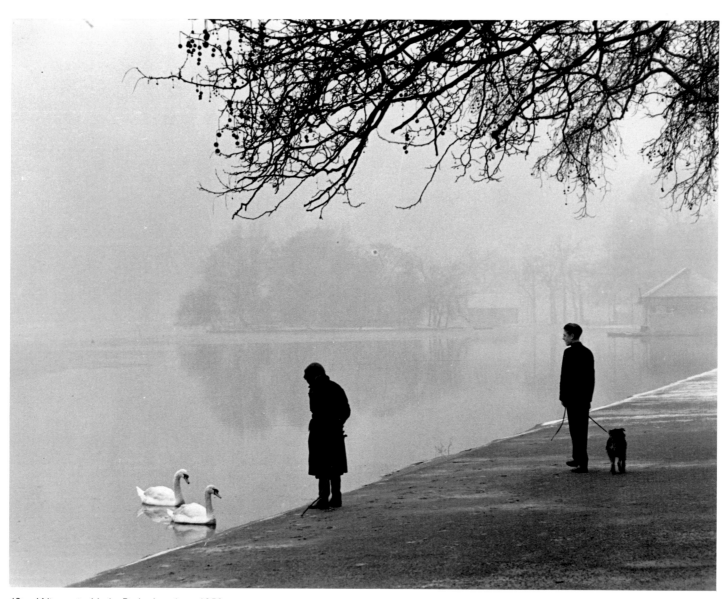

43. Winter in Hyde Park, London, 1952.

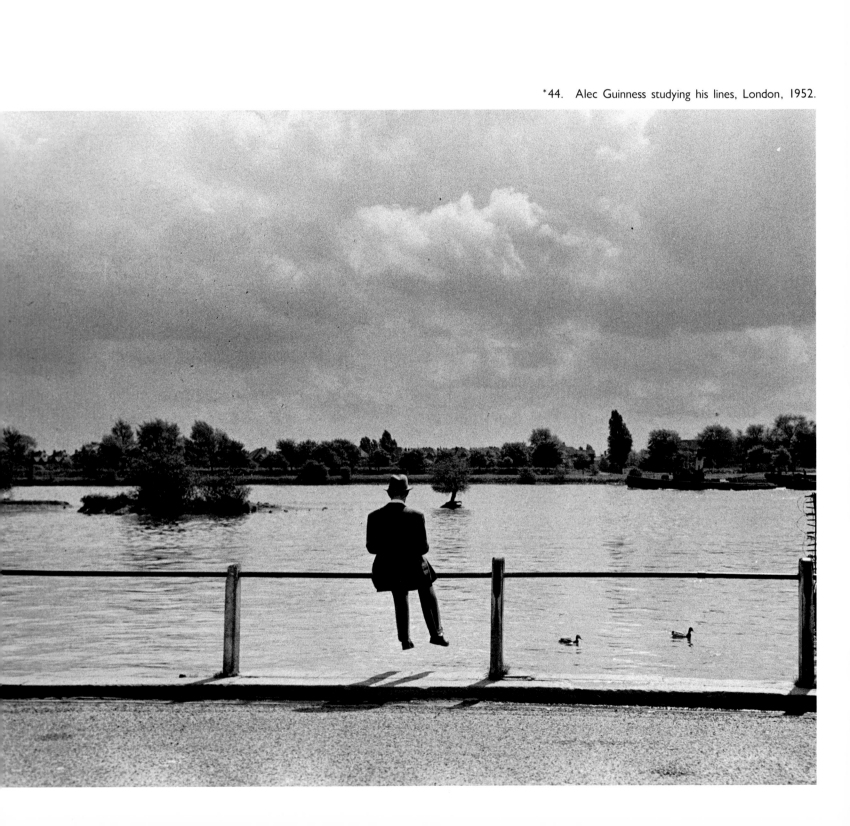

*44. Alec Guinness studying his lines, London, 1952.

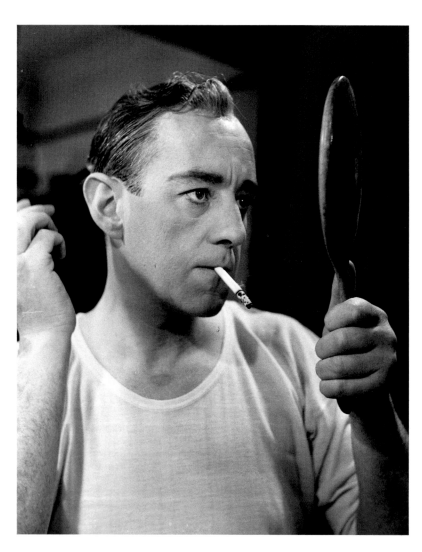 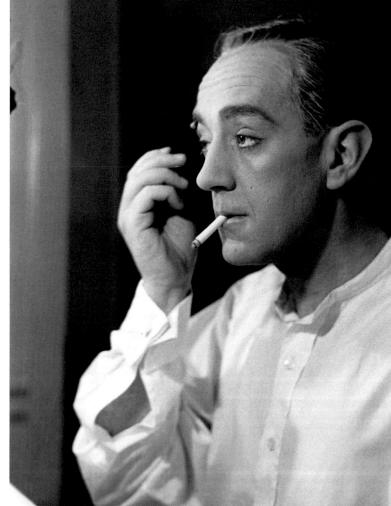

*45–48. Alec Guinness transforming himself with makeup, London, 1952.

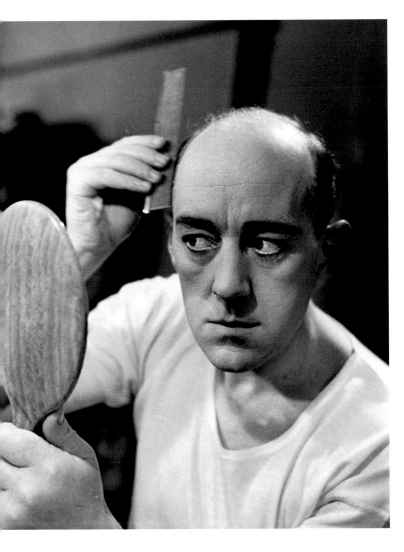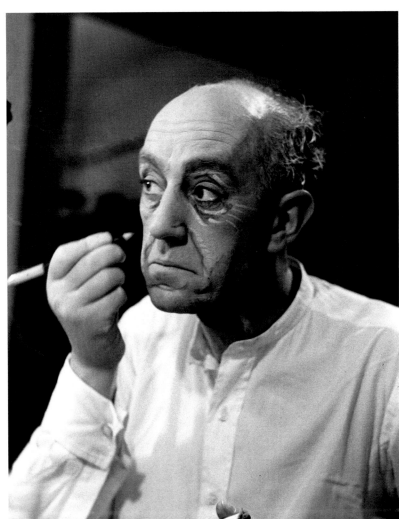

*49. Alec Guinness in his dressing room, London, 1952.

50. Hazing in a dormitory, Winchester College, Winchester, 1951.

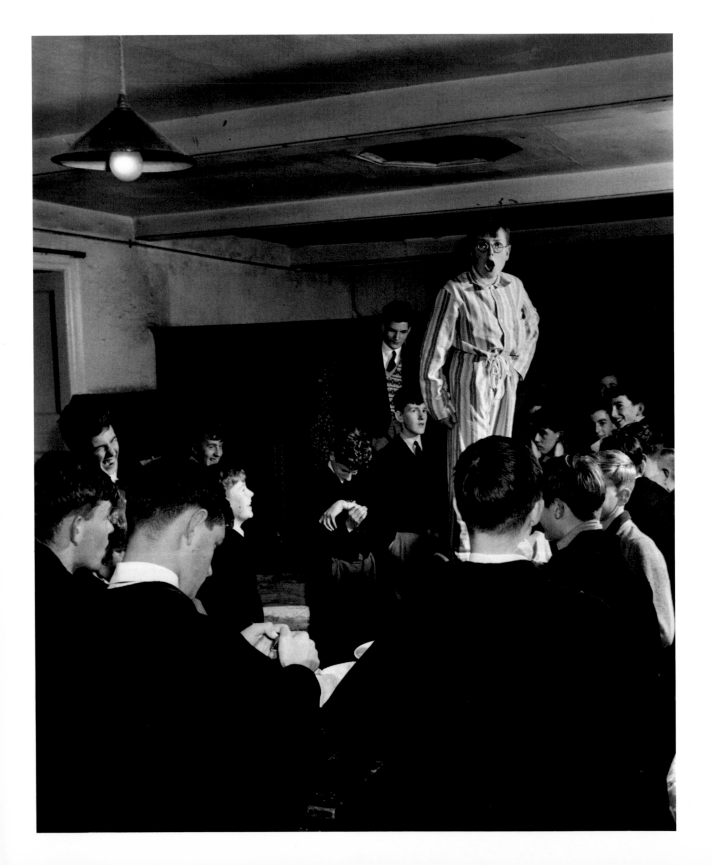

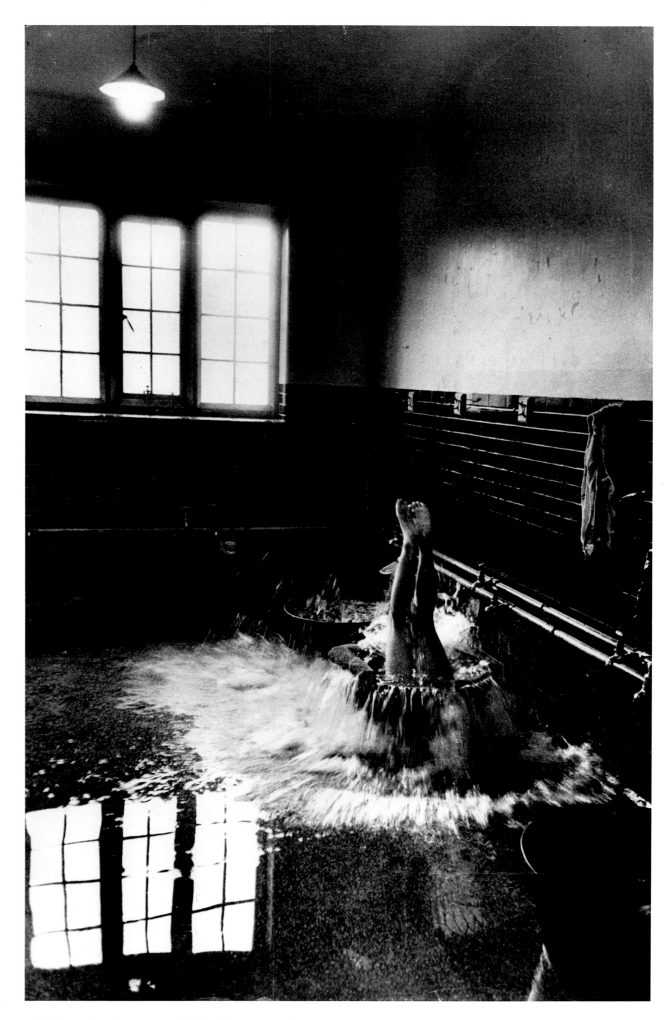

51. Early morning cold baths,
Winchester College, 1951.

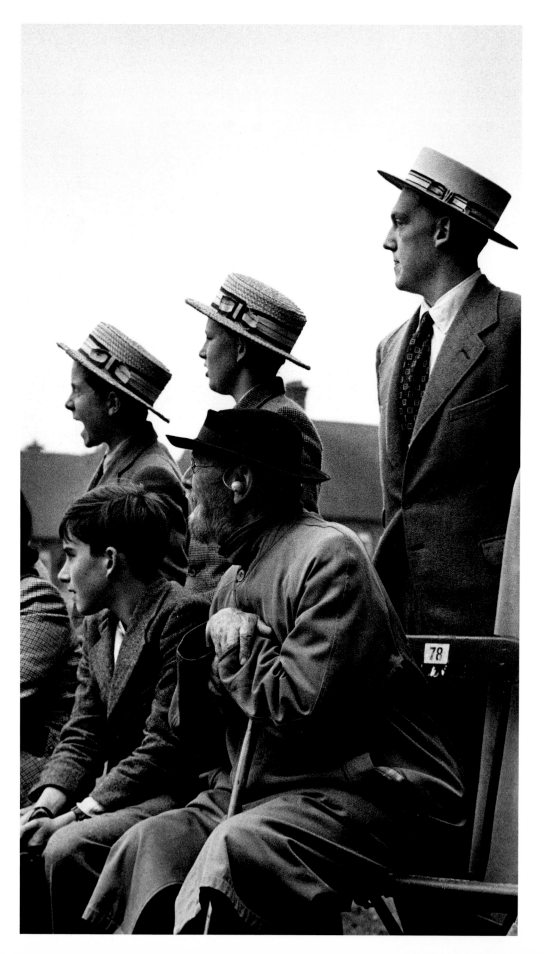

*52. Students and an old graduate watching a soccer match at Winchester College, 1951.

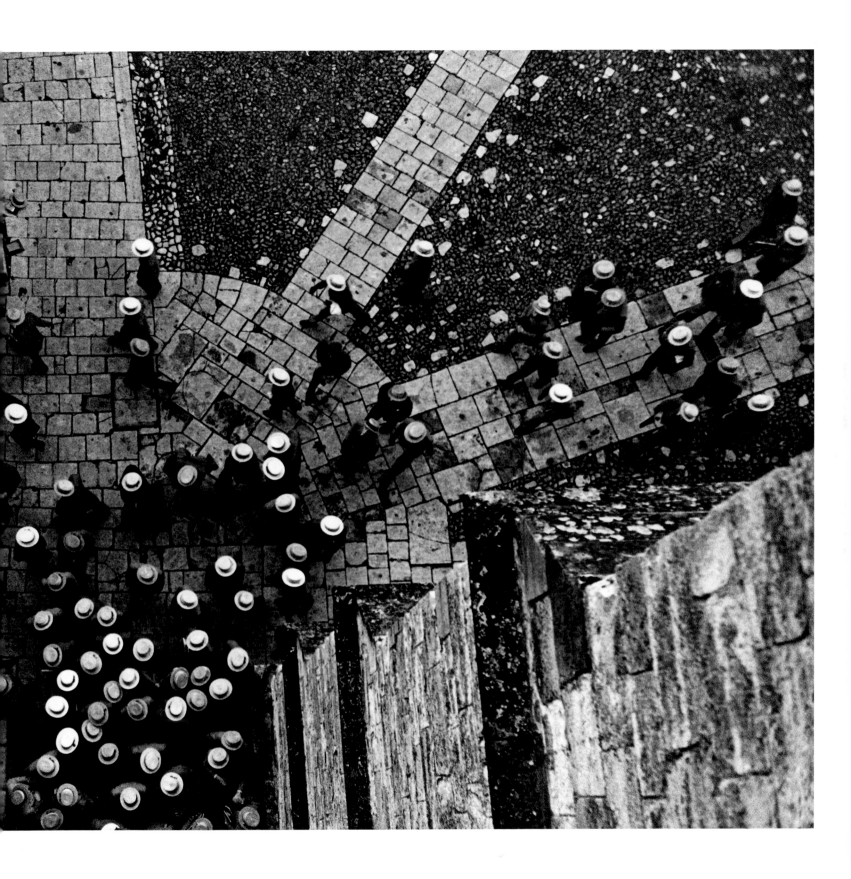

*53. Boys entering chapel at Winchester College, 1951.

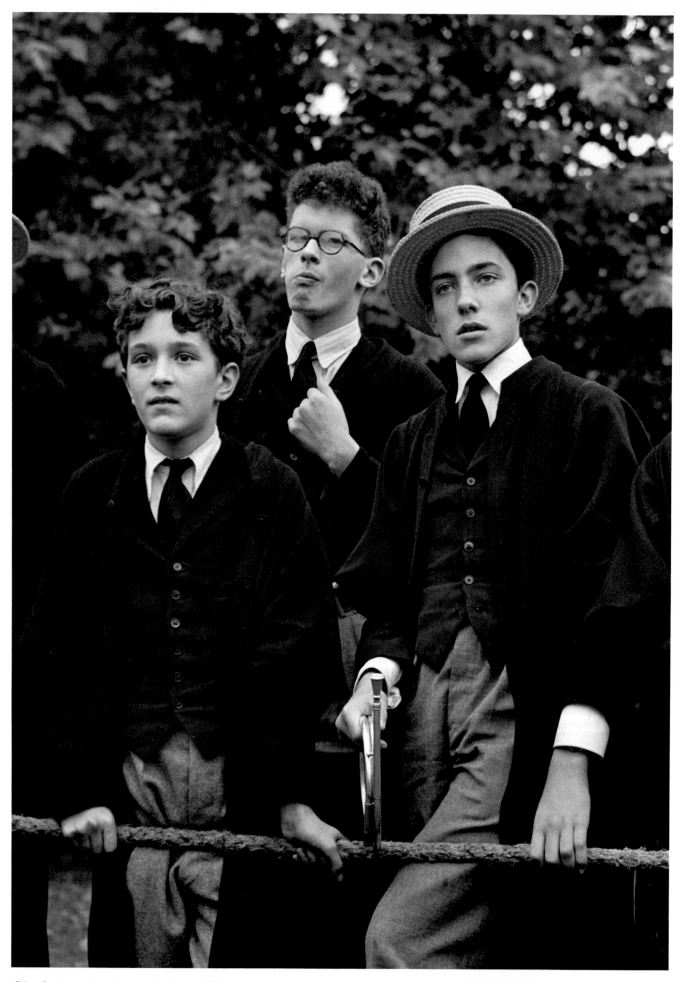

54. Students, Winchester College, 1951.

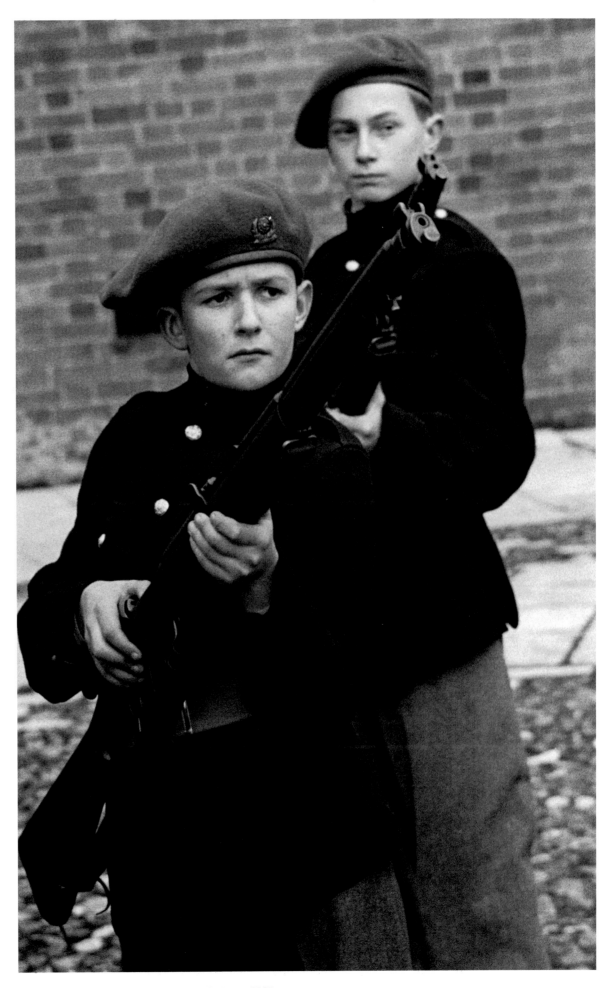

55. Weekly cadet drill, Winchester College, 1951.

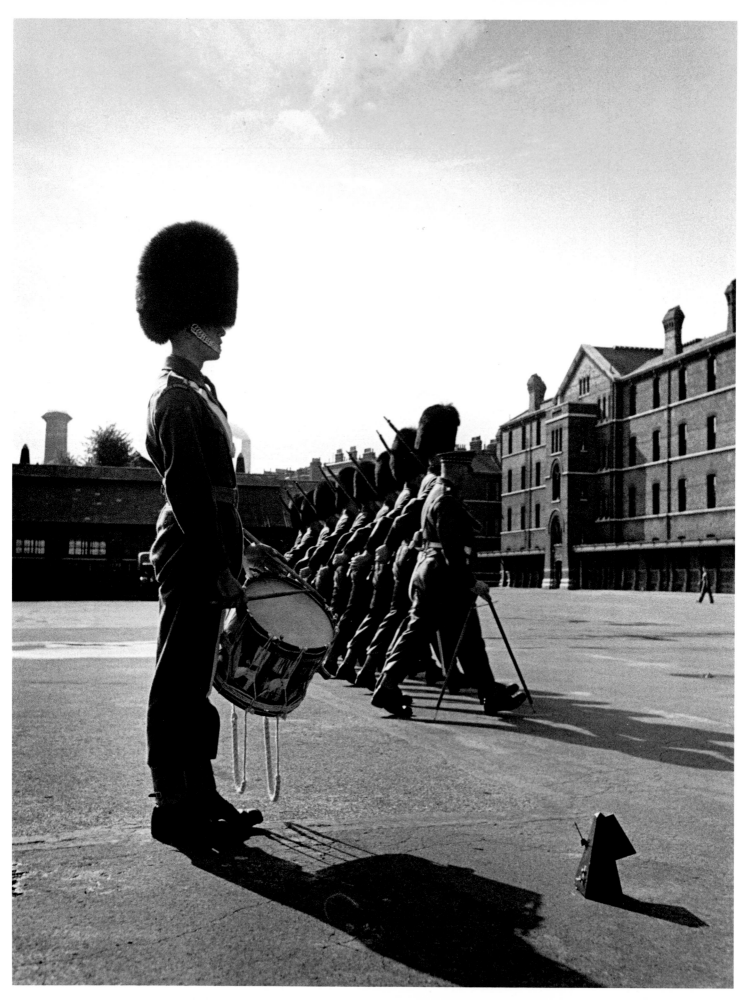

*56. Parade drill for the elite Queen's Guards, London, 1952.

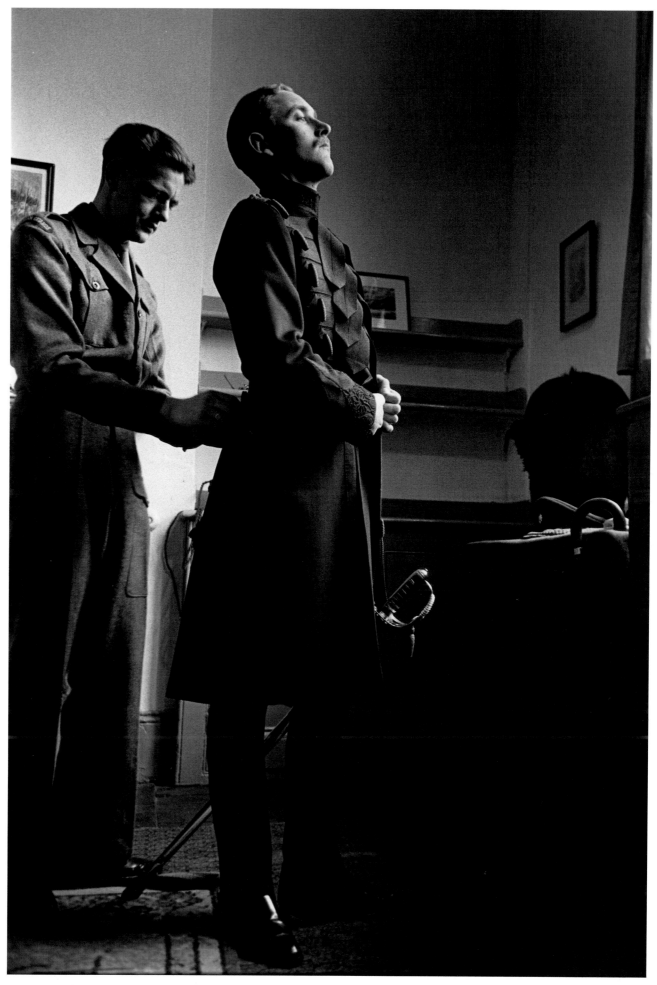

*57. An officer of the Queen's Guards being dressed by his aide-de-camp, London, 1952.

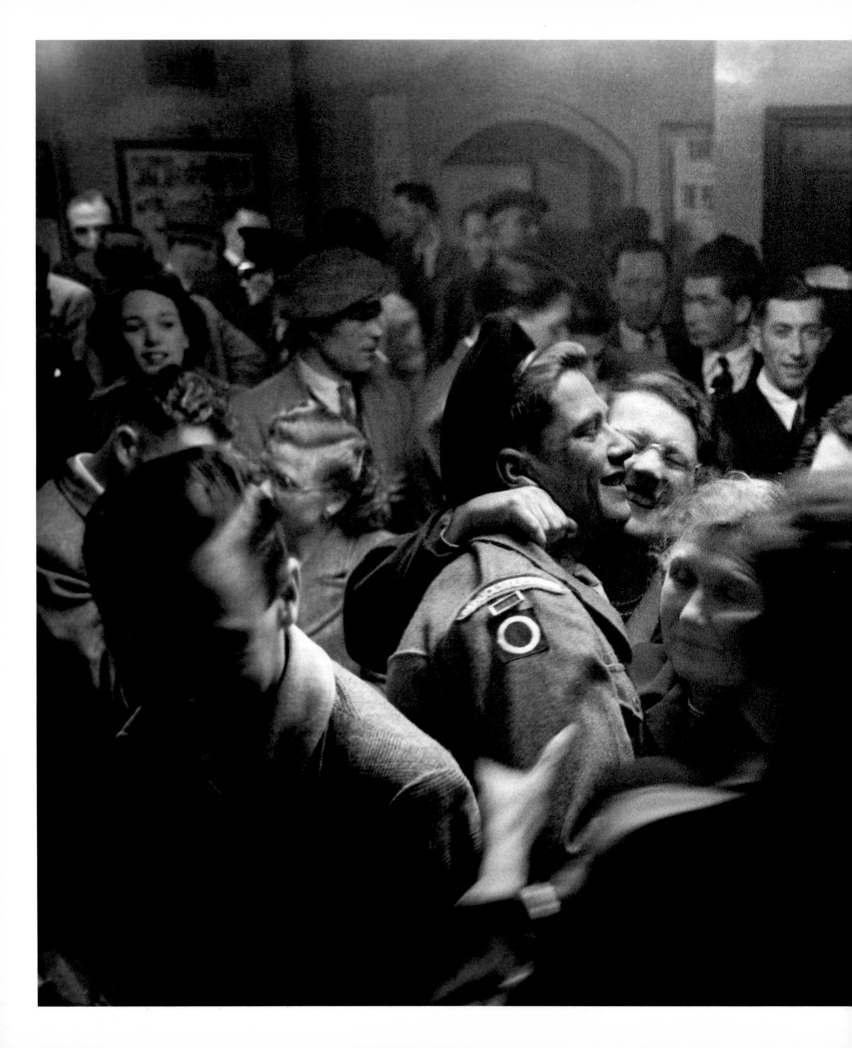

*58. The Gloucester Regiment,
which had fought heroically in Korea,
returns to England, 1951.

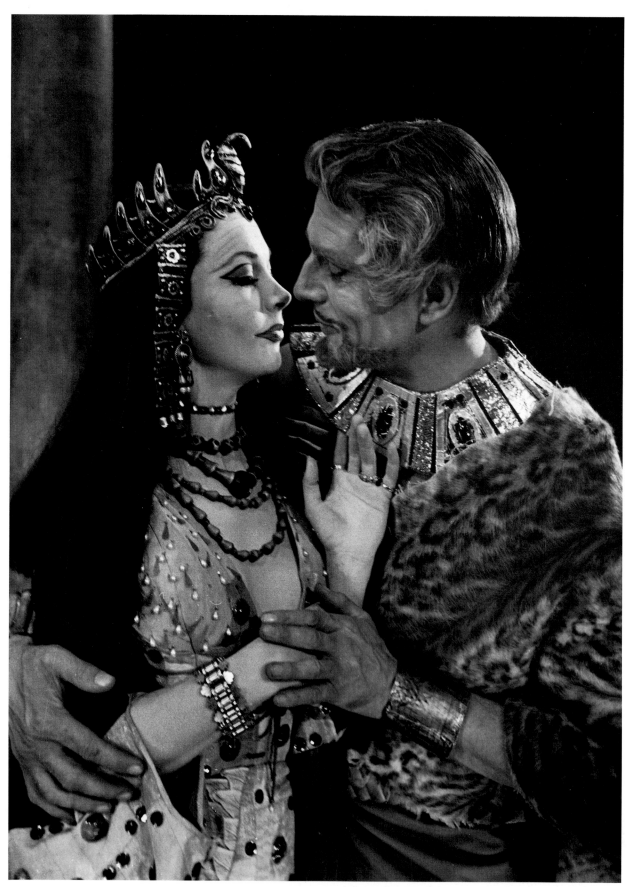

*59. Vivien Leigh and her husband, Laurence Olivier, in
Shakespeare's *Antony and Cleopatra*, London, 1951.

*60. Judy Garland at the Palladium, London, 1951.

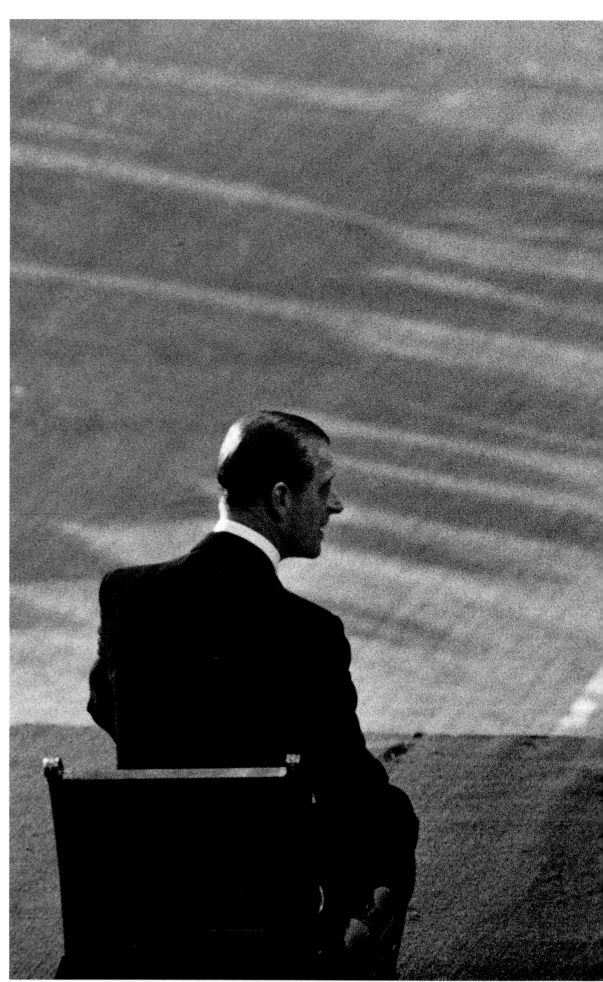

61. Queen Elizabeth II and Prince Philip,
New York, 1957.

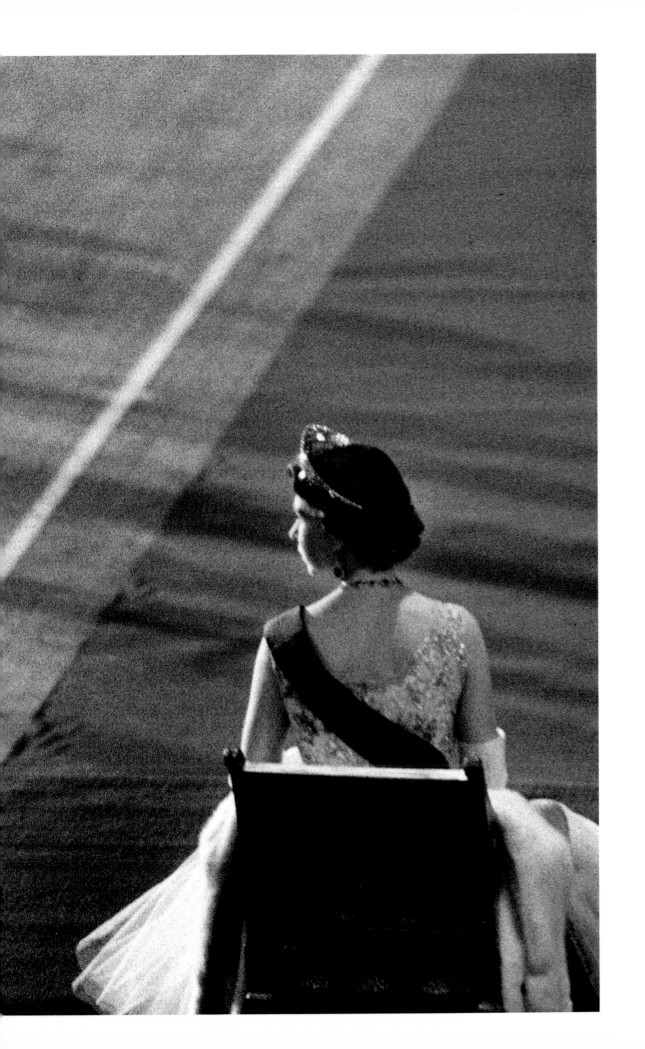

AMERICAN POLITICS

In the late 1940s I had done some minor political coverage for *Life*, but my real interest in American politics wasn't awakened until early in 1952, when I was still living in London. I began to hear a lot about a man named Adlai Stevenson, and then I heard a couple of his speeches on the overseas radio. I loved what he was saying—and the way he said it. Here was an American who spoke *English!* I decided that I wanted to support his cause in the best way I could—with my camera. I requested permission from *Life*'s New York office to return to the States to cover Stevenson's campaign in depth. The permission soon came through. Little did I know what a tremendously important chapter of my life was about to begin as I was launched on an eight-year involvement with Stevenson. Politics, the greatest of American sports, was to remain one of the dominant preoccupations of my work well into the 1960s.

In the spring of 1952 Adlai Stevenson, who was then the governor of Illinois, was still an unfamiliar figure to most Americans. So my first task was to do a story that would give the public a sense of who he really was. What I found was a wonderfully warm, wise, and witty man of high ideals and rare dedication. I photographed him not only going about his routine as governor—the heir in every way of Abraham Lincoln, another statesman from Illinois—but also in his roles as gentleman-farmer and the divorced father of three sons. I was drawn very strongly to all that he stood for and to the man himself as a person.

That year I followed Stevenson to the Democratic convention, where he succeeded in winning the party's nomination, and then on many of his extensive travels around the country in the course of his campaign. The excitement of rallies, his stirring speeches, the camaraderie of our entourage, and the enthusiasm with which he was greeted everywhere only made his defeat on Election Day all the more heartbreaking for all of us. We had been exhilarated by Stevenson's magnificent campaign against Eisenhower, the national hero, but Adlai couldn't overcome Ike's winning smile.

Stevenson tried again in 1956, with the same result. And again I accompanied him through hope and defeat. In 1960 he was to make a third try. Early in that year I had done a story for *Life* on the nature of American politics—its look and feel. In the course of working on that story, I covered the Wisconsin primary—and there I encountered a young politician who seemed to be a rising star, John F. Kennedy, and his attractive wife, Jackie. I was still very much a Stevenson man, and I resented this upstart senator with his arrogant slogan that it was now the "time for greatness." How dare he? I felt sure that he was a rich boy whose public relations were better than his real potential. And yet I could feel the surge of response that Kennedy evoked from young people, the kind of excitement that Adlai rarely elicited from them. I gradually found myself forced to admit, almost reluctantly, that Stevenson's time was past.

As before, I covered both parties' conventions that year. And when Kennedy won the Democratic nomination, *Life* asked me to cover his campaign. But I wasn't completely enthusiastic about JFK until I heard his inaugural speech. Listening to his inspiring words, I had an idea. The prevailing spirit was like that of 1933, when FDR had brought an adventurous spirit to the White House and had worked miracles during his first one hundred days in office. Why not do a book on the first hundred days of Kennedy's administration, getting nine Magnum photographers and seven writer-historians to cover every aspect of the new programs and to document some of the problems the new president faced at home and abroad? The book could then come out on the 110th day. I called my friend Dick Grossman at Simon and Schuster, and he said, "Let's do it!" Pierre Salinger, the President's press secretary, gave us his full cooperation. My own beat was the White House, where I photographed JFK with the galaxy of advisers he had assembled, his brain trust.

All went well until the eighty-eighth day, April 17, when the Bay of Pigs invasion took place in Cuba. That fiasco dampened our jubilation somewhat. But we got Barbara Ward of the *Economist* to write something about the invasion, and we put her text on the last page. The book came out, as planned, on the 110th day of the Kennedy administration and sold nearly 150,000 copies. *Time* called it instant history, and it set the pattern for many future projects.

In 1964, the year after JFK's assassination, I decided to cover the first day of Robert Kennedy's campaign for one of New York State's seats in the U.S. Senate. That first morning, we flew in the Kennedy family's small plane, the *Caroline*, to Albany. RFK, who had done much soul-searching before deciding to run for office, was greeted as if he were his brother come back to life. The response to him everywhere was overwhelming. One woman was waiting for him, her Kodak ready, at the place where we were scheduled to stop for breakfast. When she saw him, she was so overwhelmed that the camera fell right out of her hands. I had never experienced such intensity between a candidate and the public.

His dilemma was like Hamlet's—to be or not to be. That is, was he going to be his own man, or was he going to assume the role of the resurrected brother? By the end of the first half hour of campaigning that first day, he had fallen into all of JFK's gestures and intonations, in spite of himself. As the campaign progressed, he became more and more like his dead brother.

Early in June 1968 I was in Chicago, doing a story on Mayor Richard Daley for *Look*. I was staying in a terrible fleabag across from City Hall. The bed took up nearly the whole room. Daley had agreed to let me come to his house the next day—a real scoop. That night, around midnight, I was half sleeping and half watching a movie on TV when the station cut to Los Angeles and the murder of Bobby Kennedy. I hoped it was just a bad dream.

62. Supporters of Lyndon B. Johnson for the presidential nomination,
 Democratic National Convention, 1960.

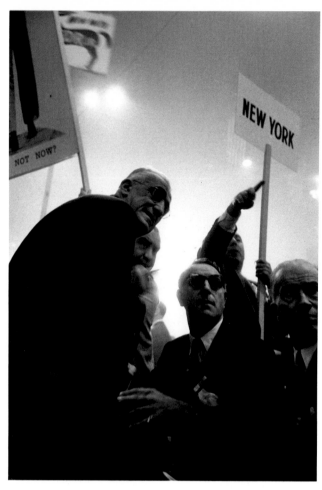
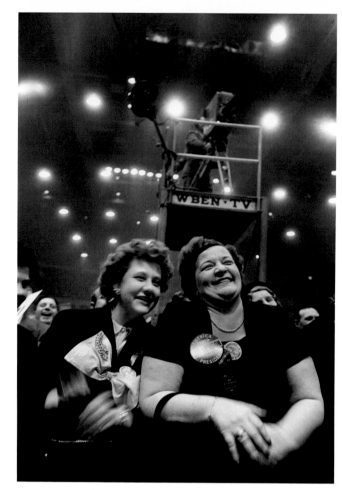
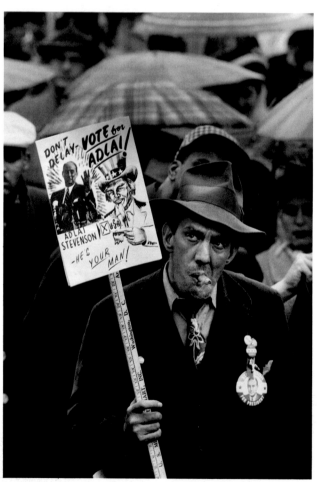
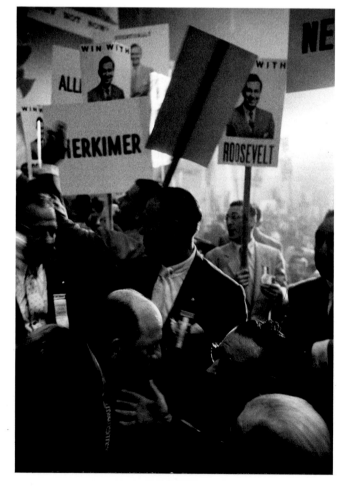

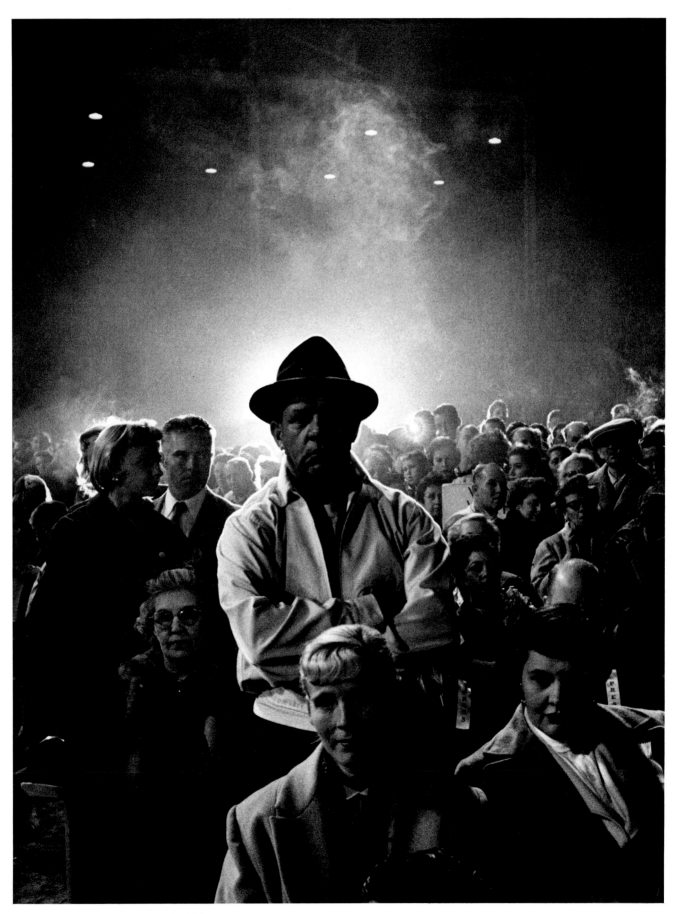

*63–67. Politicians and voters, 1950s.

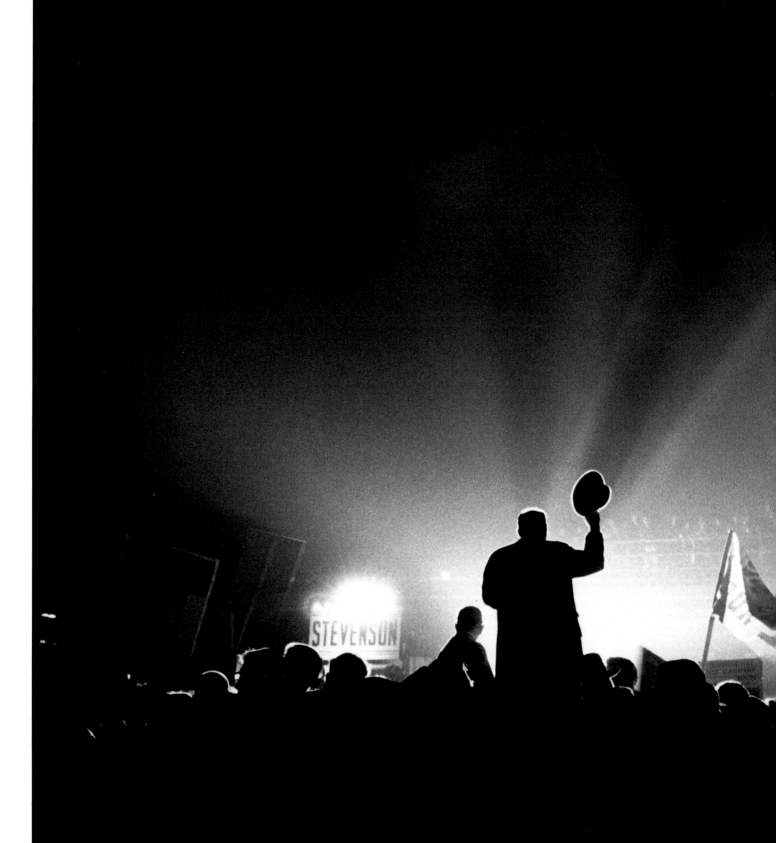

69. Adlai Stevenson campaigning
for the presidency, Boston, 1952.

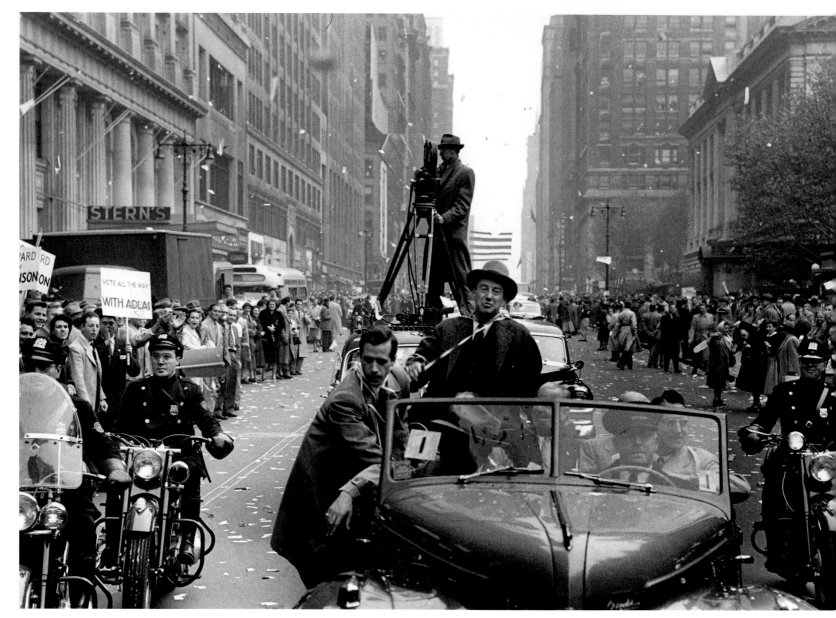

*70. Adlai Stevenson campaigning, New York, 1952.

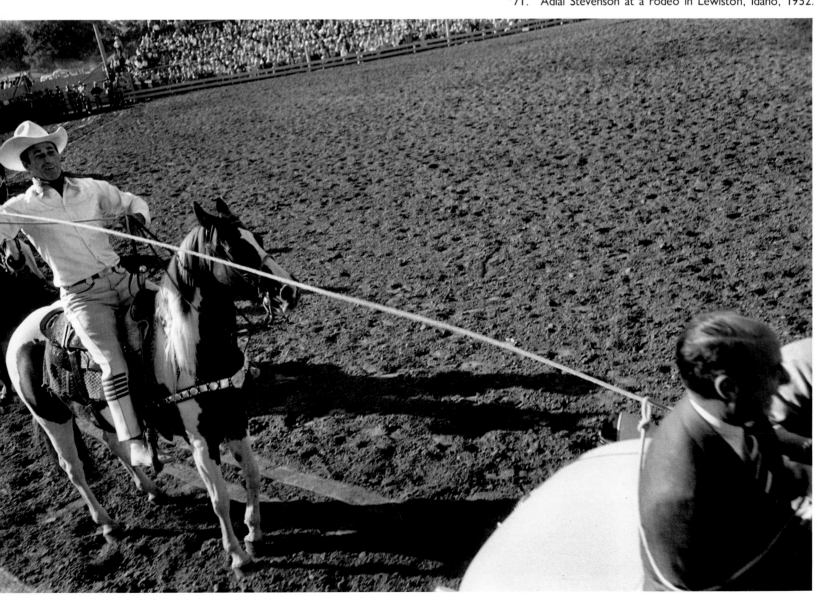

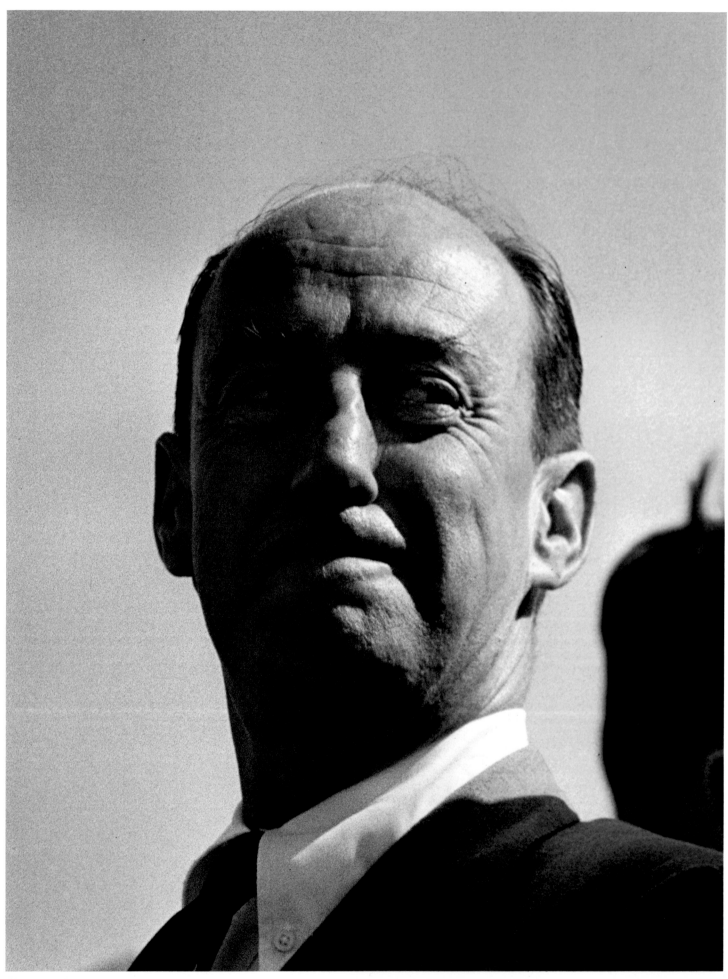

72. Adlai Stevenson early in his campaign, 1952.

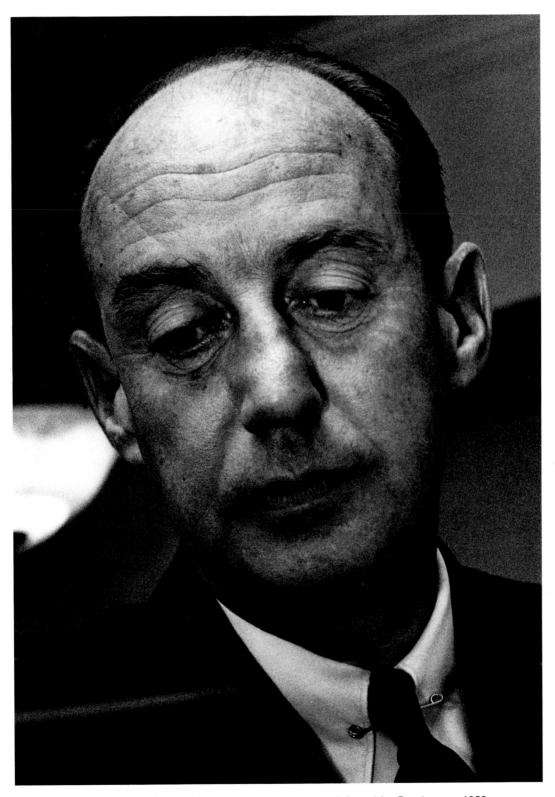

73. On the night of the election, learning that he had been defeated by Eisenhower, 1952.

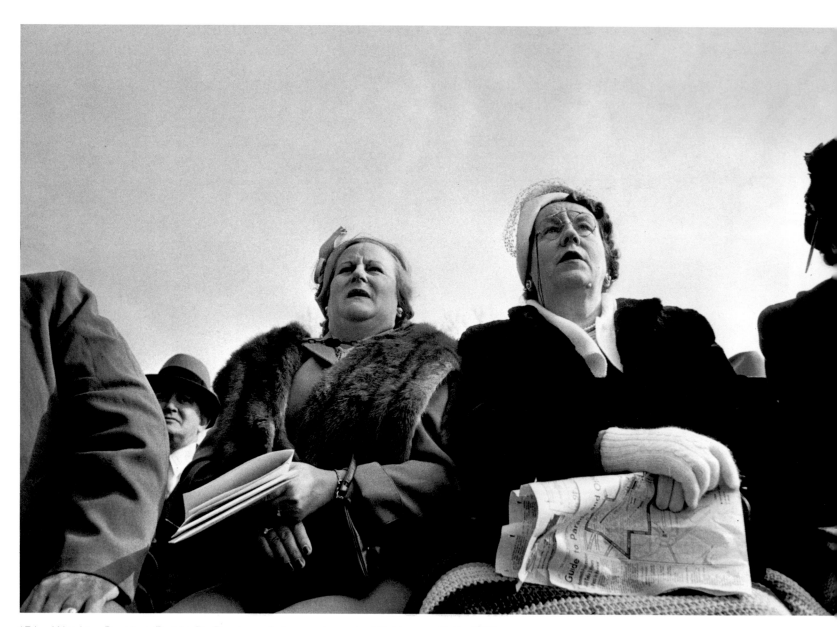

*74. Watching President Dwight D. Eisenhower's inaugural parade, Washington, D.C., 1953.

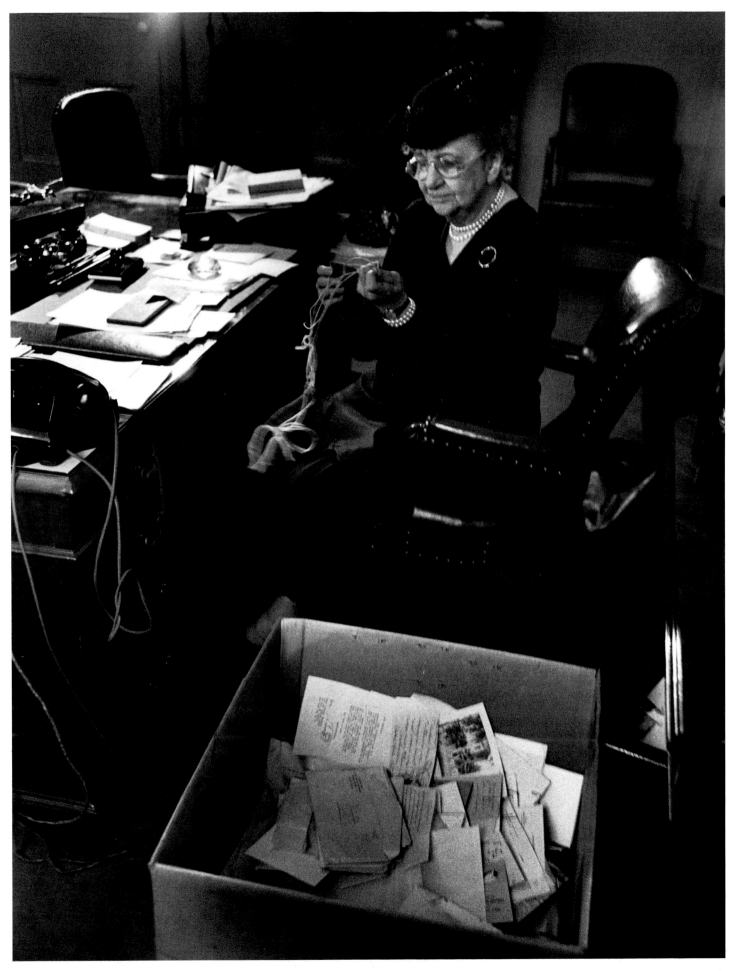

*75. Frances Perkins, the first female Cabinet member in U.S. history,
cleaning out her desk on the day of her retirement, Washington, D.C., 1953.

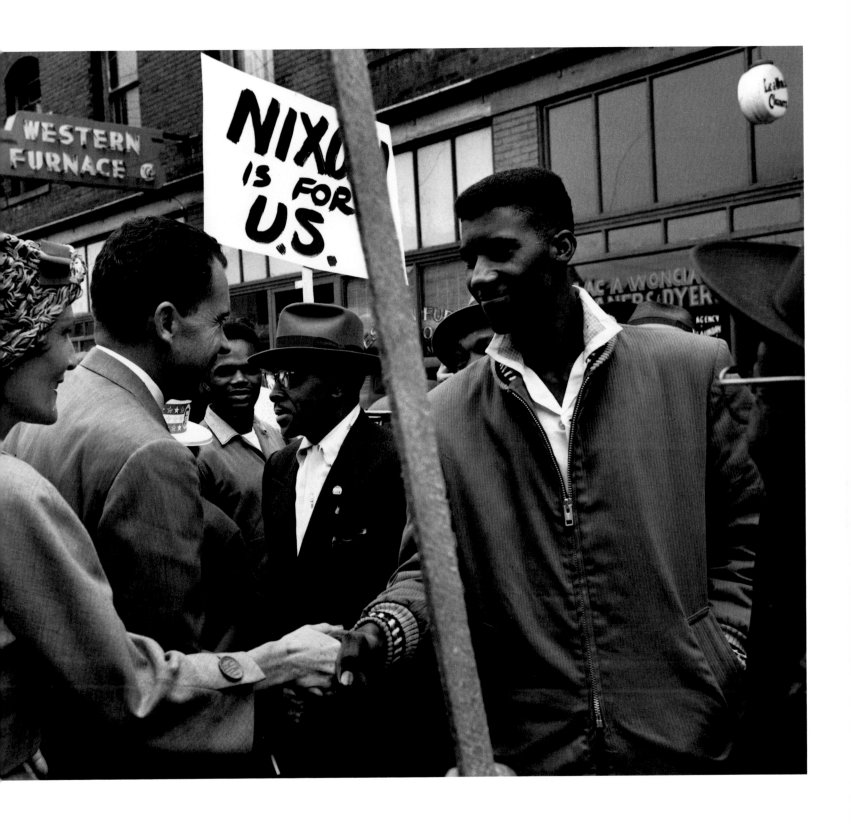

*77. Richard M. Nixon and his wife, Pat, as he campaigns for the presidency, Oregon, 1960.

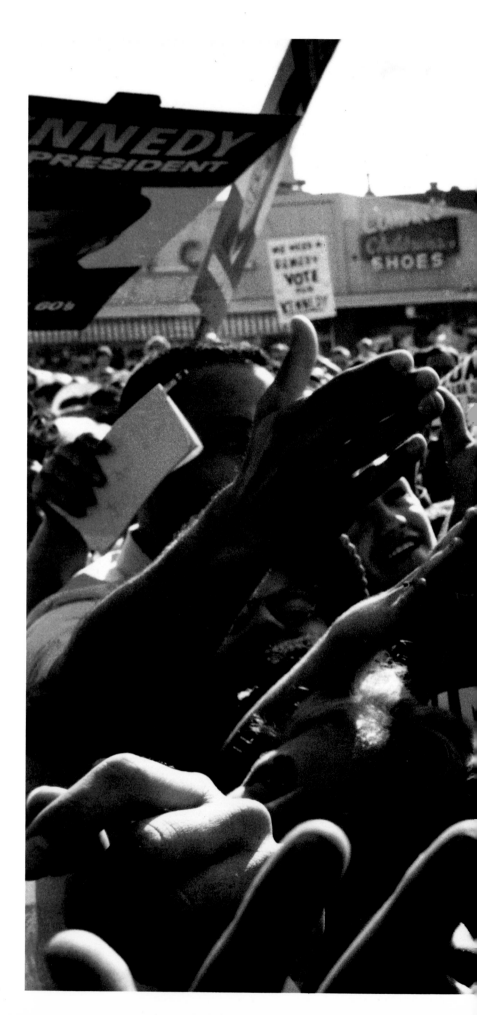

*78. The hands of John F. Kennedy
 as he campaigns in California, 1960.

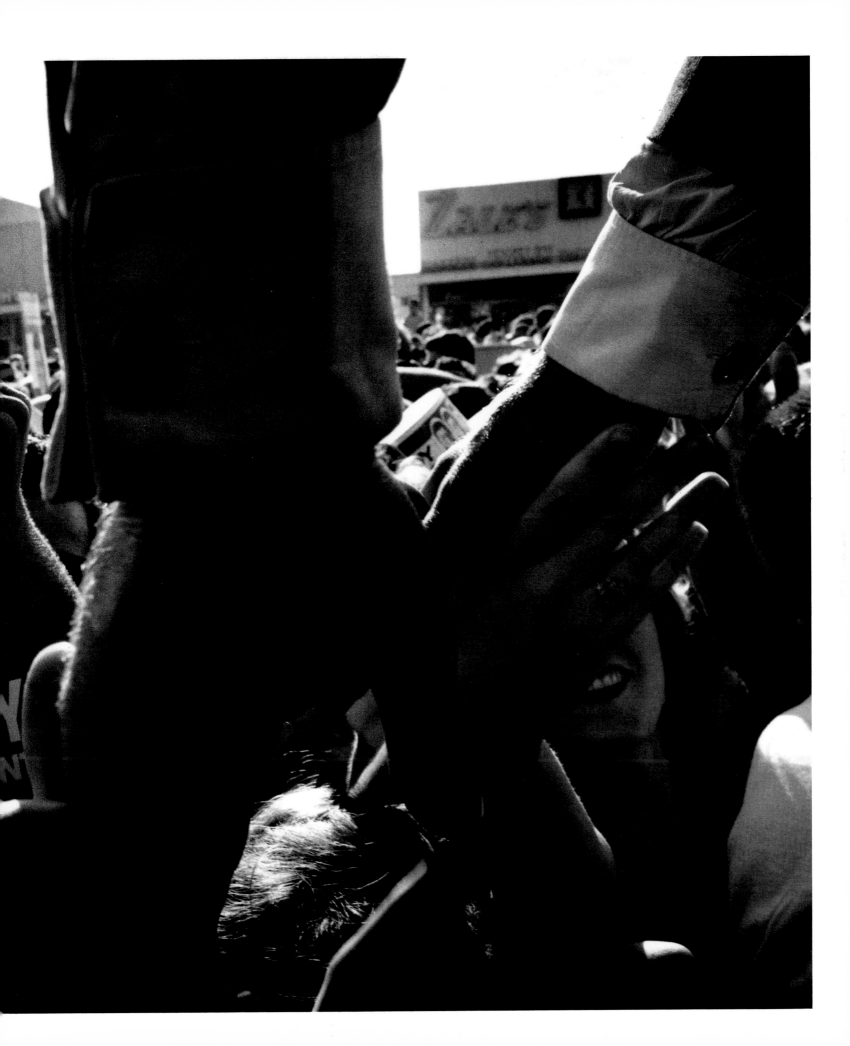

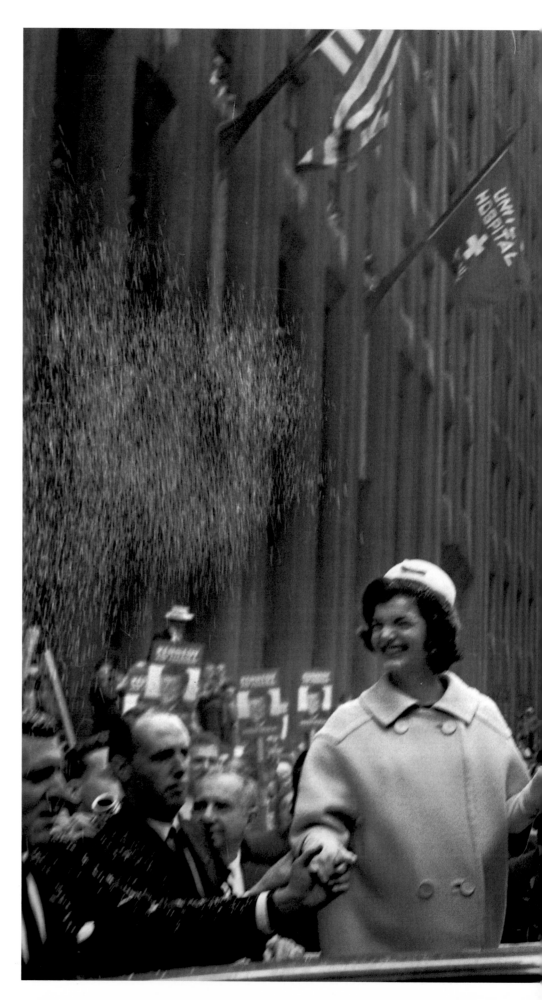

*79. John F. Kennedy and his wife, Jackie,
 campaigning in New York, 1960.

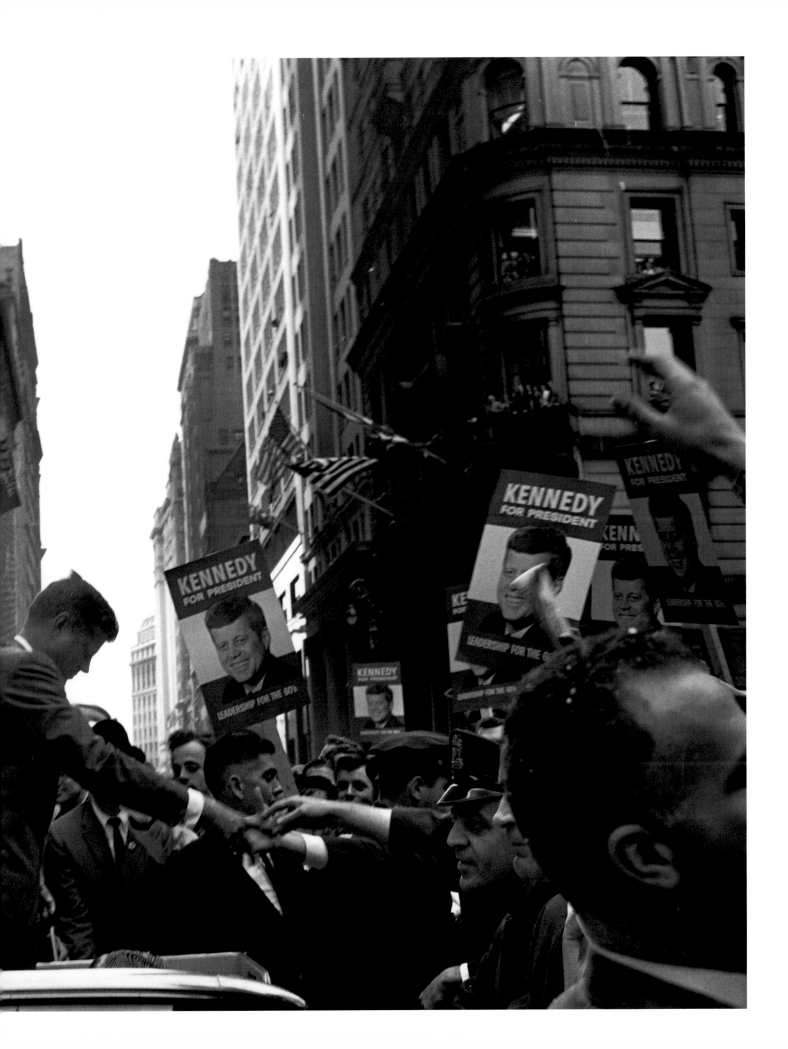

*80. Jackie Kennedy pushing her three-month-old son,
 John-John, on the grounds of the White House, 1961.

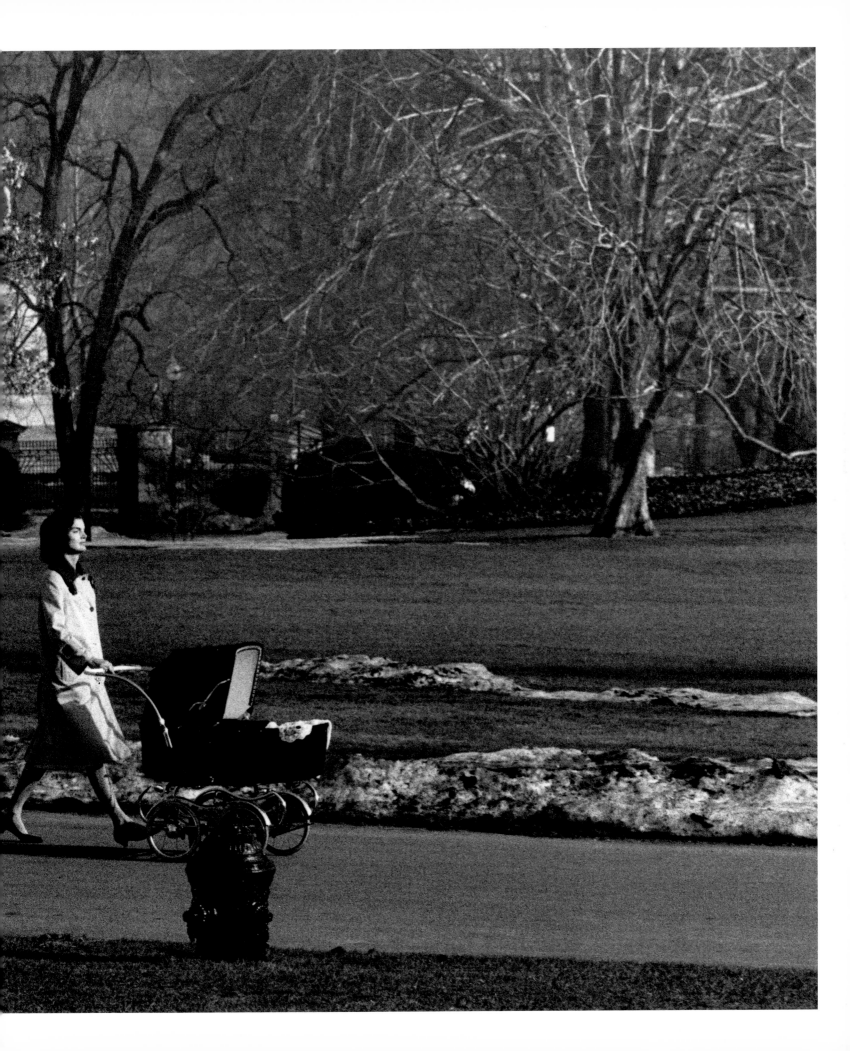

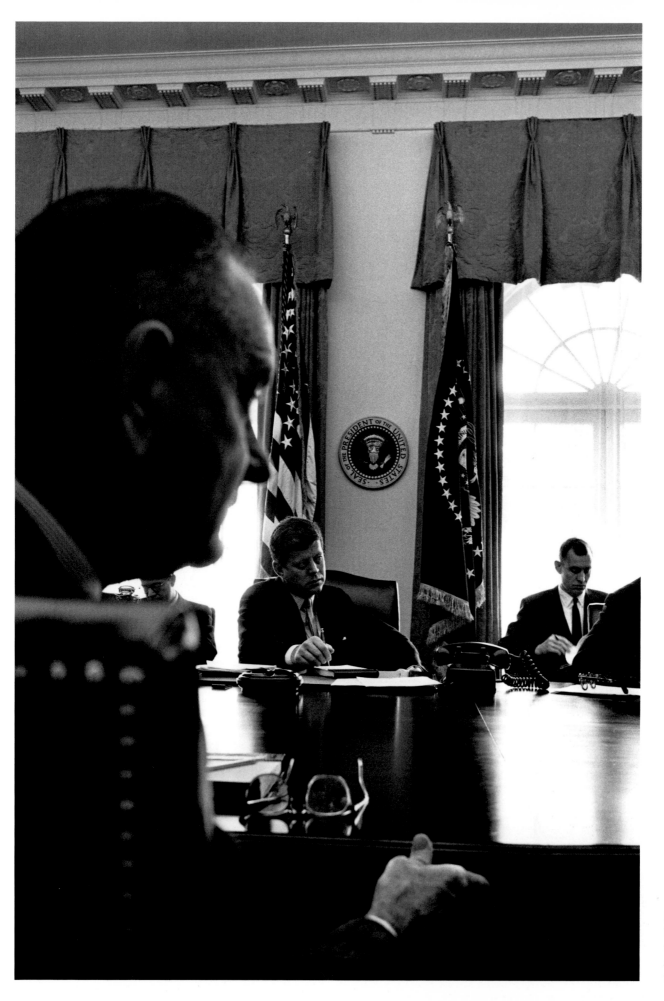

81.
Vice-President Lyndon B. Johns
with President John F. Kennedy
at a Cabinet meeting,
the White House, 1961.

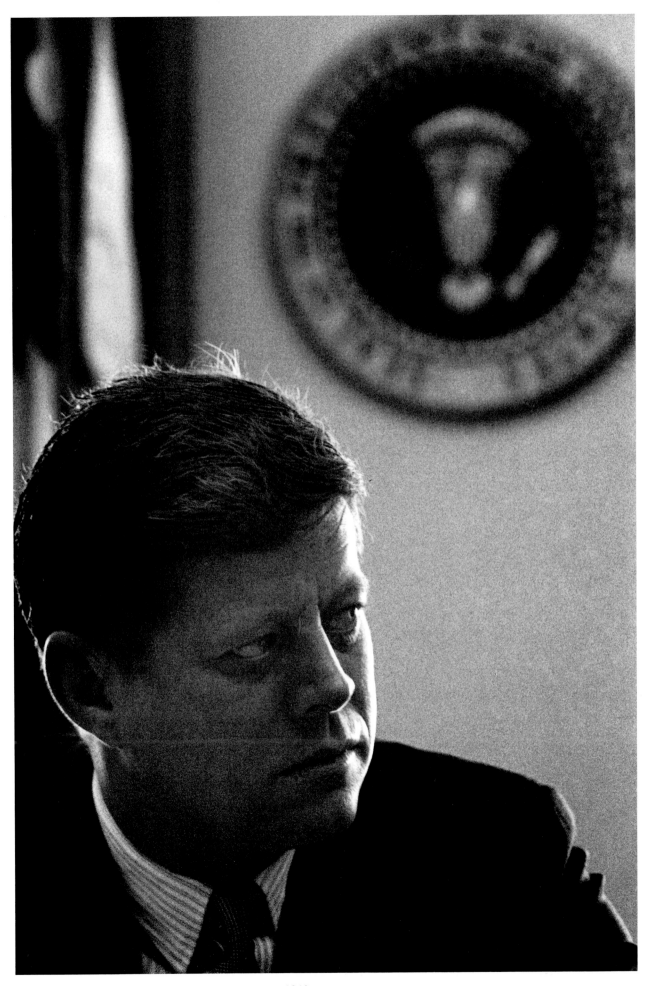

82. President John F. Kennedy, the White House, 1961.

83. President John F. Kennedy at his first Cabinet meeting, the White House, 1961.

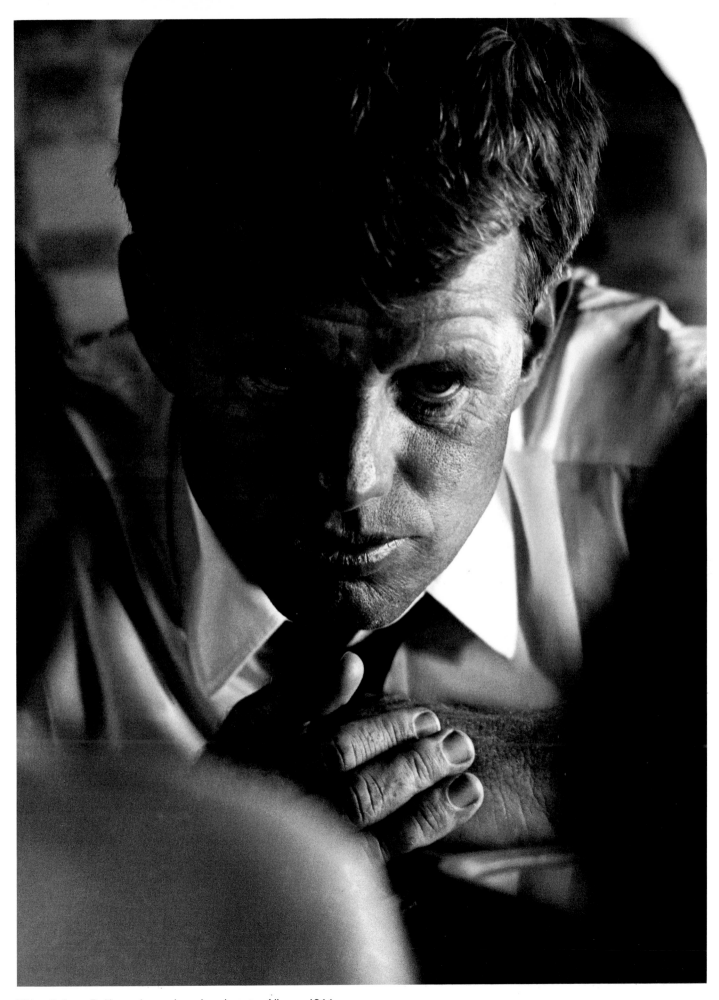

*84. Robert F. Kennedy, on board a plane to Albany, 1964.

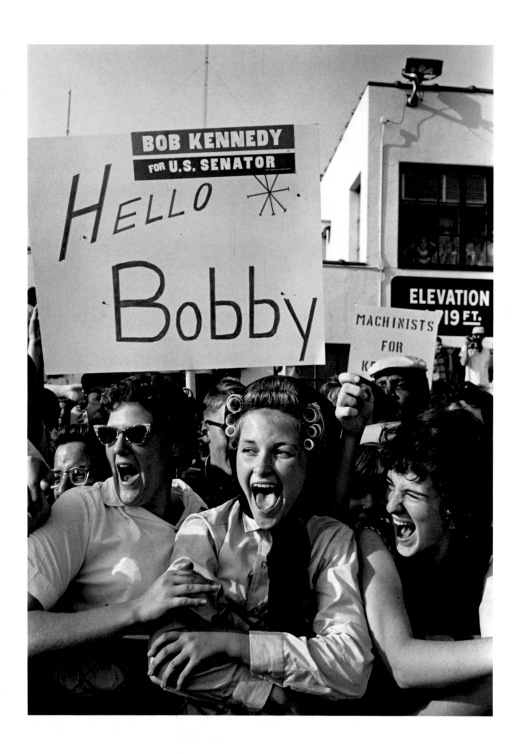

85–86. Supporters of Robert F. Kennedy
during his campaign for a seat in the U.S. Senate,
New York State, 1964.

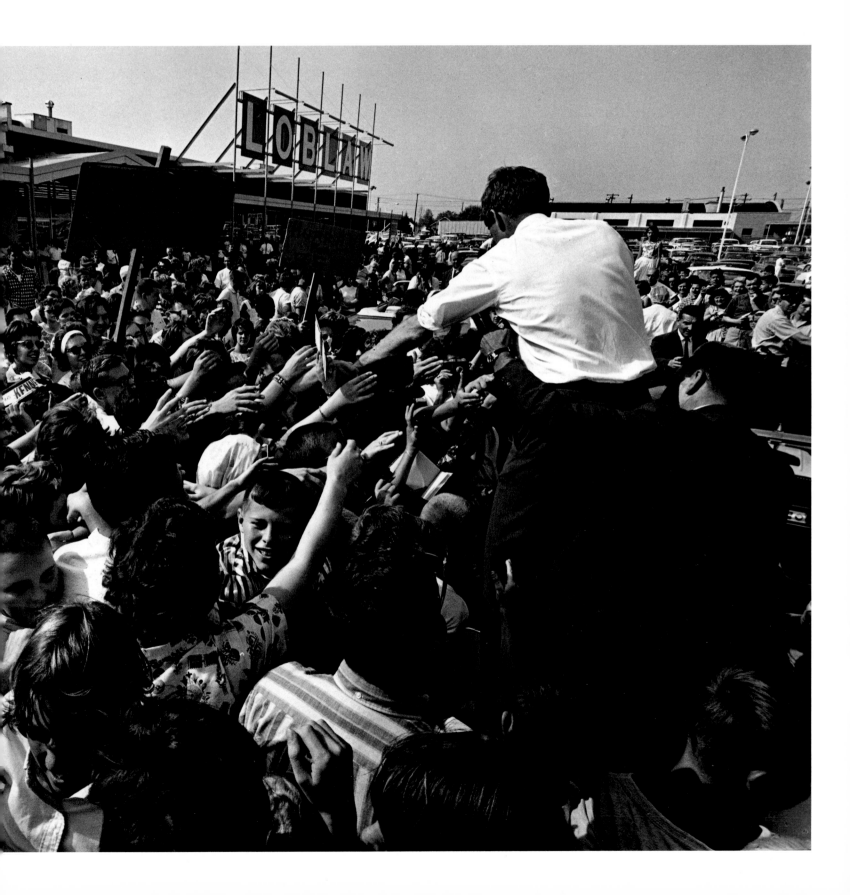

*87. Robert F. Kennedy
campaigning in Buffalo, 1964.

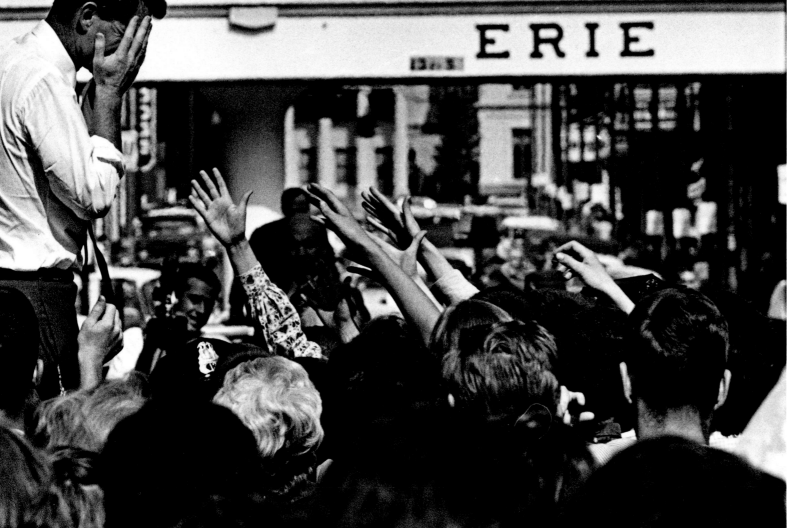

*88. Advisers of right-wing conservative presidential candidate Barry Goldwater, 1964.

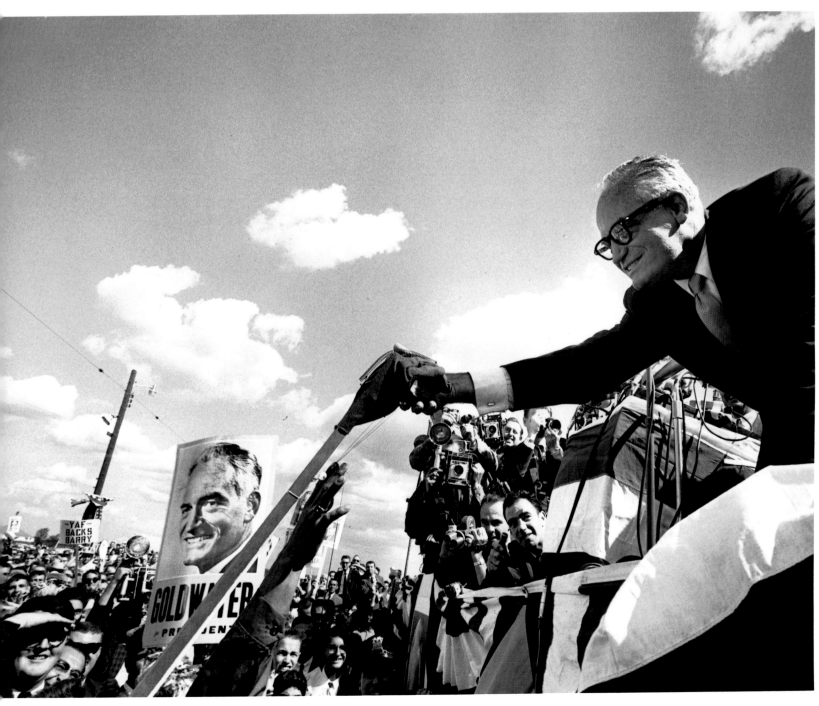

Senator Barry Goldwater campaigning for the presidency, Phoenix, 1964.

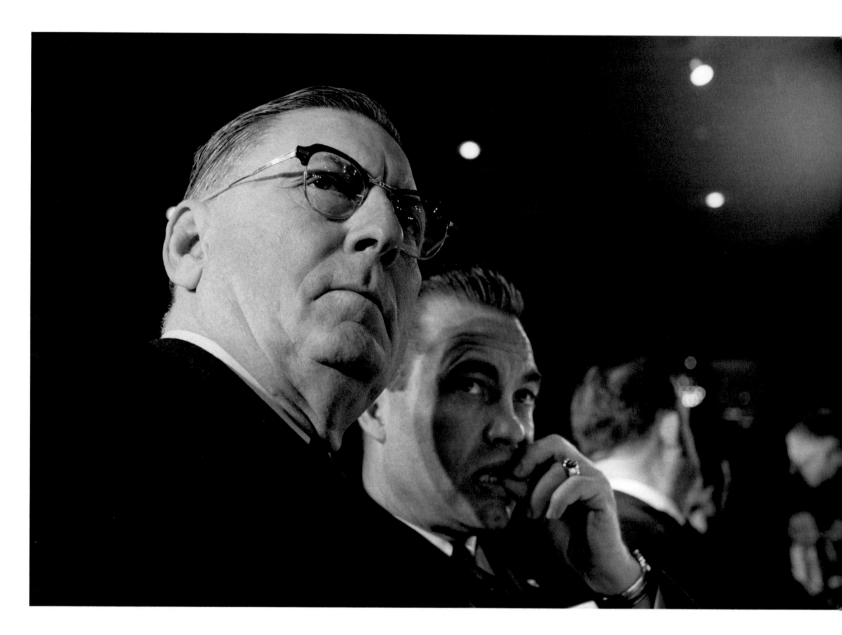

90. Senator Jesse Helms and Governor George Wallace listening
 to Governor Nelson Rockefeller, Republican Party meeting, 1964.

91. Nelson Rockefeller and a colleague, 1964.

92. Hubert H. Humphrey and his wife, Muriel, on his campaign plane during his successful bid for the vice-presidency under Lyndon B. Johnson, 1964.

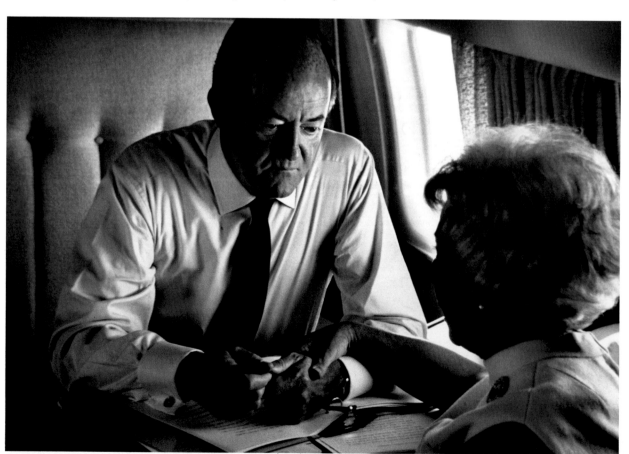

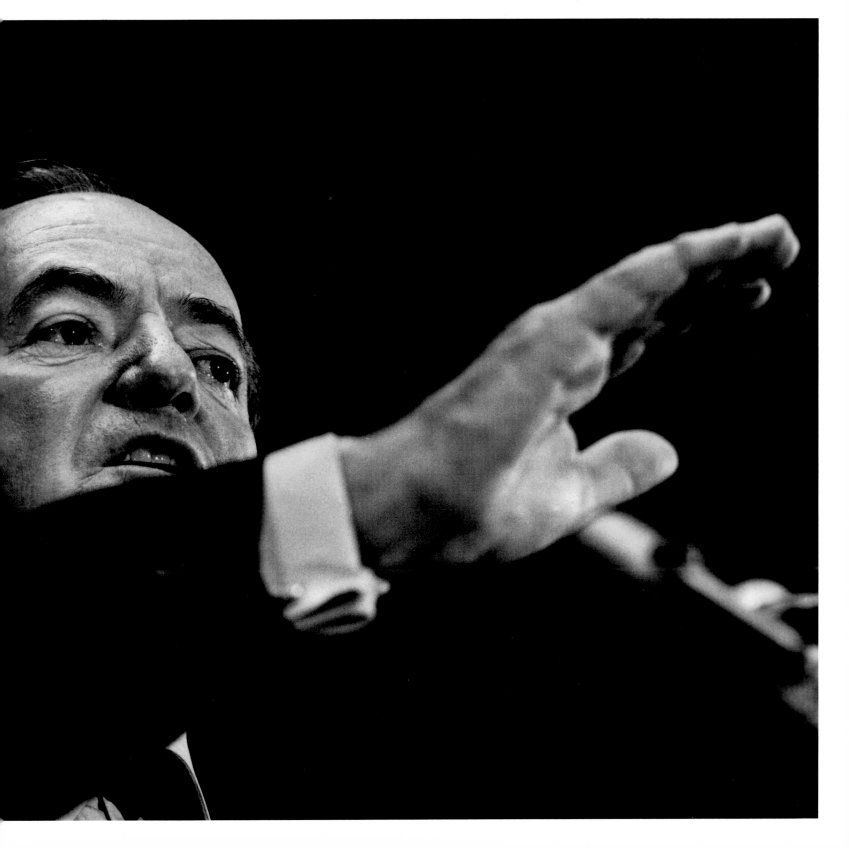

THE SOVIET UNION

I went to the Soviet Union in September 1958 to do a story about Russian Orthodoxy for *Life*'s ongoing series entitled "The World's Great Religions." Since the clergy in the Soviet Union wanted to demonstrate that they were not dominated by the government, they opened all doors to me. It was a unique opportunity to record the remnants of the faith among the predominantly elderly worshipers, the rich vestments, the singing of three-hour-long High Masses, and the life of the clergy, who fared so well under atheistic Communism that fifty thousand of them served some fifty million believers—one-quarter of the Soviet population.

Life already had Howard Sochurek as its resident American photographer in the Soviet Union. Since the agreement in those days stipulated that the admission of every accredited American correspondent or photographer to the USSR would require a Russian counterpart to be allowed into the United States in return, to accredit me would have caused quite an inconvenience to the magazine. Thus, I had to go on a tourist visa. That meant I wasn't eligible for any professional courtesies, and in a country that didn't even have telephone directories to enable one to call ahead to make arrangements, that was a very serious handicap.

In preparation for my trip, I reread the book that my brother and John Steinbeck had worked on together about their 1947 trip to the Soviet Union. It was not encouraging reading. Although they were honored guests, they had encountered many formidable obstacles—and Bob had managed to get very few decent pictures. I was soon to find out for myself that things hadn't gotten any better in the eleven intervening years.

Two problems were that I did not speak or read Russian and that at first I was assigned a different Intourist guide-interpreter every day. I was acting like a very strange tourist, haunting nearly empty churches and taking close-ups of priests in their fabulous vestments. I had to start over from zero with my explanations every morning, and so I never had time to win the confidence and cooperation of my guide. Finally, however, I managed to hold on to a young lady named Galina, a professor's daughter, who grew up knowing nothing about religion, who was fascinated by my behavior, and who liked her job because it enabled her to go right to the head of any line to buy things. When I told her about my assignment, she asked me why I would want to photograph anything as obsolete and insignificant as Russian Orthodoxy. "It is like an archaeological ruin," I explained to her. "I want to photograph it before it disappears completely." She accepted that.

I took with me to the Soviet Union a letter from the archbishop of the Russian Orthodox Church in the United States to the Metropolitan of Moscow, who gave me a laissez-passer. But even the Metropolitan's blessing wasn't enough to guarantee me access to all that I wanted to photograph. At the catacombs in Kiev where monks had been interred for centuries, the priest in charge would

not let me set up my lights. When I said that I would use dozens of candles instead, I could see the madness in his eyes as he ranted that I could never photograph this holy place, no matter what the Metropolitan had said. I then tried to force my way past him, but he responded by inciting the old women with whom the place was filled to riot. There was nothing I could do in the face of such fanaticism.

Late in October, Jerry Cooke, a photographer and a friend, arrived in Moscow with a copy of *Doctor Zhivago*, which had just been published in the United States. Only a few weeks earlier Boris Pasternak had been named the winner of the 1958 Nobel Prize for literature. I remember soaking for hours in a hot tub in the freezing bathroom of my suite in Moscow's Savoy Hotel as I read the novel. The only light came from a single bare bulb in the ceiling, ten feet above. The eerie setting was perfect for reading that book.

Of course, I wanted to meet and photograph Pasternak. Henry Shapiro, then the dean of American correspondents in Moscow, offered to have his son drive me out to the writers' colony at Peredelkino, where Pasternak had a dacha, a country cottage. It was an unforgettable day. Pasternak, a great spirit and a wonderful actor, spoke Shakespearean English. I photographed him sitting outside under the bare birches, and inside toasting his wife on her name day (plates 100, 101). It was all very Chekhovian. It turned out that we were the last foreign visitors allowed to see him. The Soviet government forbade him to go to Stockholm to accept his prize, and two years later he died.

In addition to my *Life* story, I had an assignment from *Harper's Bazaar* to photograph the Bolshoi Ballet School. One of the people who helped me the most while I was in Moscow was the NBC correspondent Edmund Stevens, whose daughter happened to be attending the ballet school. Although she was in no position to introduce me or to arrange for any special courtesies, she briefed me on what to expect and what to look for. I went to visit the school just as any tourist would do, but during the two hours that I was there, I shot what was to become the best-known picture of my career: dancers practicing at the bar in front of a large and elegant mirror (plate 103).

My time in the Soviet Union was truly a strange interlude. I was not mistreated in any sense, but the atmosphere, the gray sky, the penetrating cold, the somber mood of the people, the style of life, the belligerent and suspicious hostility to the foreigner with a camera, all contributed to a depression I never experienced anywhere else in all my travels.

I have never felt more liberated or relieved than I did when I finally left the Soviet Union. My six weeks there had been the most miserable time of my life. I had felt that I was constantly fighting a losing battle. And yet, despite all, I got more good pictures in those six weeks than during any other comparable period in my entire career.

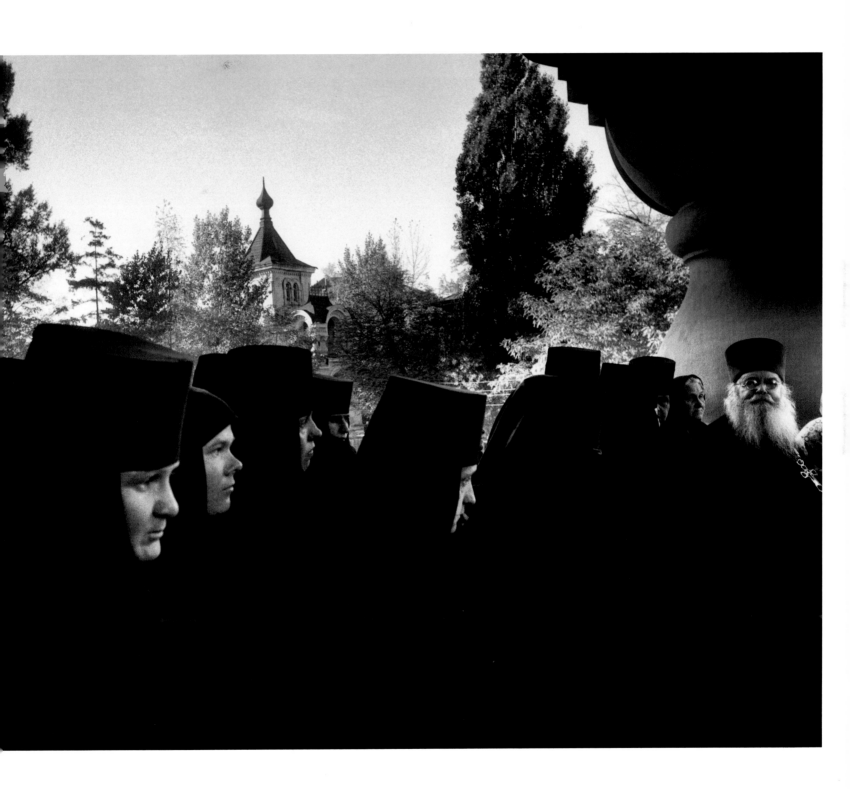

Russian Orthodox nuns and priest, Zagorsk, 1958.

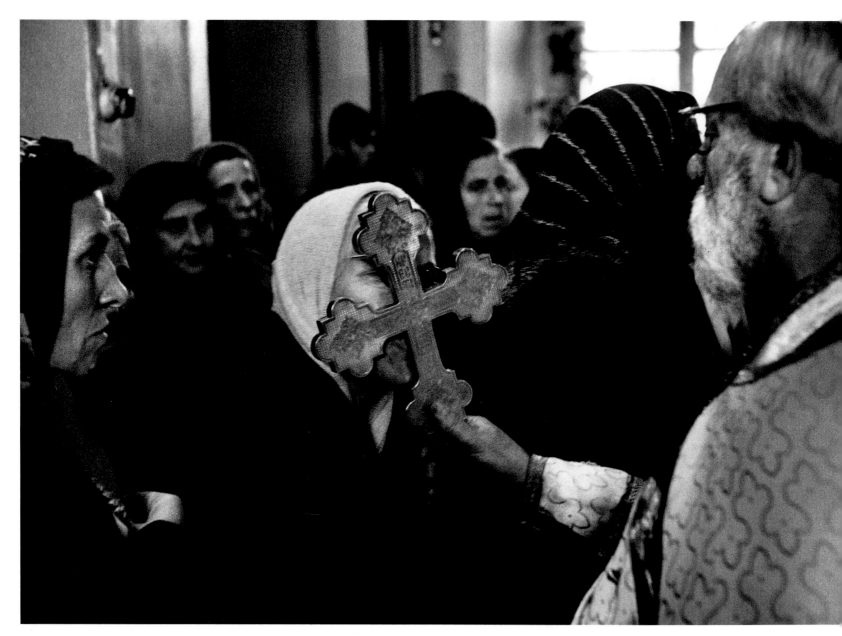

95. Russian Orthodox service, Moscow, 1958.

96. Zagorsk, 1958.

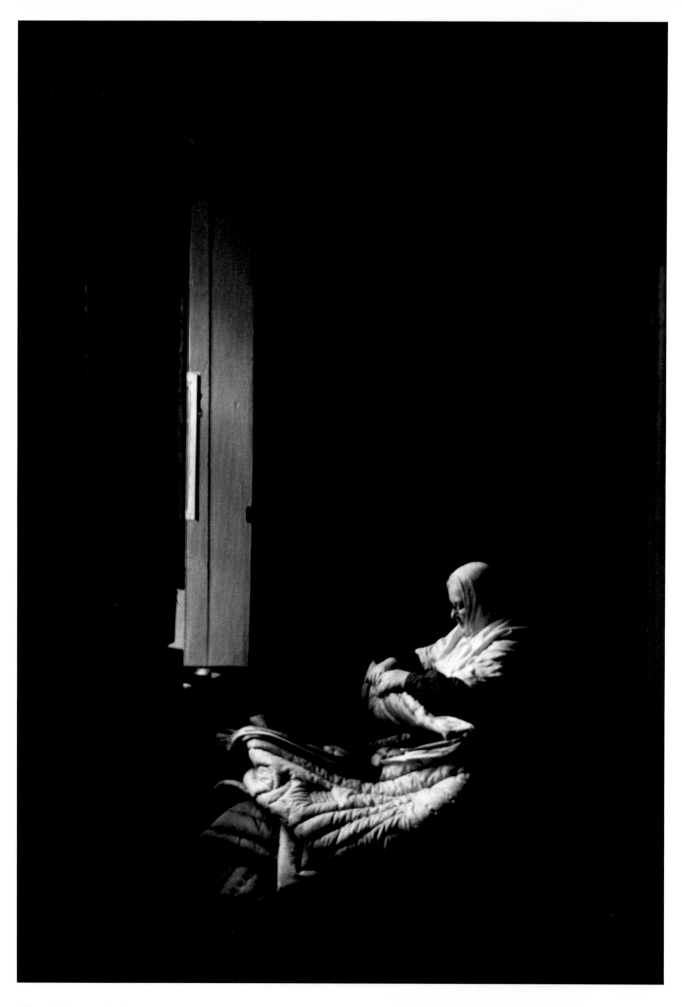

97. A Russian Orthodox nun sewing in a convent, Zagorsk, 1958.

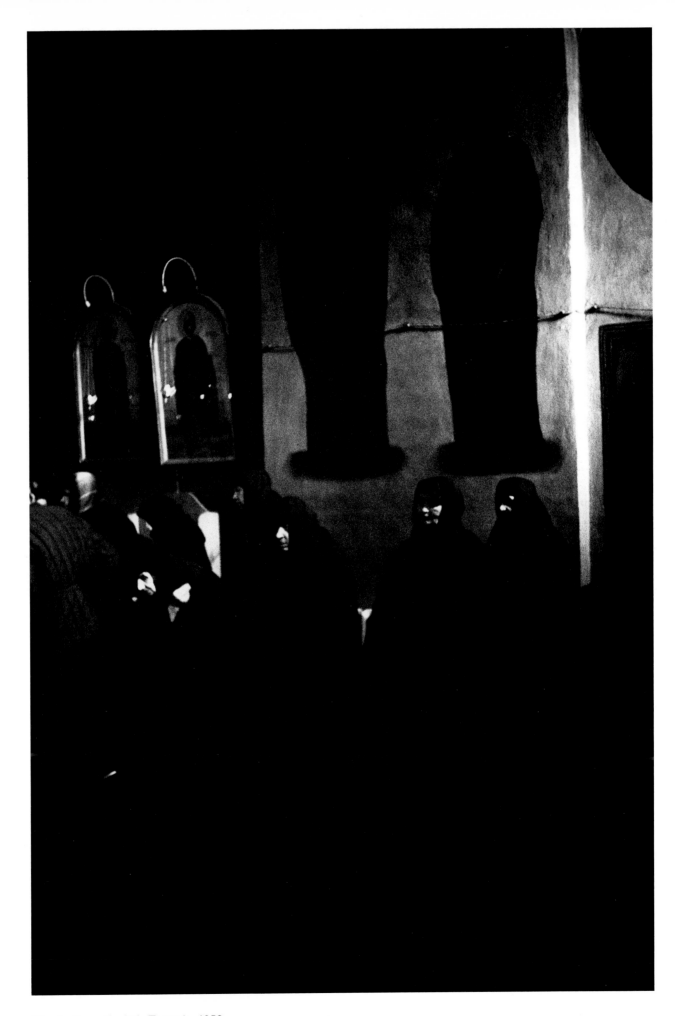

98. In the cathedral, Zagorsk, 1958.

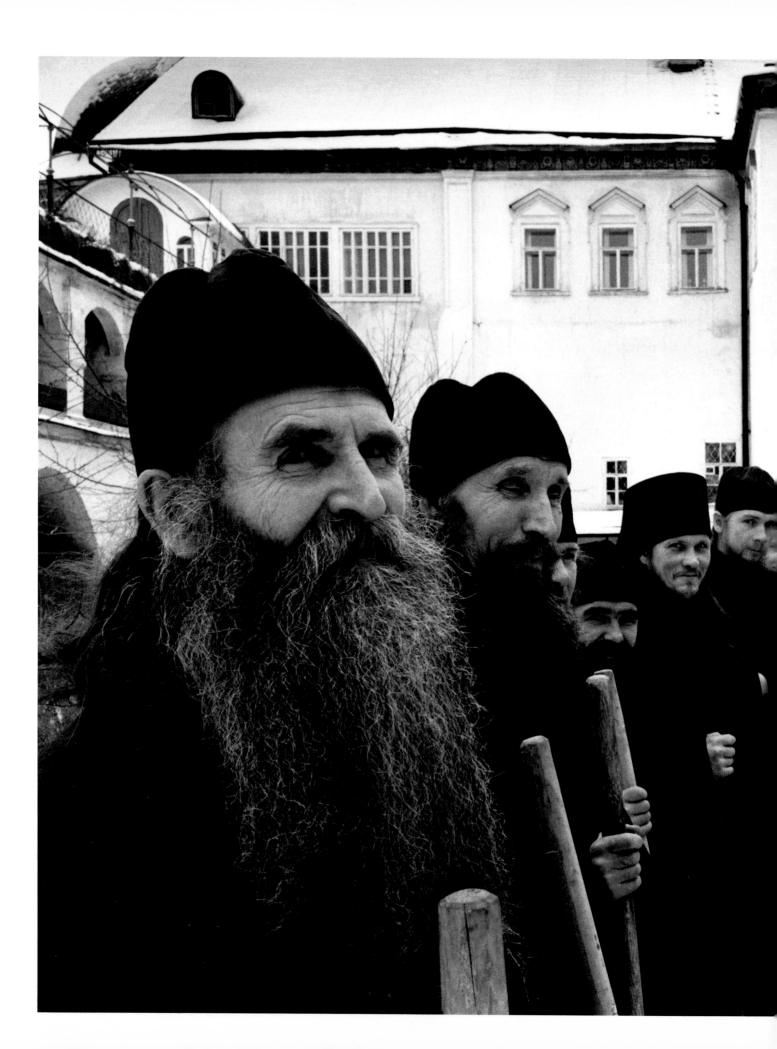

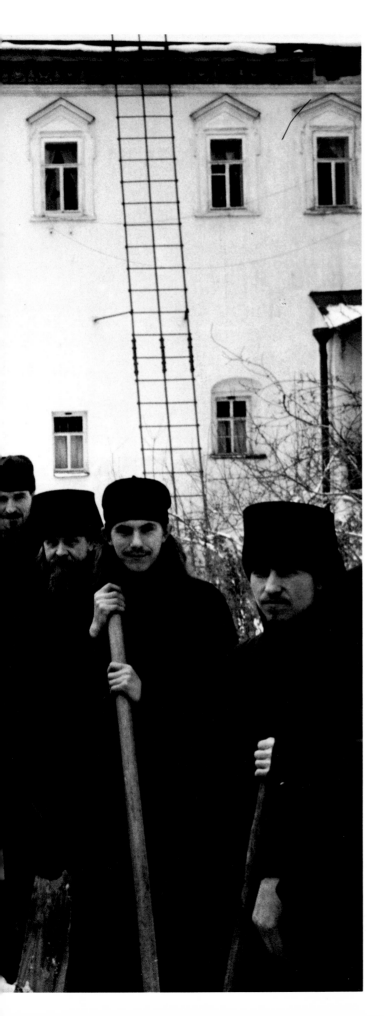

99. Russian Orthodox monks, Zagorsk, 1958.

100–101.
Boris Pasternak at his country
house in Peredelkino, 1958.

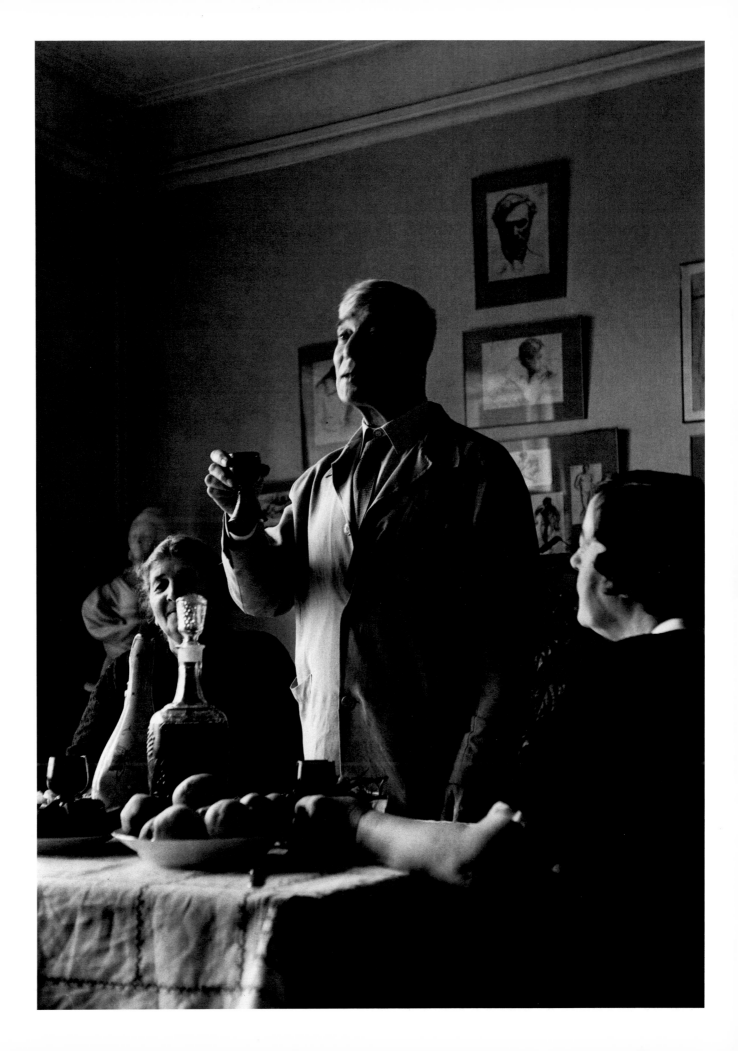

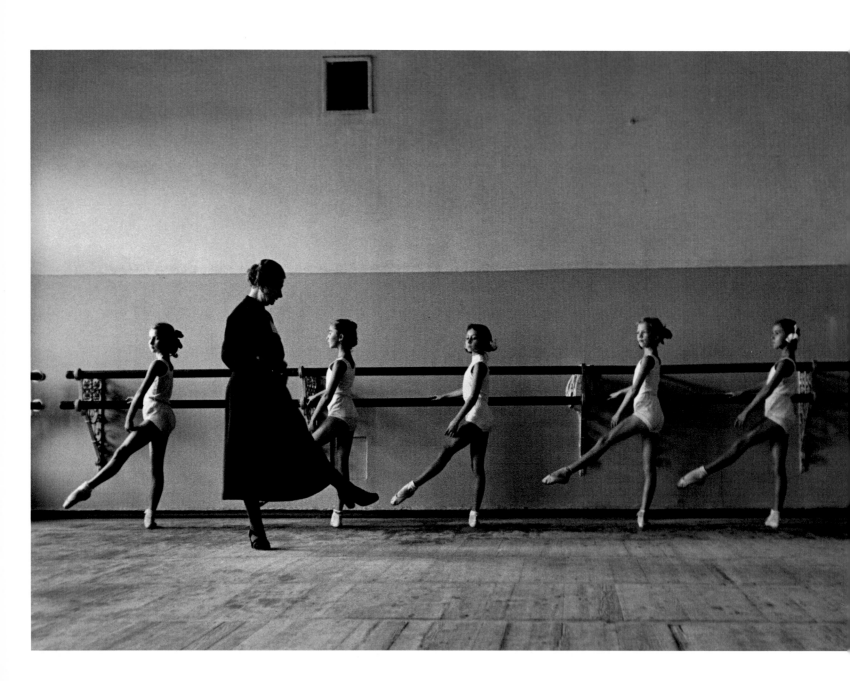

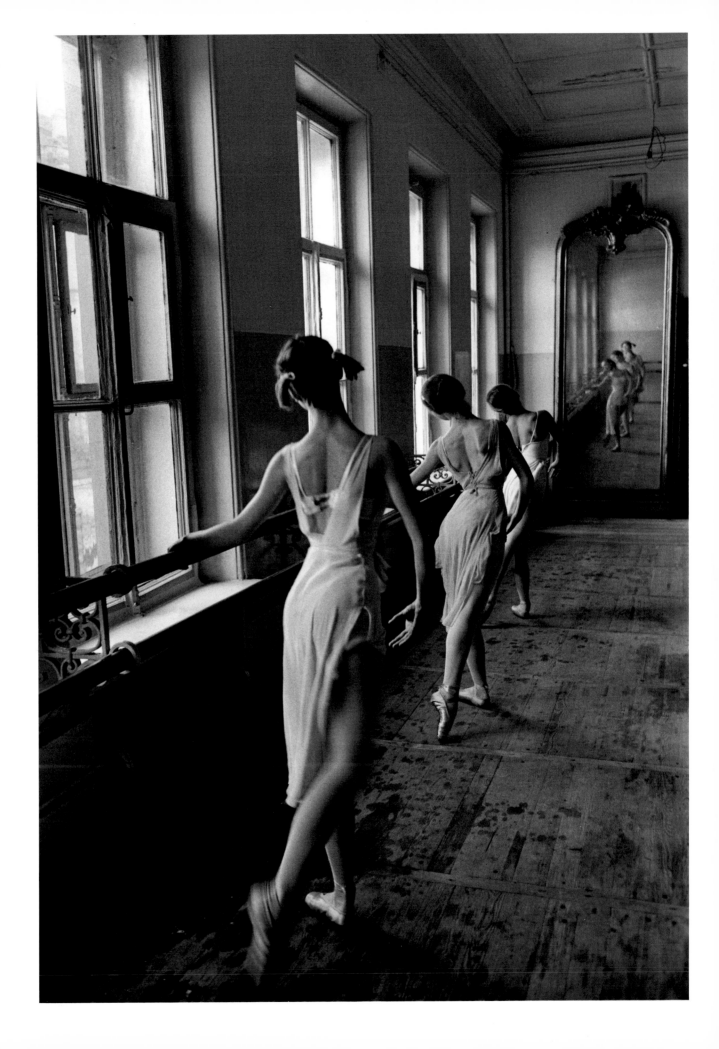

JUDAISM AND ISRAEL

During the 1950s *Life* was on a jag of doing ambitious series, including "The World's Great Religions." In 1954 the editors were ready to tackle Judaism and assigned the task of making photographs for the story to Alfred Eisenstaedt and myself, both of us completely nonpracticing Jews. In Budapest I had attended the predominantly Protestant Evangelisches primary school and the Imre Madách public gymnasium, where a rabbi came in once a week to give Hebrew lessons to the handful of Jewish students. Because my parents kept him supplied with his favorite cigars from Vienna, he was so lenient that I barely managed to get through my bar mitzvah. In the nine months of working on the *Life* story, I was to learn far more about my Jewish heritage than I had at any previous time in my life.

Coming soon after my brother's death, my work on this story not only brought me much professional satisfaction but also put me in touch with my religious roots at a time when I needed them.

Eleven years later, in 1967, I made my first visit to Israel. My brother Bob had many friends there, people he had met and photographed between 1948 and 1950, when he covered the founding and the early progress of the state of Israel. Also in Israel were some of my distant relatives, people I knew of but had never met.

I arrived in Tel Aviv a few hours before Passover was to begin. I had the great plan of spending the holiday at a kibbutz near the Israel-Lebanon border. All the family and friends met me at the bustling airport, and after the kisses I was given the keys to a rented car and told, "Lebanon is that way. This is the name of the kibbutz where you will spend Passover. We are so happy that you're here." Then they all hurried home to their holiday preparations. That was my introduction to Israel, where I, a Jew who spoke neither Hebrew nor Yiddish, found myself a true foreigner.

I had gone to Israel with the intention of doing a book showing the nation in its twentieth year of peace. By May 1, about two weeks after my arrival, it was evident that there was going to be war, not peace. The war would probably not break out for another couple of weeks, since the United Nations secretary-general, U Thant, was conducting negotiations in New York. Nevertheless, war seemed inevitable in the very near future.

One war photographer was quite enough for my family. But I felt that, in good conscience, I simply couldn't leave; I would have to stay on and break my vow against war photography. And yet I needed to leave for a few days. I had revised the concept of my story to a report on the last month of peace, and I had to sell the idea to *Life*. For various reasons I felt I could only do that in person in New York. But I didn't want to seem to be fleeing when war threatened. My Israeli friends told me not to worry. I could almost certainly get back to Tel Aviv before the war broke out, and even if it started before my return, the Tel Aviv airport always remained open in wartime. So home I went.

I spent the weekend editing my work. On Monday I presented it to the foreign editor at *Life*, who was bored with the whole idea. "They ain't shooting yet," he told me and promised me a mere two pages for my story. I flew back to Tel Aviv the next day.

By this time it was the end of May, and fighting still had not broken out. I had arranged to cover the war together with Micha Bar-am, a young man who had won an award established in memory of my brother and Chim and who was the official photographer for the Israeli army magazine. Micha would be notified immediately if war broke out.

For seven days, amid heavy war threats, all packed and ready to go, I slept on Micha's couch. But by Saturday, June 3, there was still no war, and the threats seemed less urgent. So I went back to my room at the Hilton to luxuriate in a hot bath and to sleep. I wouldn't be setting foot outside my room for the rest of the weekend, so I sent my only pair of sturdy shoes out to be fixed. Micha had decided that he didn't want us to go out to the front in his car and had asked me to reserve a Hertz car—but there would be time for that on Monday.

At sunrise Monday morning Micha's voice on the phone said, "It's on." My first thoughts were: "Oh, my God! My shoes! My car!" Once we had taken care of both the shoes and the car, we headed out toward Beersheba on the road to Suez and crossed into Egypt, but we kept getting stuck in the sand dunes that the wind blew onto the two-lane road. Behind us were tanks heading for Suez, and coming toward us were the first ambulances already carrying wounded men back from the front. Finally we decided that we wouldn't get very far in our crummy rented car and that we should turn back to Beersheba, where Micha said he knew a general who would give us a jeep.

When we reached Beersheba, of course we couldn't get a jeep, and the radio was reporting that an attack on the Old City in Jerusalem was in progress. So we decided to forget about Suez and head for Jerusalem. In spite of our best efforts to reach Suez, we had found ourselves forced to go to Jerusalem, which turned out to be the most important story of the war—the Six-Day War.

My ill-conceived introduction to Israel was a real God-given gift. Micha Bar-am was my guardian angel, and saved my life probably even more times than I realized. I did get some good photographs, but it was ultimately more important to me that my understanding of the Middle East was greatly increased and that I established some wonderful and enduring friendships. Eventually, through ICP, I was able to organize a number of exhibitions at the Jerusalem and Tel Aviv museums that made far more of a contribution than my intended book on the twentieth year of peace ever could have made.

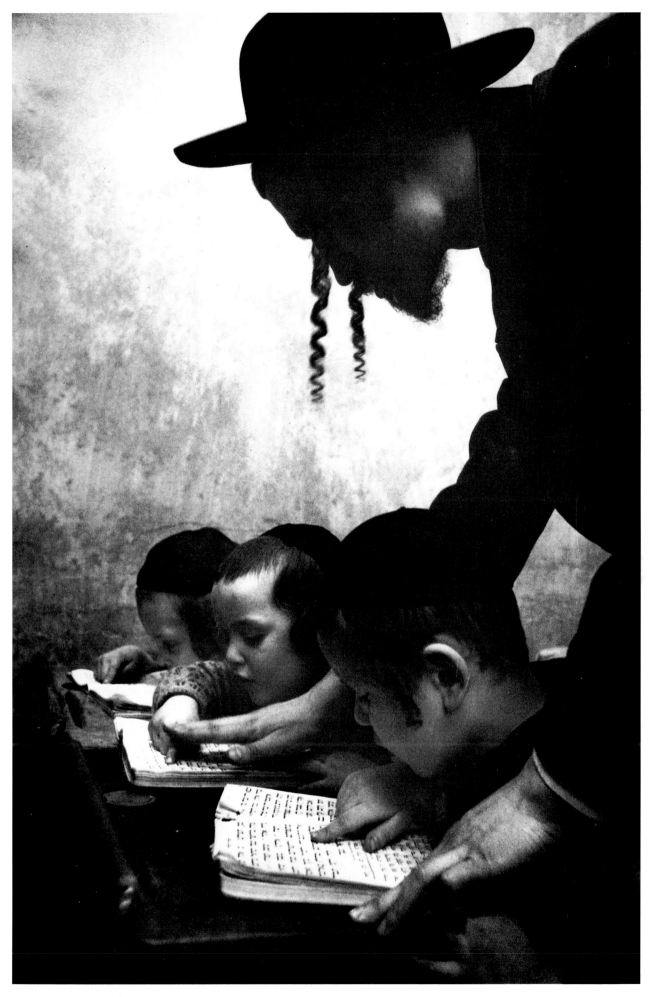

*104. Hebrew lesson, Brooklyn, 1955.

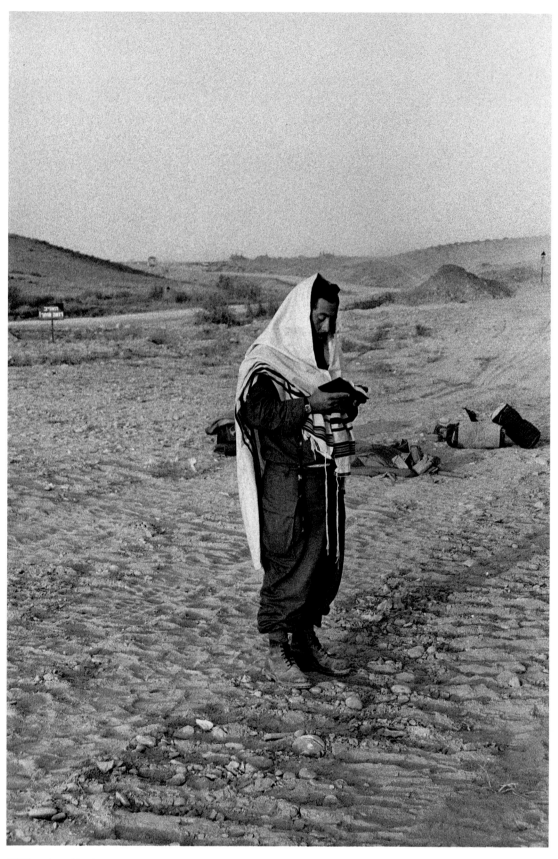

*105. A soldier's early morning prayers during
the Six-Day War, Negev Desert, 1967.

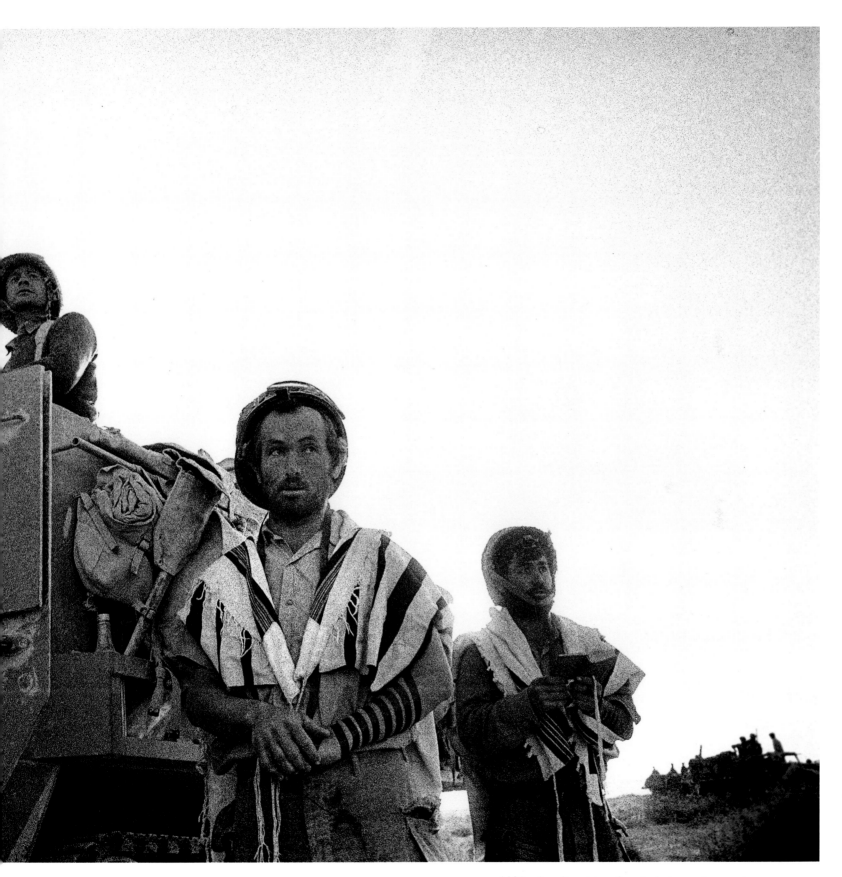

*106. Israeli antiaircraft unit during early morning prayers,
in the midst of the Six-Day War, Sinai Desert, 1967.

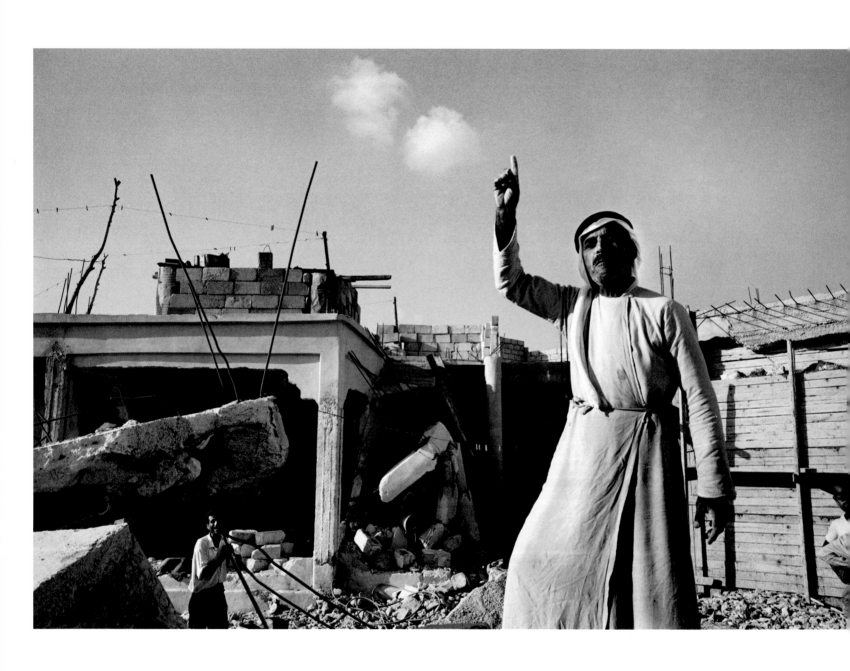

*107. A Palestinian Arab, enraged at the Israelis for
having destroyed his house during the Six-Day War, 1967.

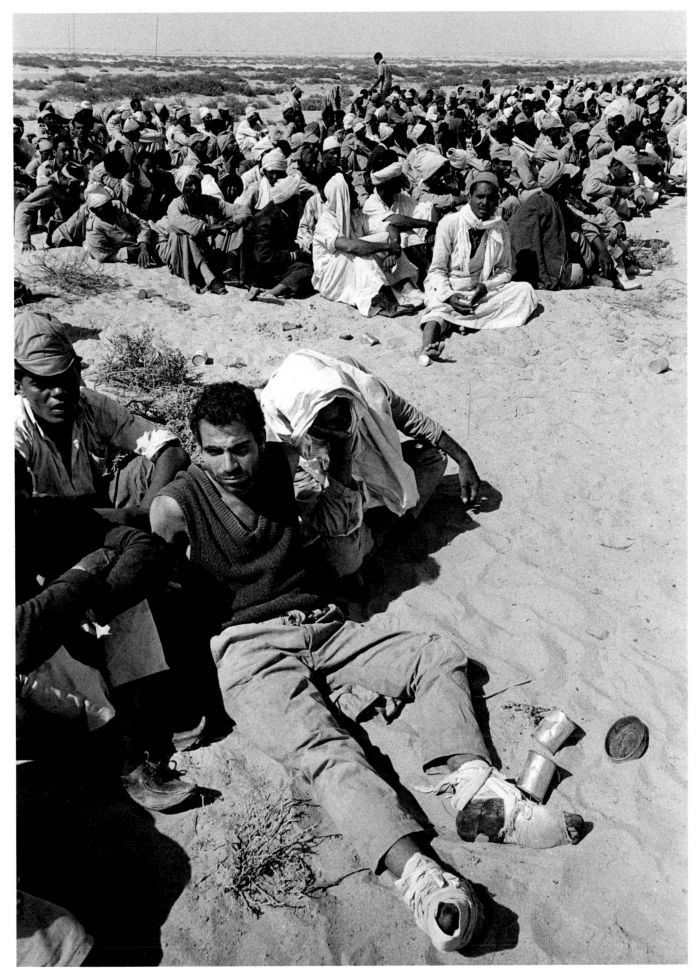

*108. Egyptian soldiers captured by the Israelis,
El Qantara, on the east shore of the Suez Canal, 1967.

109–110. Palestinian Arabs who have fled to Jordan during the Six-Day War,

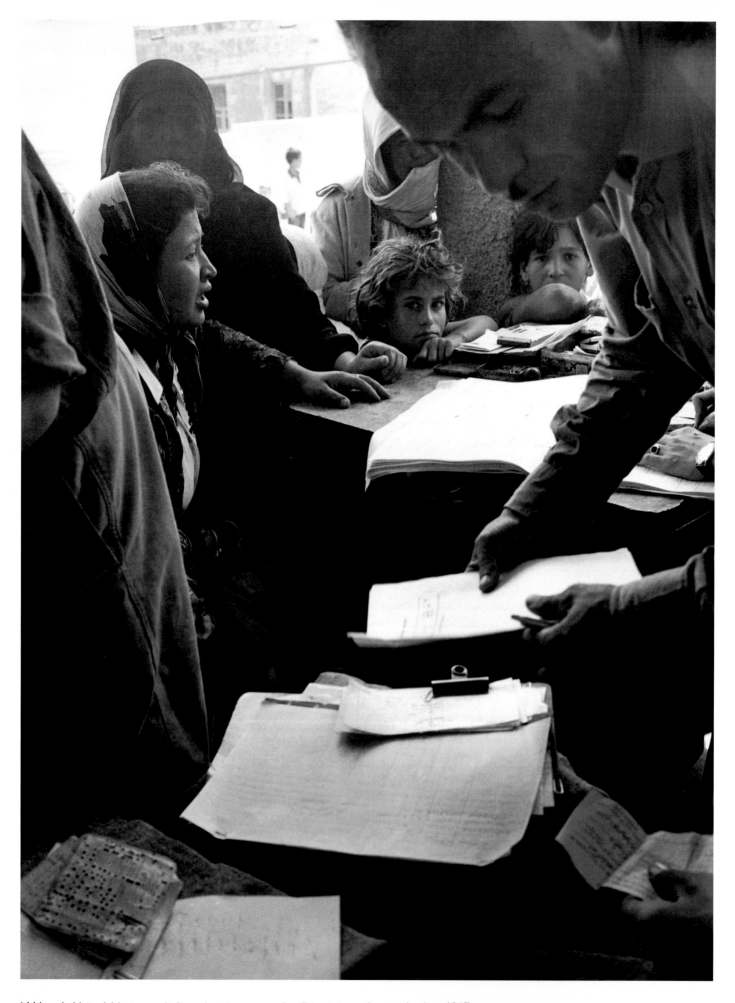

*111. A United Nations relief worker in a camp for Palestinian refugees, Jordan, 1967.

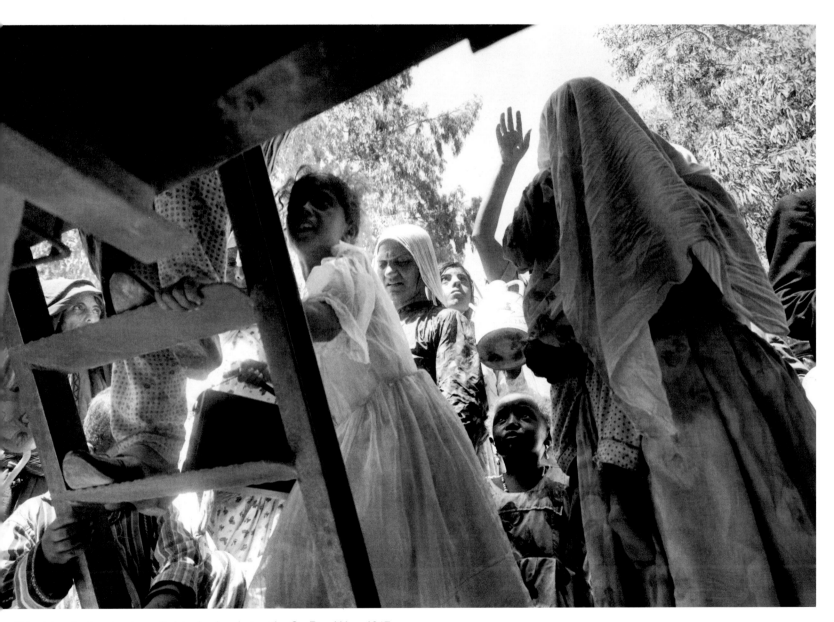

Palestinian Arabs who have fled to Jordan during the Six-Day War, 1967.

THE MENTALLY RETARDED

The most wonderful thing about being a photojournalist is that it enables one to undertake journeys into regions, whether geographic or sociological, that one probably wouldn't or couldn't visit otherwise. Since the costs of doing a book-length photographic essay on one's own were too great, and the audience for such books too small, magazines were the great patrons and disseminators. If I could sell the editors an idea—and the appetite of a weekly magazine for interesting ideas and unfamiliar subjects was enormous—then a *Life* assignment would give me a passport to almost any corner of the world, as well as pay my expenses. And working for *Life*, with its millions of readers, gave us photographers the hope that, if our stories were good enough, we could effectively shape public opinion and bring about real change for the better. Our role was not to be voyeurs or neutral observers; we had no interest in standing by helplessly. We believed that photojournalism was a powerful and positive force. Our work would illuminate the dark corners of humanity.

In 1954 mentally retarded people were still largely sequestered in one such dark corner. On those rare occasions when a magazine might publish a photograph of one, a black mask was always superimposed across the eyes—both to spare the family embarrassment and to spare the reader discomfort. Retarded children were never shown with their parents, again because of supposed guilt or shame. But the climate was changing; many parents were finally realizing that there was nothing to be ashamed of—and, indeed, when I began working on my story, I was surprised and pleased to discover that parents often cared more about a retarded child than about their other children. And so my story became one not only about helping retarded children and young adults to develop skills but also about mutual pride, joy, and love.

I focused on a number of retarded children and young adults in the hope that I could capture the spirit of these wonderful people on film and thereby move *Life*'s readers. One of my favorite sequences of pictures shows a therapist at Flower–Fifth Avenue Hospital in New York City, helping a child to learn to speak (plates 114–116). I loved watching this woman, who obviously loved the children she worked with as much as if they were her own. She coaxed and encouraged this child lovingly and patiently at every step, calling upon his imagination to get the desired effect. "Pretend you're blowing out a match," she instructed. And when the child succeeded, she was delighted and full of praise. "You see, you did it!"

Another of my favorite pictures from this project depicts the teaching of a basic concept. It shows a doctor trying to convey the understanding that pulling the cord is what makes the light go on (plate 117). The nine-year-old girl could not utter a word and essentially lived isolated in a dream world. However, after the doctor had pulled the string many times, she seemed to catch on and finally began to pull it herself. There is a connection between the string and the light!

There were many other success stories. One involved a young man named Robert, who had learned a trade in the bakery of the progressive Southbury Training School, in Connecticut, where retarded children and young adults lived in a familylike environment in comfortable cottages. At eighteen Robert was ready to take a job in the outside world as a baker's assistant. I accompanied him as he began his journey. Wearing a new suit that the school had given him, he moved into his brother's house in Waterbury. The first thing he did when he arrived was to pick up his little nephew and give him a loving hug (plate 119).

Although I focused on progressive schools for the retarded, I also visited a New York State institution (Letchworth Village, in Thiells) where the children were simply taken care of but not really helped to develop. The parents who put their children in a place like this rarely visited. The institution was very nervous about my photographing. They didn't want anything on record and made it difficult for me to get much more than a symbolic shot, in which the patients, silhouetted, are unrecognizable (plate 113).

My editors were enthusiastic about the pictures and gave the story so many pages that it had to be published in two parts, in two successive weeks. Together with Maya Pines, the young *Life* medical-story researcher who had been working with me, I eventually expanded the story into my first book, *Retarded Children Can Be Helped*. That theme came as a revelation to many people, who had thought that the retarded were hopeless and could only be "warehoused" in institutions. But here was visual evidence that these people were sensitive, loving human beings who could learn and lead productive lives.

Despite my story's optimism, it has a sad personal association for me, since it was while working on it that I learned my brother had been killed in Indochina.

113. At a state institution for the mentally retarded, Letchworth Village, Thiells, New York, 195

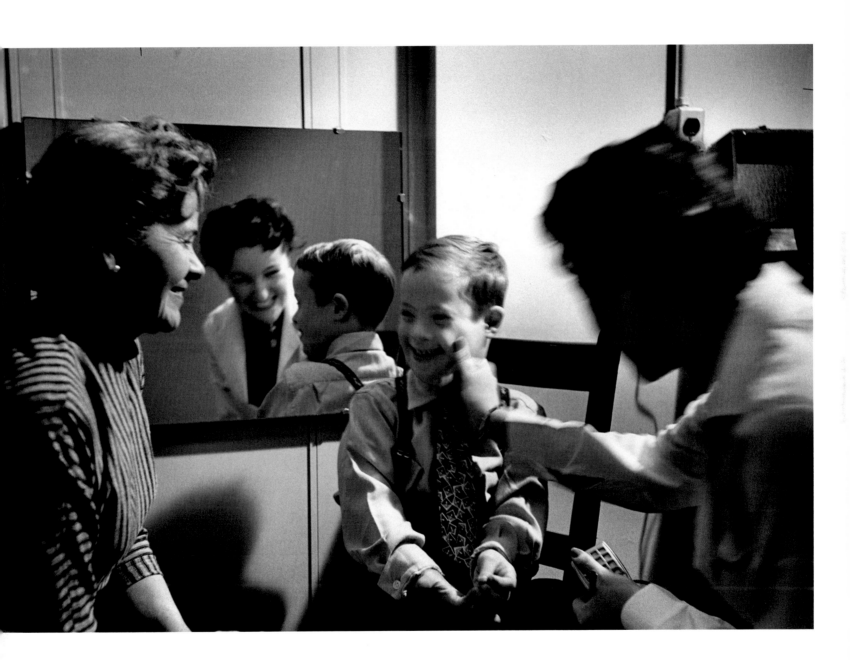

-116. A therapist working with a retarded boy, New York, 1954.

117. A doctor trying to teach a nine-year-old girl that
pulling the string makes the light go on, New York,

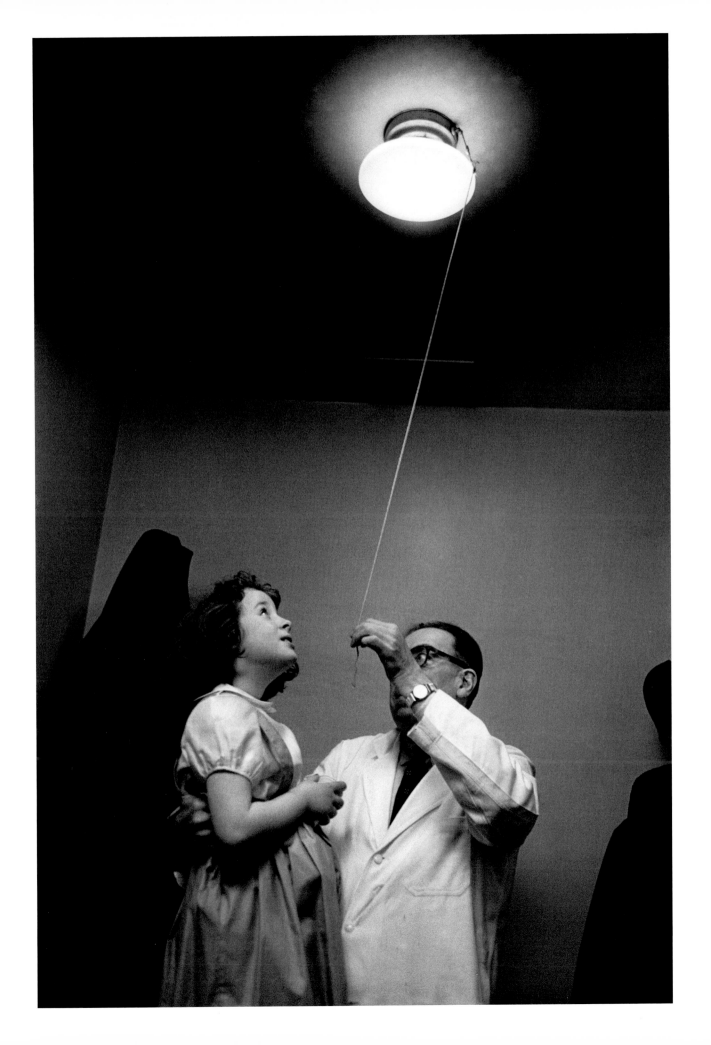

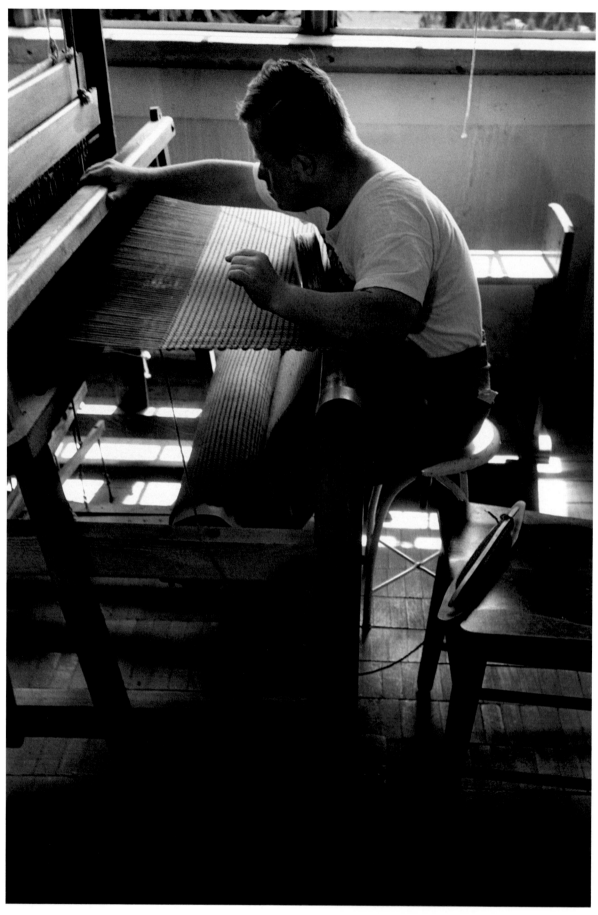

118. A young retarded man learning to weave at the progressive Southbury Training School, Connecticut, 1954.

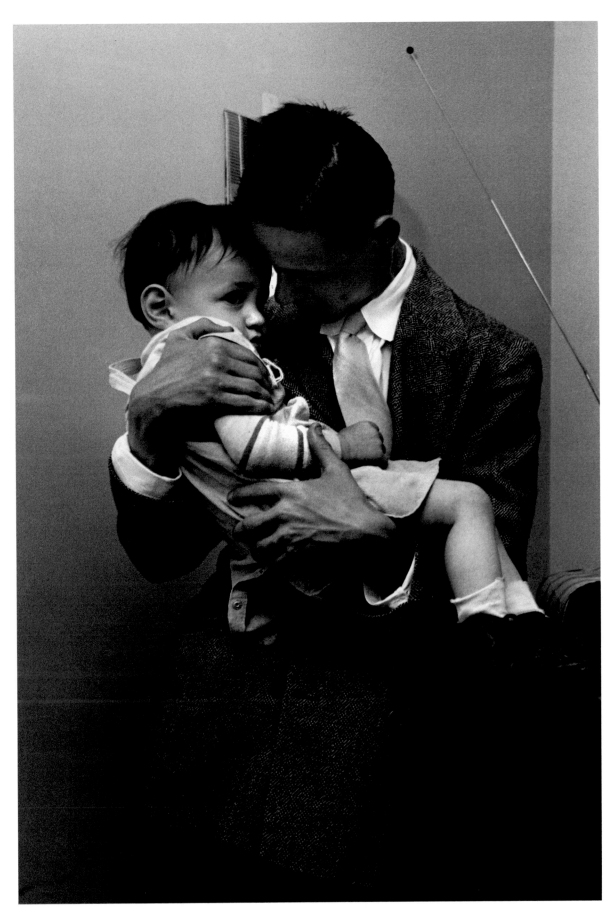

119. A young retarded man arriving at his brother's house, where he would live
 while he worked at his first job, Waterbury, Connecticut, 1954.

INDIANS AND MISSIONARIES

Hungary has no jungles and no Stone Age tribes. My only acquaintance with tribal peoples came from having read James Fenimore Cooper in a Hungarian translation as a boy. Thus a totally unfamiliar world was thrust upon me in January 1956 by a six-line Associated Press report stating it was feared that five American missionaries had been killed in the Ecuadorian jungle by the Indians they were trying to convert to Christianity.

I had only recently returned to New York to spend Christmas with my family, after six months of work in Latin America. My cameras were being cleaned. But when *Life* called to ask whether I was interested in going to Ecuador to follow up on the AP story, I replied without hesitation, "Yes!" So began one of the most extraordinary adventures of my life.

When I arrived at the airport in Guayaquil, in western Ecuador, I was told that the dead missionaries had been found and their bodies flown to Panama. If that was true, then I was too late and there was no more story. But my reporter's instincts told me that having come this far, I owed it to myself to verify the rumor. I asked about transportation to the missionary base at Shell Mera and was told that the only plane going there for some time was an American military transport that was leaving in a few minutes. Luckily, before I had left the States, my friend Jerry Hannifin (an expert on aviation and Latin America who was a *Time* correspondent based in Washington) had used his influence at the Pentagon to get orders cut that would allow me to fly on U.S. military planes in Ecuador, just in case. Before I boarded the transport in Guayaquil, I made a reservation for my return flight to the States for the following Wednesday, so that I would reach New York in time for the *Life* deadline.

It was quite a week. I got my story, which involved an eerie helicopter flight into the jungle along the Curaray River, where we found the bodies of the missionaries, floating facedown in the water, their backs bristling with spears. After an absolutely incredible series of the most improbable connections—which seemed simply too amazing to be mere luck—I made my return flight. The missionaries with whom I had spent the week insisted that it was all a matter of divine guidance. They said that I had clearly been sent by the Lord, who was using me to tell this story. By that time I was beginning to think they might be right. It was certainly my most rewarding assignment, and *Life*'s readers responded with a deluge of enthusiastic letters.

That trip began my long involvement with missionaries and tribal peoples. It seemed a strange role for me, a nonobservant Hungarian Jew. And yet there was a certain logic to it all. I had gone from the Evangelisches School of my Budapest boyhood to evangelists in South America.

I had somewhat mixed feelings about the intrusion of the missionaries, for I greatly admired the beauty, the grace, and the self-sufficiency of the tribal peoples' Stone Age life. And yet I understood that the modern world was rapidly encroaching upon them no matter what, and if that contact was to be made, the missionaries were the best people to make it. They at least could give the tribes the education and the skills they would need to cope with the less benign influences—the poachers, exploiters, traders, and developers—that would inevitably soon confront them.

I felt that it was essential to make a photographic documentation of tribal life, as untouched as possible by modern civilization, before that life was eradicated forever. I also wanted to show the world the tragic disruption of that life, as tribal peoples were transformed into pittance-earning peons, cheated by unscrupulous traders, and seduced by the call of cities with which they were unprepared to deal. My entrée came through Sam Milbank, a Wall Street financier who was not himself a religious zealot; he helped the missionaries but was not of their ilk. He introduced me to the anthropologist Matthew Huxley and gave Huxley and me a grant to do a book about the Amahuaca tribe of Peru, which was still living its traditional life. Robert Russell of the Wycliffe Bible Translators was living with the tribe, engaged in learning its language, writing it down, and translating the Bible into it. Russell agreed to take us on.

I was enthralled by the beauty of the Amahuacas' life (plates 127–131). It seemed to me that they were still living in the Garden of Eden. They were totally adapted to their environment and lived in harmony with it. I had equipped myself for the expedition with rubber-soled shoes from Abercrombie & Fitch, but they were not nearly so good for crossing log bridges as were bare feet with curled toes. I quickly learned that my cameras were safest when I let the Amahuacas carry them. My greatest frustration was that I could not communicate directly with these remarkable people. I would have liked to spend four or five years photographing them through the cycle of the seasons, making a permanent record of their life and rituals before they vanished—as it seemed likely they would, within another generation or two. The Amahuacas seemed to be a people on the verge of having to say farewell to Eden, the title that we gave our book. But it simply wasn't possible for me to stay. I too had to say farewell to Eden. So I coached Robert Russell in photography, and he provided many wonderful pictures to complement my own.

My experiences with the tribal peoples of Latin America changed my view of life. I became fascinated by the universality of human responses. In the early 1960s, after having returned from one of my many trips to Latin America, I embarked on a long project of photographing American "tribal" rituals, which, with my new perspective, seemed no less exotic or primitive than what I had seen in the jungle.

*120. Expedition to locate missionaries who, it was feared, had been killed by the Indians they were trying to convert, Ecuador, 1956.

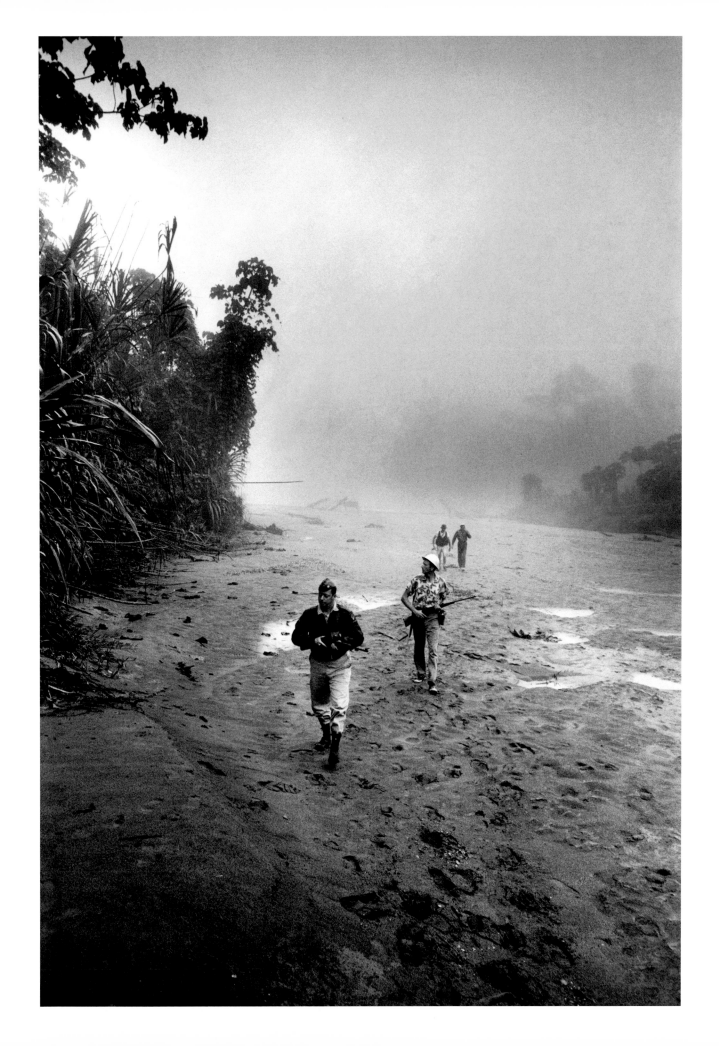

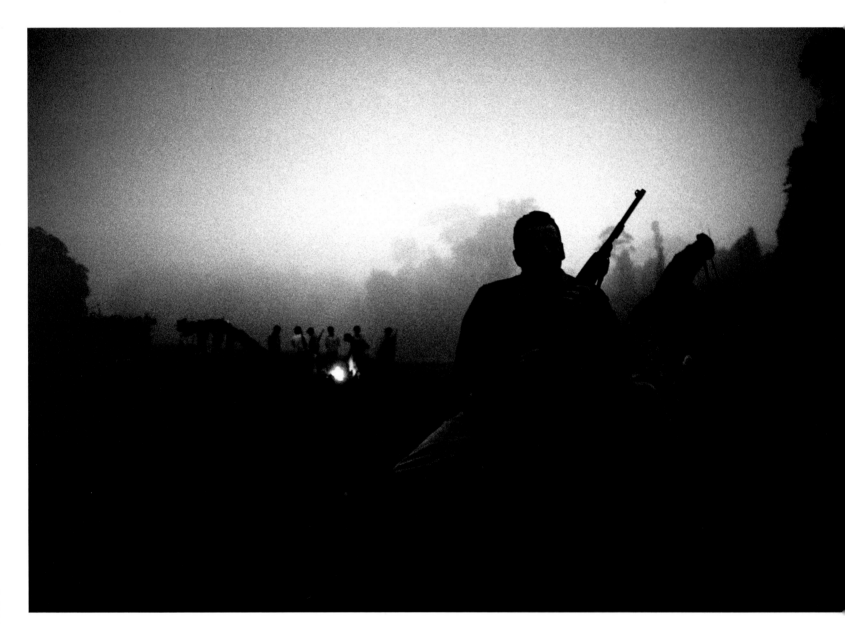

*121. Expedition to locate missionaries, Ecuador, 1956.

. Women listening to an account of the expedition that
located the bodies of their missionary husbands, Ecuador, 1956.

123. Elisabeth Elliot, the widow of one of the missionaries, Ecuador, 1956.

124. Dee Short, a missionary who had gone on the expedition to find the bodies of his dead colleagues, Ecuador, 1956.

*125. A man of the Atshuara tribe and a missionary pilot, Ecuador, 1957.

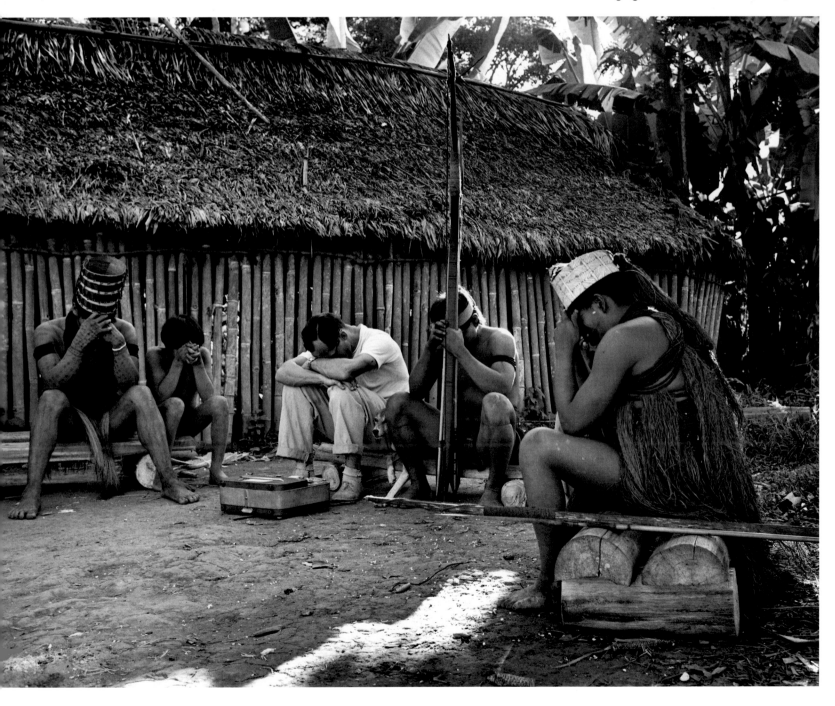

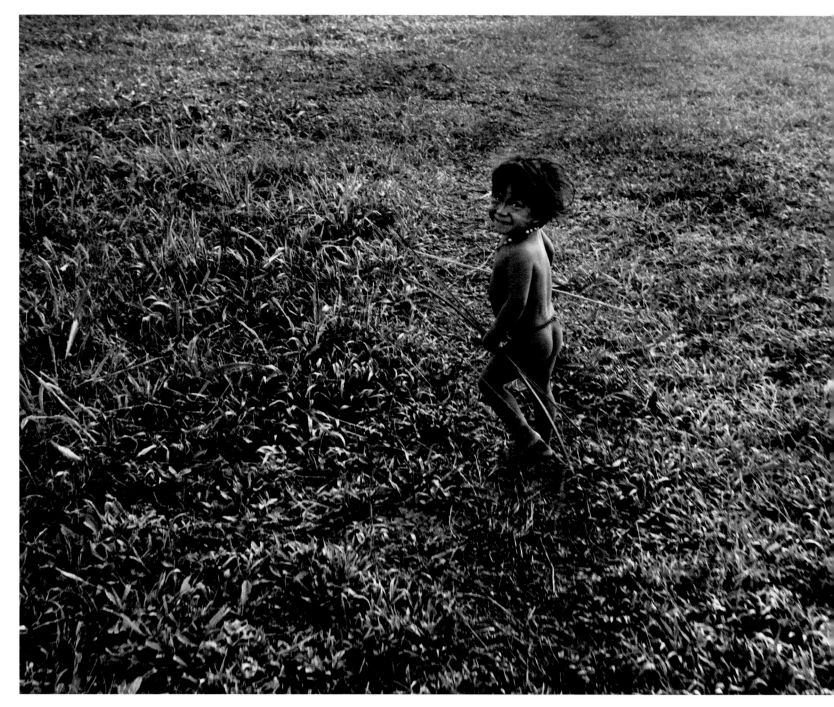

127. An Amahuaca boy, Peru, 1963.

*128. An Amahuaca family, Peru,

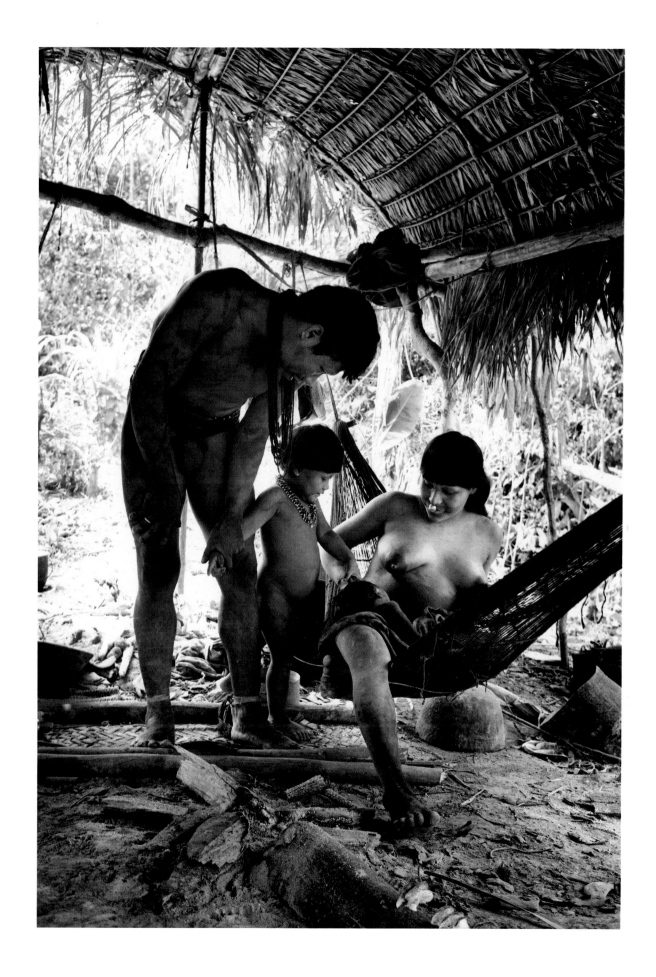

130. Amahuaca children, Peru, 1963.

129. An Amahuaca boy named Pansitimba, Peru, 1963.

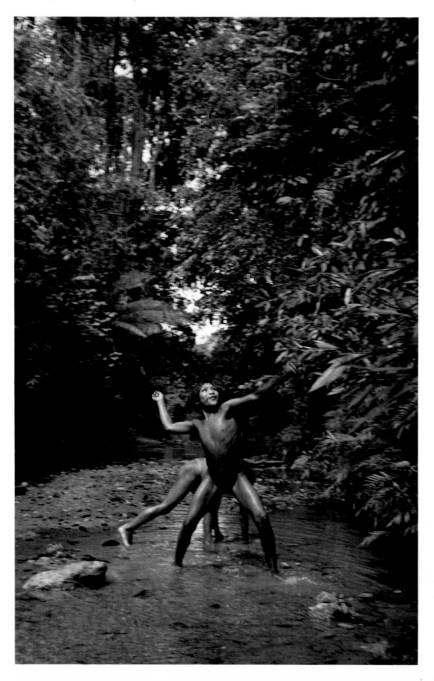

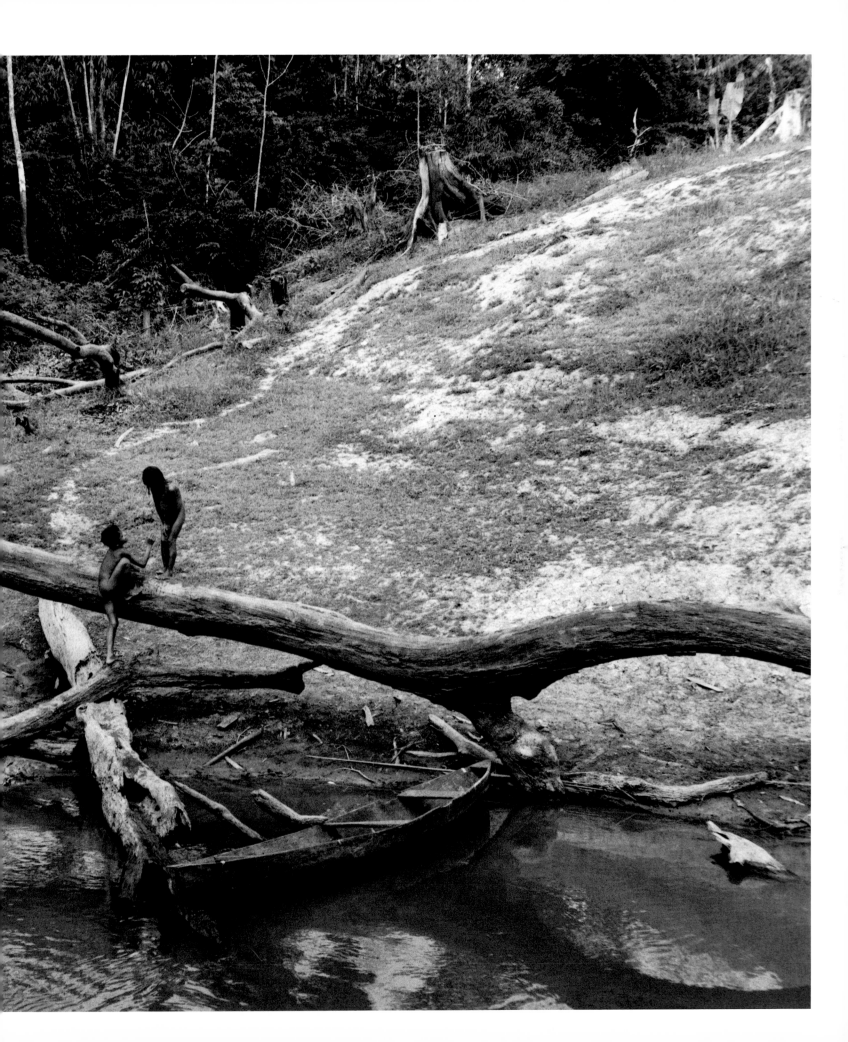

131. Amahuaca Indians clearing the jungle for farming, Peru, 1963.

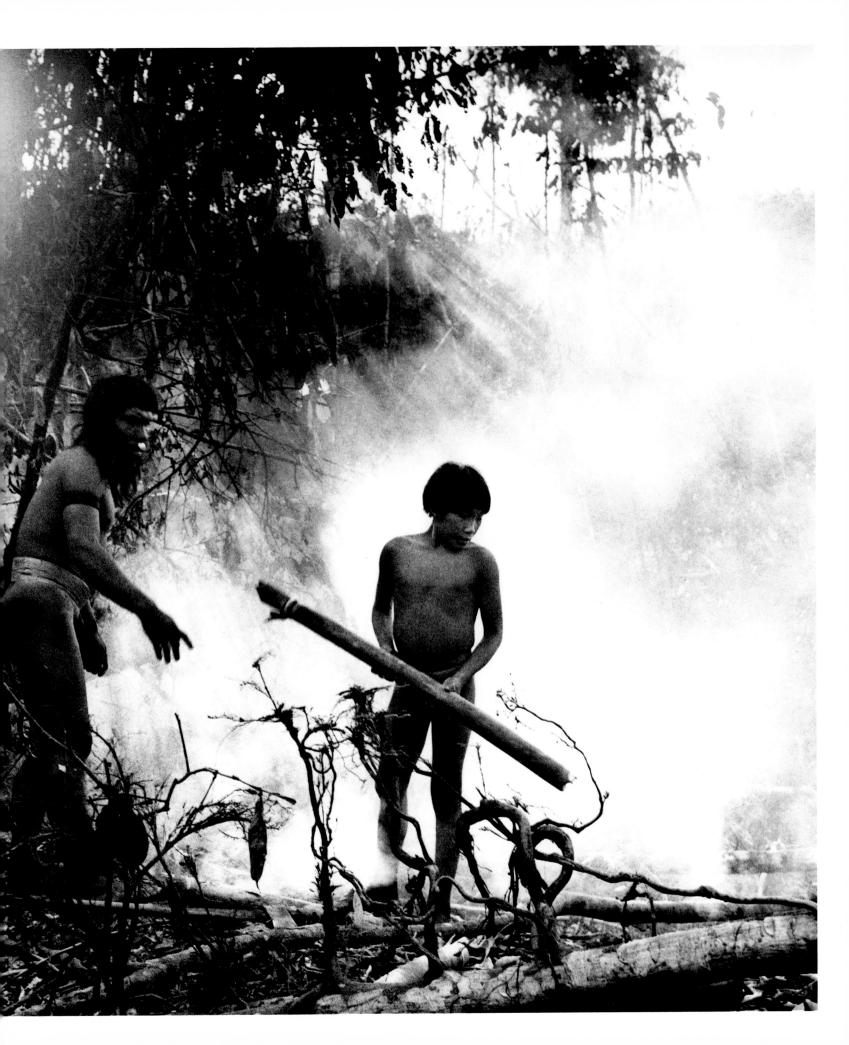

*133. Santos preaching to Campa Indians on the banks of the Rio Tambo, Peru, 1963.

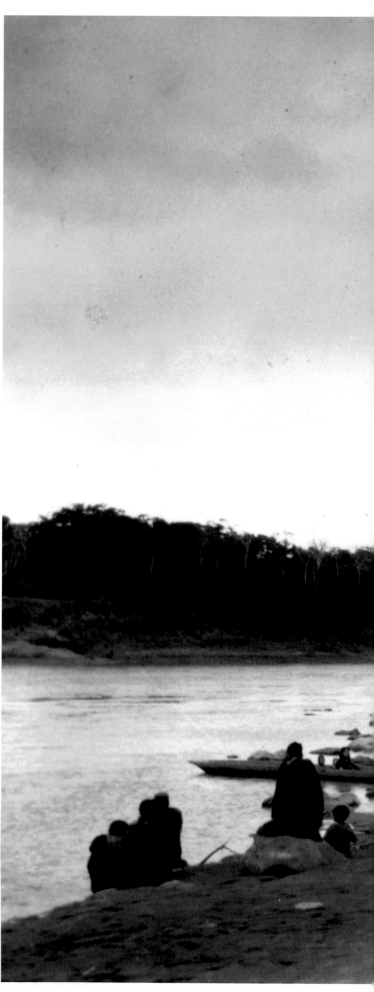

*132. A Campa Indian named Santos with a young student, Peru, 1963. Santos had been educated at a missionary school and then returned to his village to teach his people.

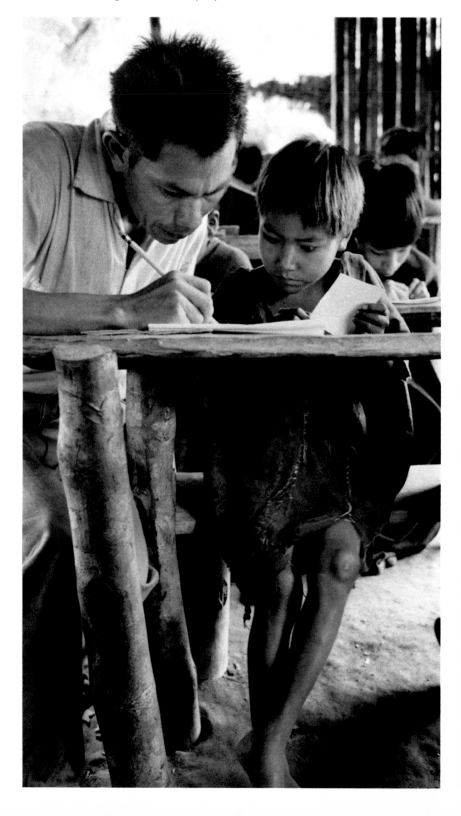

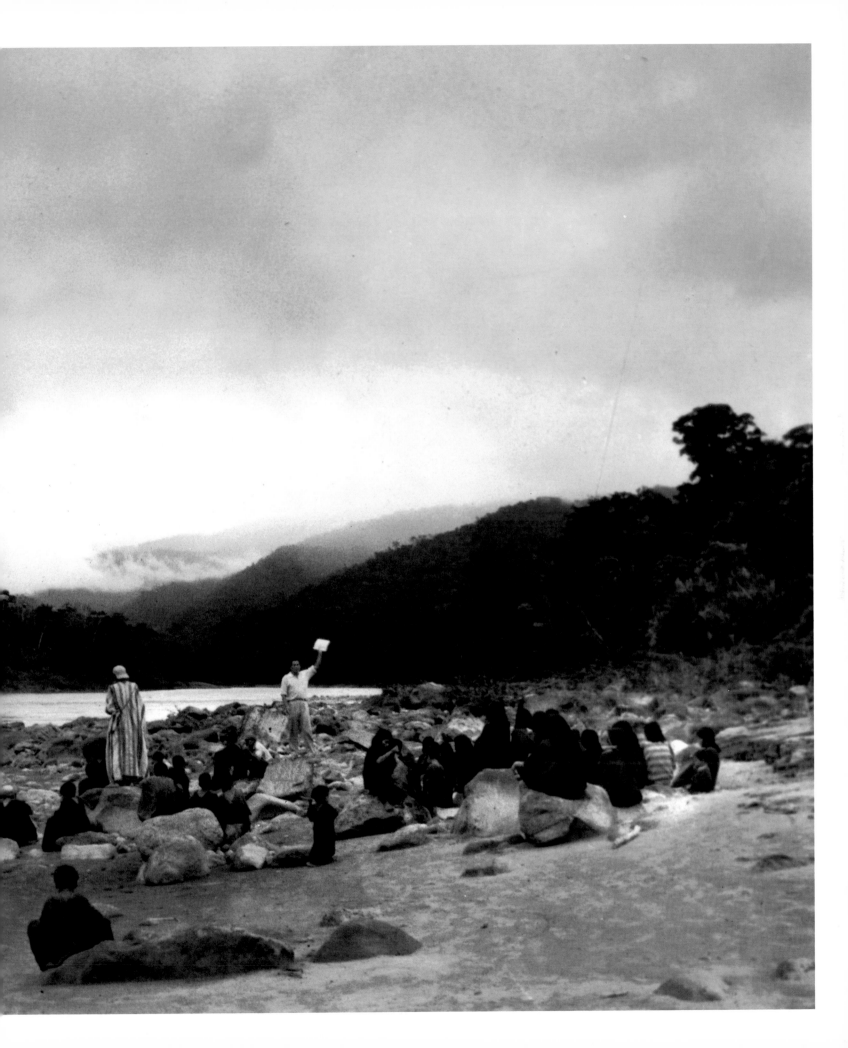

LATIN AMERICA

I first visited Latin America in July 1953. I had assignments in Guatemala and Venezuela, but just before I was to leave New York, *Life* editor Ray Mackland asked me to stop in Cuba on the way. It seemed that a young lawyer named Fidel Castro was trying to start a revolution to overthrow dictator Fulgencio Batista. I went to Abercrombie & Fitch and bought clothing appropriate for the tropics, or even for the jungle. The green khaki clothes were shelf-rumpled, but that didn't matter for the moment. I flew to Havana and was told that the fighting had been in Santiago de Cuba. So I put on my jungle clothes and flew there to take a look. I went to the local newspaper to ask some questions about the uprising and asked the editor what I should do. "The first thing," he told me, "is to get out of those clothes. The revolutionaries wear rumpled khakis just like yours. If you walk down the street like that, you will probably be shot." This was a fine introduction to a chapter of my professional life that was to last for twenty years.

The situation in Guatemala was very interesting, for President Jacobo Arbenz Guzmán, a passionate and idealistic reformer, had made himself very unpopular with the United Fruit Company ever since he had taken office in 1951. Arbenz had passed a law expropriating large estates owned by foreign interests (most of them American) and was redistributing the land to Guatemalan farmers. Although he was not himself a Communist, his programs naturally won the support of the local Reds. Their backing ultimately proved, in 1954, to be the kiss of death, for it gave the U.S. government—and the CIA in particular—an excuse for aiding Arbenz's military opponents, who overthrew him.

I spent about six months in Latin America in 1955, mostly in Argentina, where Juan Perón's regime finally collapsed in September of that year. A few months earlier Perón, in an attempt to stifle Roman Catholic criticism of his government, had launched an anti-Catholic campaign, which led to his excommunication by the church. In August, I covered the great Eucharistic Congress that Rome held in Rio de Janeiro to put pressure on Perón. Some 700,000 Catholic pilgrims, 300 archbishops, and 20 cardinals converged upon Rio for the greatest assembly of its kind that had ever been held outside Rome. Thousands of children received their first Communion during a spectacular outdoor Mass (plate 150).

Perón had become more high-handed than ever after his army had suppressed a revolt led by Argentine naval officers in July. On every possible occasion he paraded his goose-stepping forces through the streets of Buenos Aires to impress and intimidate the population (plate 138), and he constantly evoked the memory of his late wife, the enormously popular Eva, who had died of cancer in 1952. Late in August, Perón planned to throw off all pretense of restraint and

tolerance. Following a carefully contrived strategy, he began by making a sham offer to resign, at which point Peronist leaders immediately called for a general strike and a mass demonstration that would occupy Buenos Aires's Plaza de Mayo until Perón "consented" to stay on. Trucks brought Perón supporters into the capital from outlying districts, and soon the plaza was filled to overflowing with a mob calling for Perón (plate 145). Finally, at dusk, the dictator appeared on a balcony. Shedding histrionic tears of gratitude, he announced that he would yield to popular demand and withdraw his resignation. It was quite a performance.

It was also the beginning of the end. Perón declared Buenos Aires under a state of siege and proclaimed martial law. In September resistance to his repression boiled over. The Argentine fleet of Admiral Isaac Rojas steamed into the harbor of Buenos Aires and threatened to shell the city if Perón did not resign. The dictator acquiesced, and five days after the revolution had begun, Perón was allowed to board the Paraguayan gunboat that would take him into exile.

As I made my way from the harbor to the Casa Rosada, the president's house, the crowd was so densely packed that I had to carry my camera above my head. Throughout the crisis the Uruguayan radio was the Argentines' main source of reliable information, and so when people heard my Hungarian-accented Spanish they said, "*Pase el fotógrafo. Él es uruguayo.*" I always sound as though I come from somewhere else. But it helps. The crowd opened and let me through.

I found Latin America a fascinating region to cover, because it was—and still is—such a fantastic stew of dictators and revolutionaries, of terrible poverty and great potential prosperity, of despair and hope, of religion as a counterprogressive force and religion as the vanguard of reform. Over the years I returned again and again to photograph missionaries and tribal peoples, to cover the rise and fall of dictators, and, most important, to document the appalling poverty in which so many Latin Americans have been condemned to live. I went to Latin America as a concerned photographer, hoping that my work in that underreported area would prove to be a catalyst for positive change. In Latin America—despite the absence of war—I was constantly confronted with scenes that reminded me of my brother's pictures of suffering endured by civilians in Spain, China, and all the other places where he covered wars. I was grieved by what I saw and became a partisan in that longest and most critical war of all, the war against poverty, ignorance, and oppression.

I have never understood why the United States government, industry, and press continue to treat Latin America so badly. Our understanding and sympathy have not increased one bit since my first visit to Cuba, in 1953.

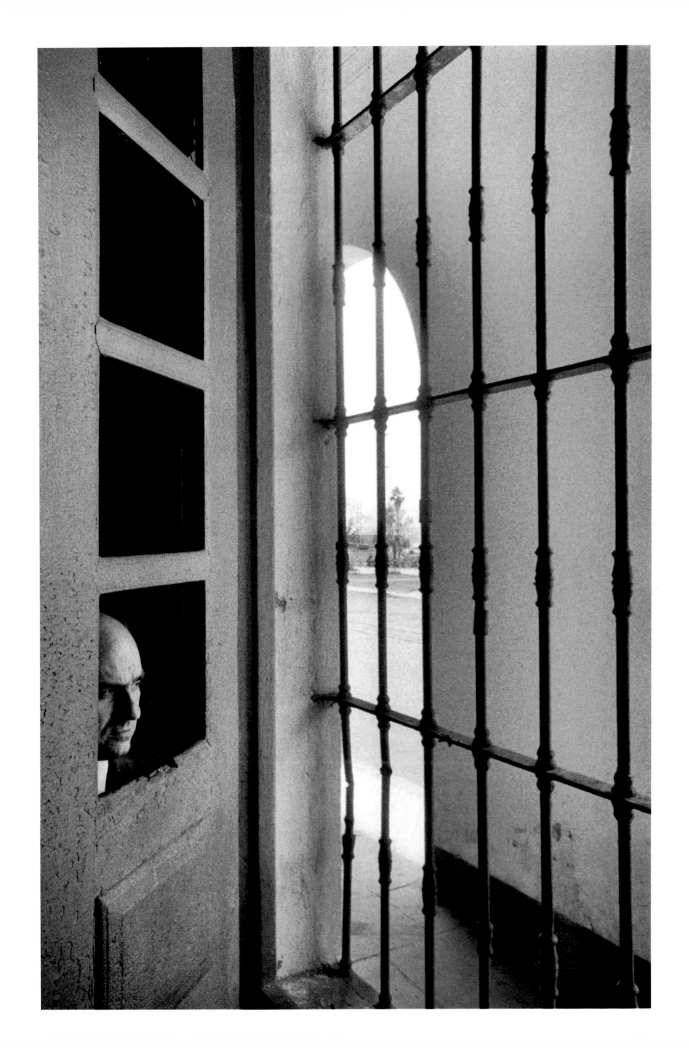

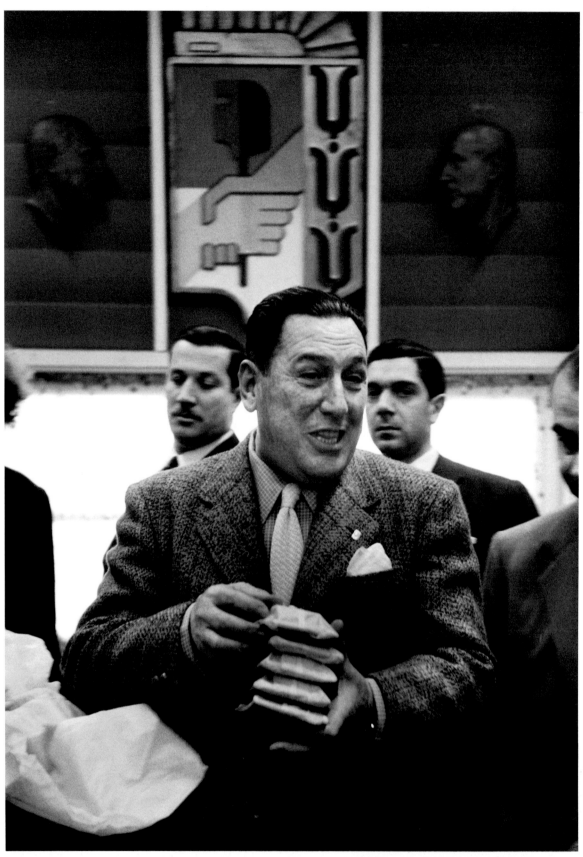

*135. Argentine dictator Juan Perón, Buenos Aires, 1955.

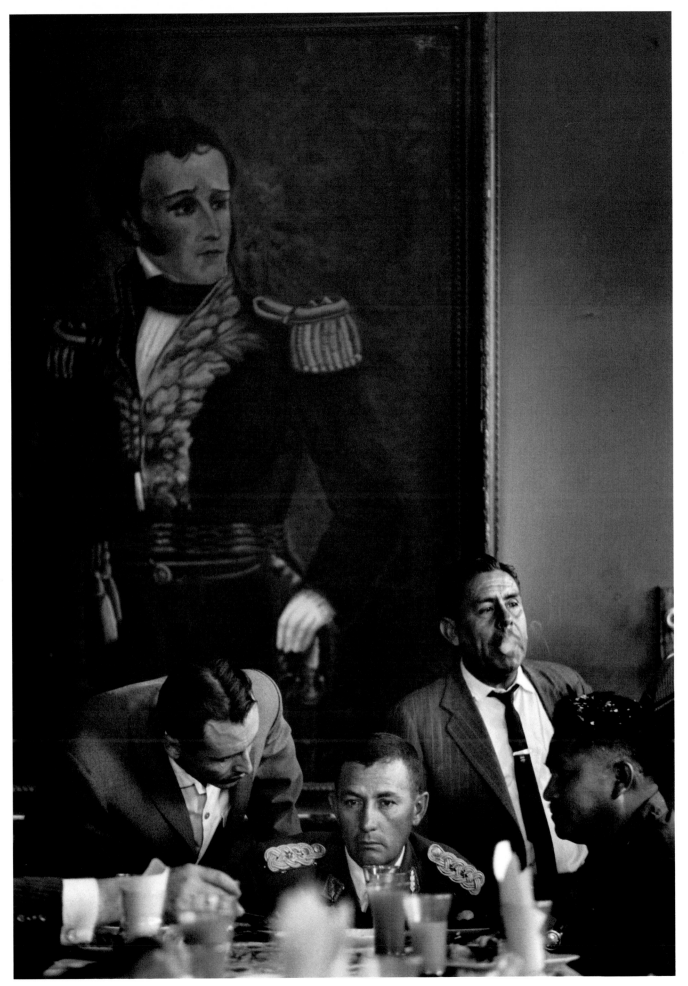

*136. General René Barrientos (center), head of the military junta that had recently seized power in Bolivia, 1964.

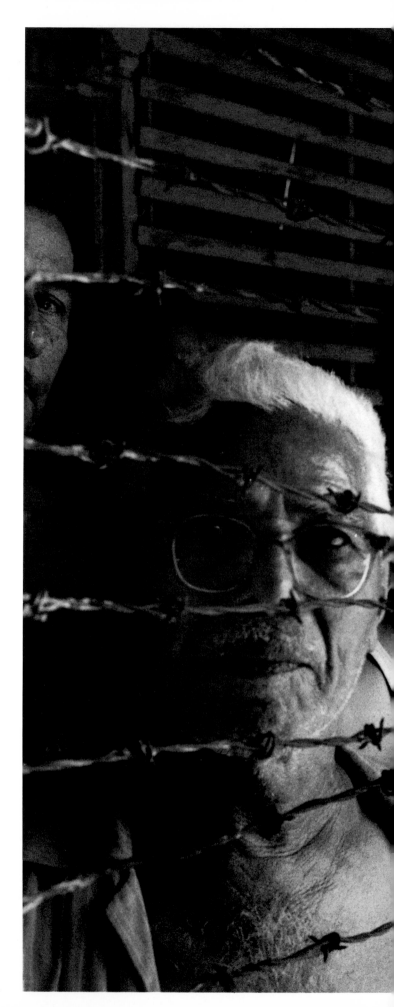

*137. Some of the one thousand political dissidents
who were arrested after the assassination of
Nicaraguan dictator Anastasio Somoza, Managua, 1956.

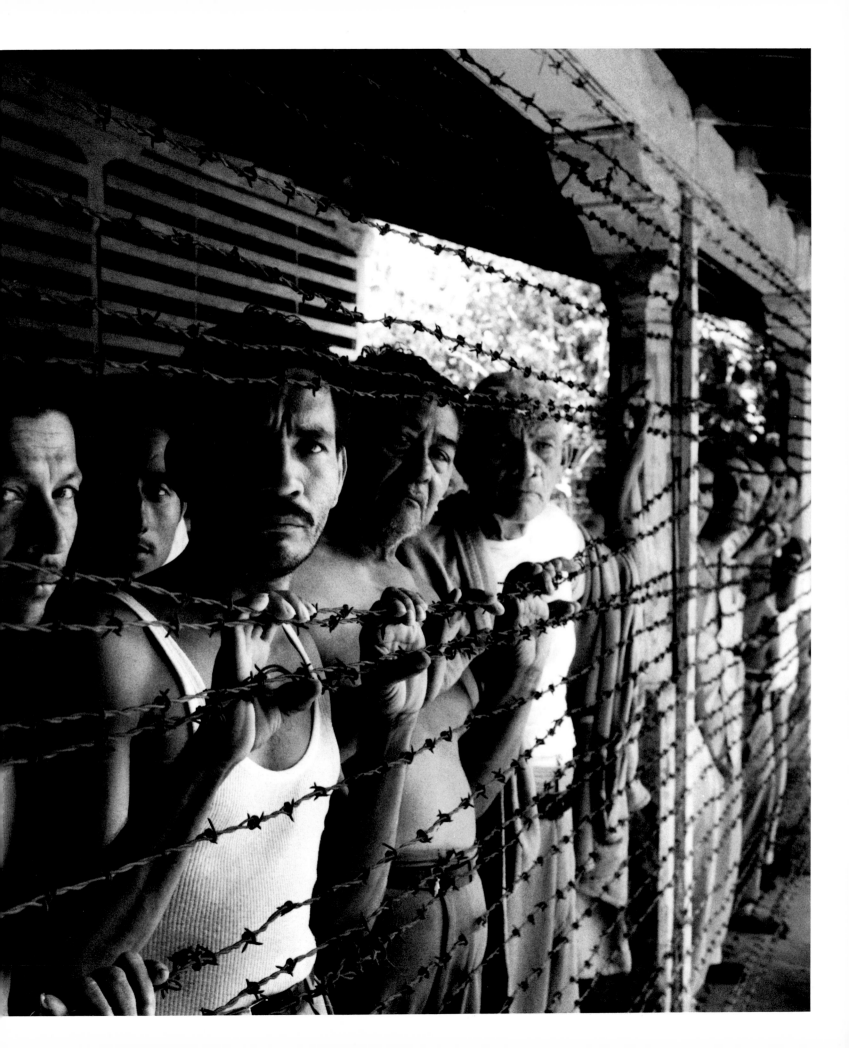

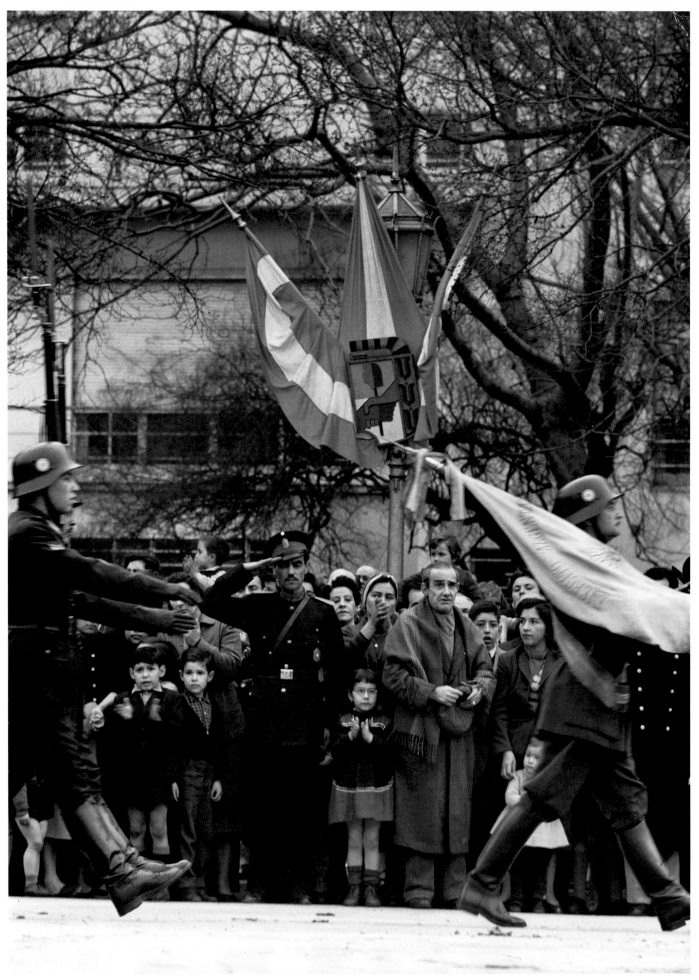

*138. The goose-stepping troops of Juan Perón's dictatorial regime in Argentina, Buenos Aires, 1955.

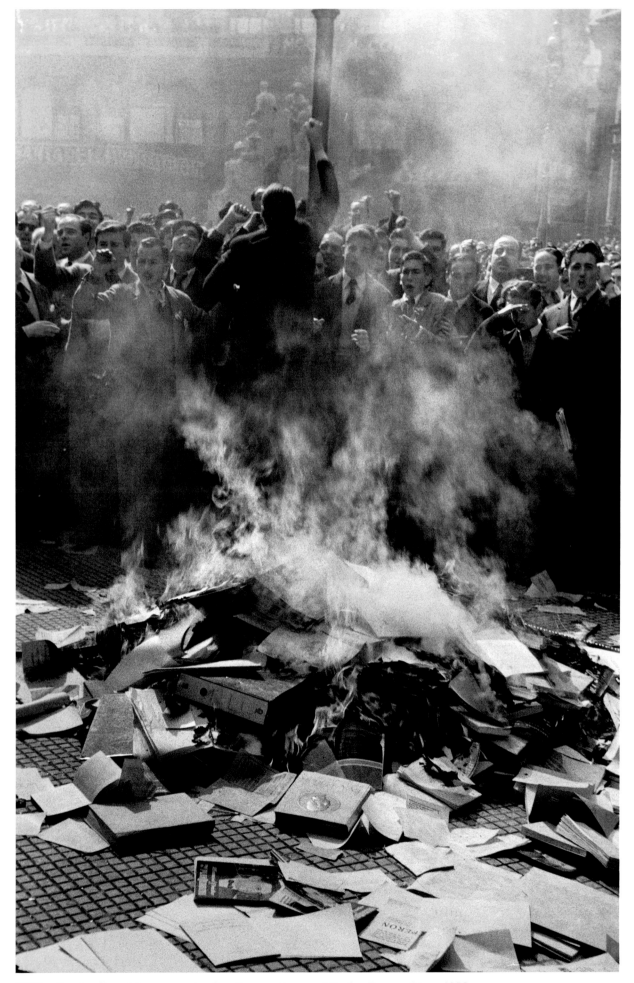

*139. Burning Peronist propaganda after the overthrow of Perón, Buenos Aires, 1955.

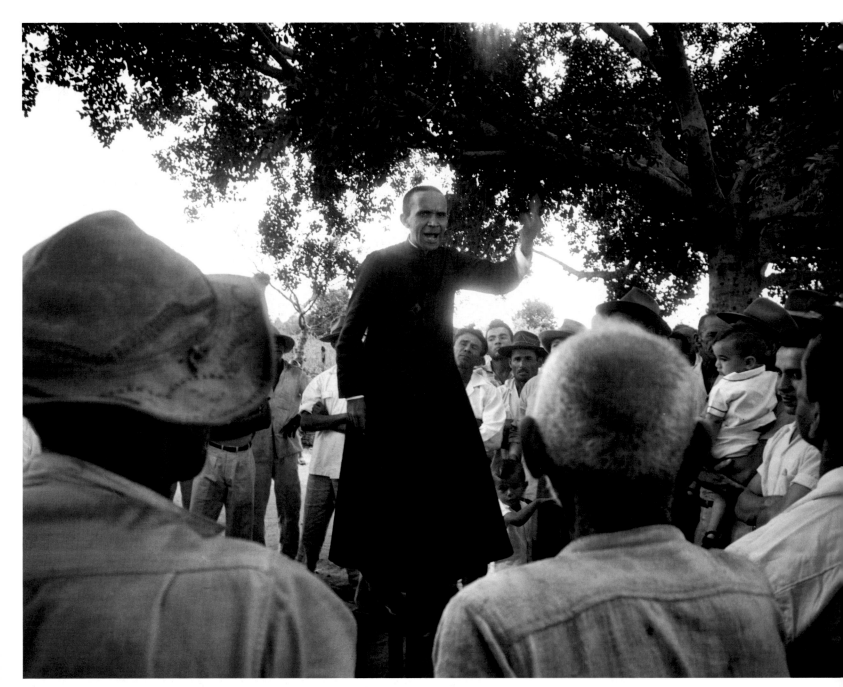

*140. A radical priest encouraging poor tenant farmers to protect themselves
against their ruthless landlords, Macau, northeastern Brazil, 1962.

141. Farmers on the Hacienda San Bernardo, a governm
experiment in land reform, Honduras, 1972.

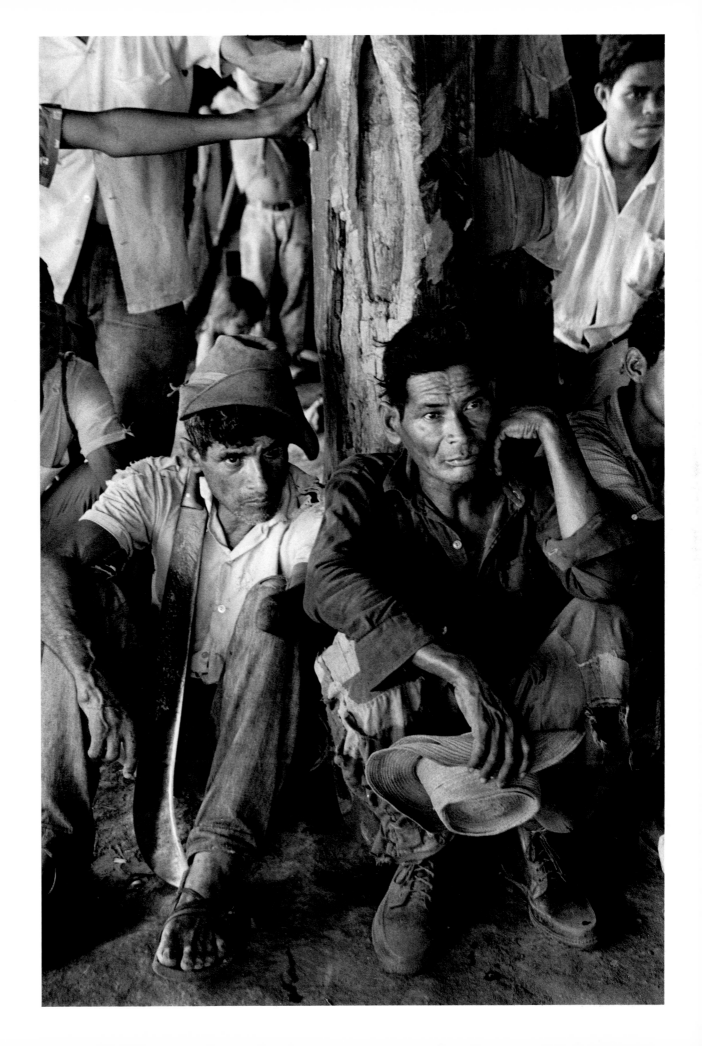

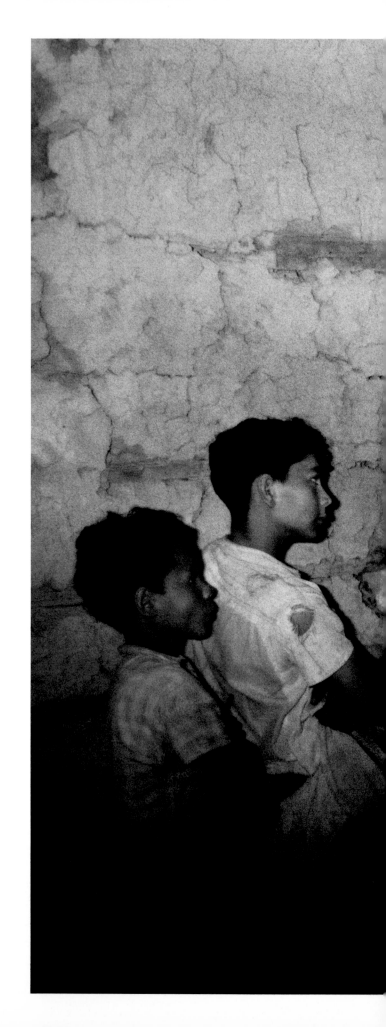

*142. An activist priest reassuring a family of peasants, driven off their land by their landlord, that he will help them, northeastern Brazil, 1962.

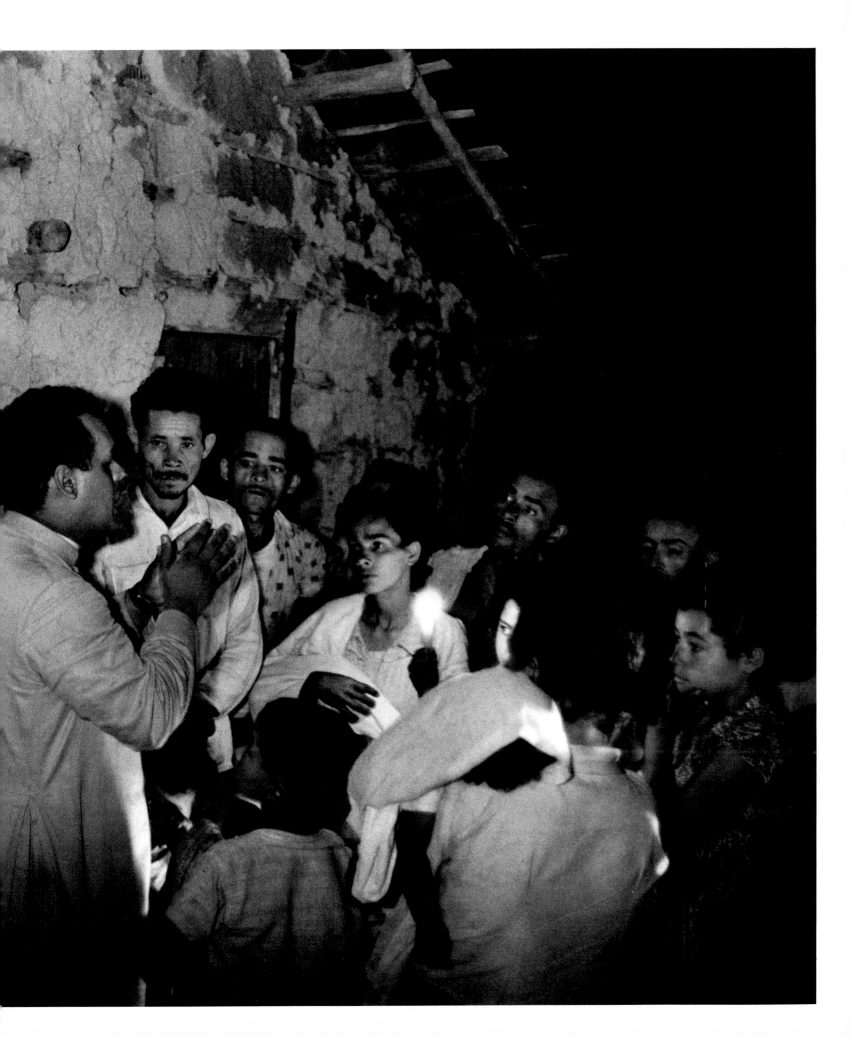

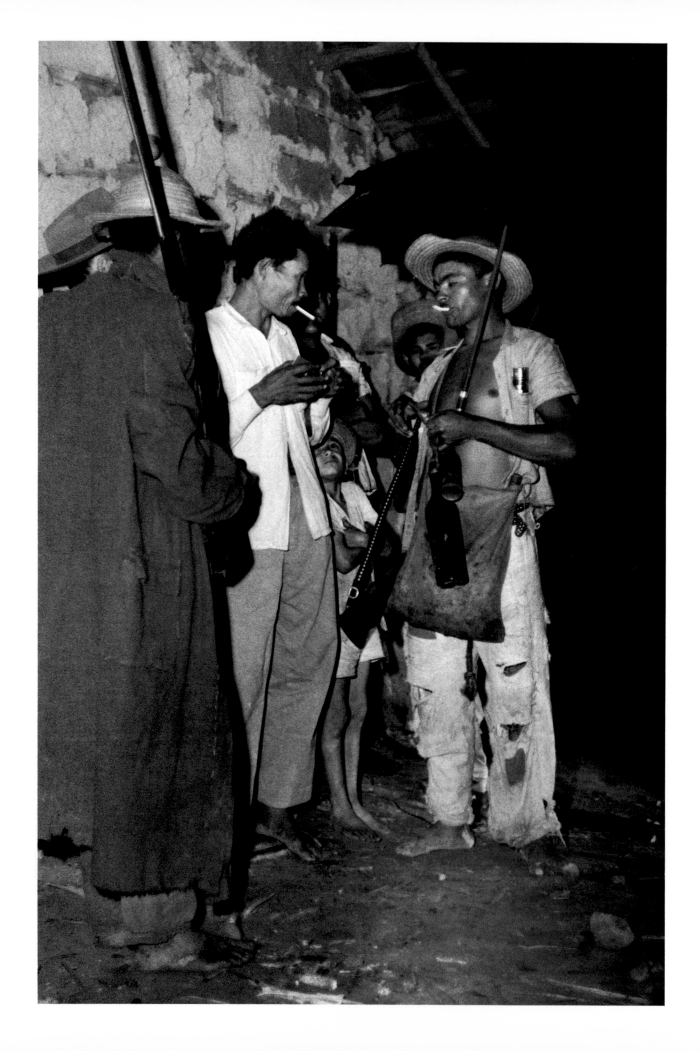

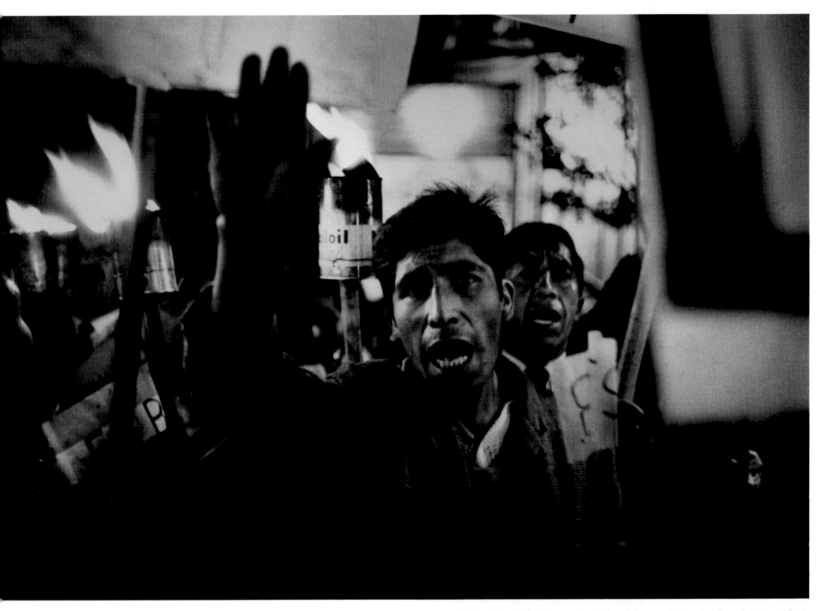

144. Workers demonstrate for labor reform, La Paz, Bolivia, 1964.

Peasants who had taken up arms in sympathy with a neighbor
who had been driven off his land, northeastern Brazil, 1962.

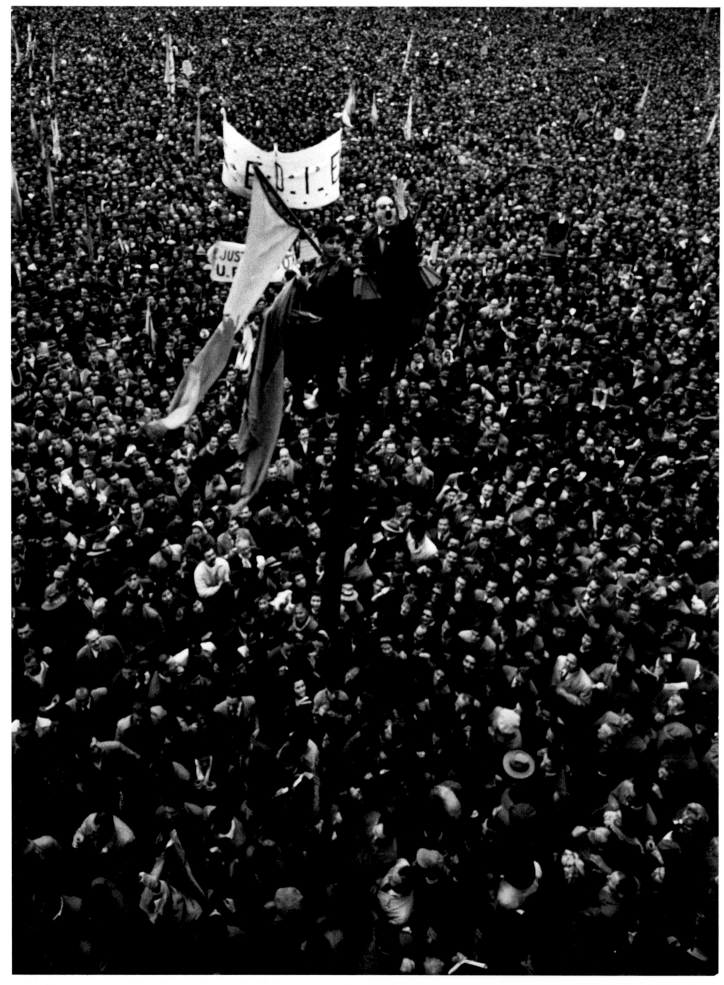

*145. Supporters of Juan Perón, Buenos Aires, Argentina, 1955.

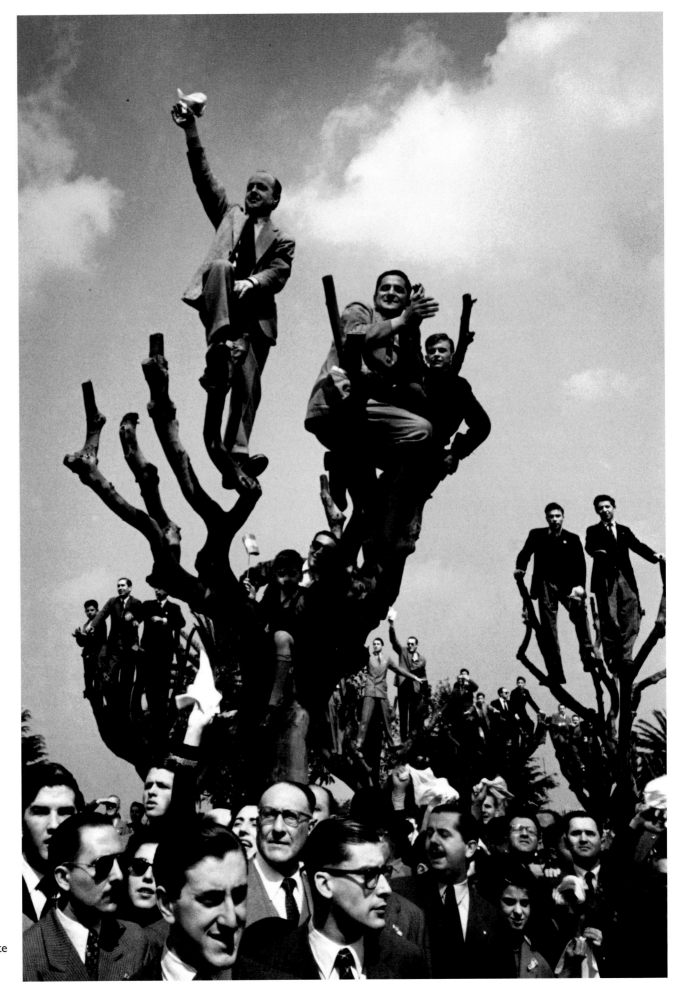

*146.
Cheering the arrival of
rebellious Argentine naval
troops, who would complete
the overthrow of Perón,
Buenos Aires, 1955.

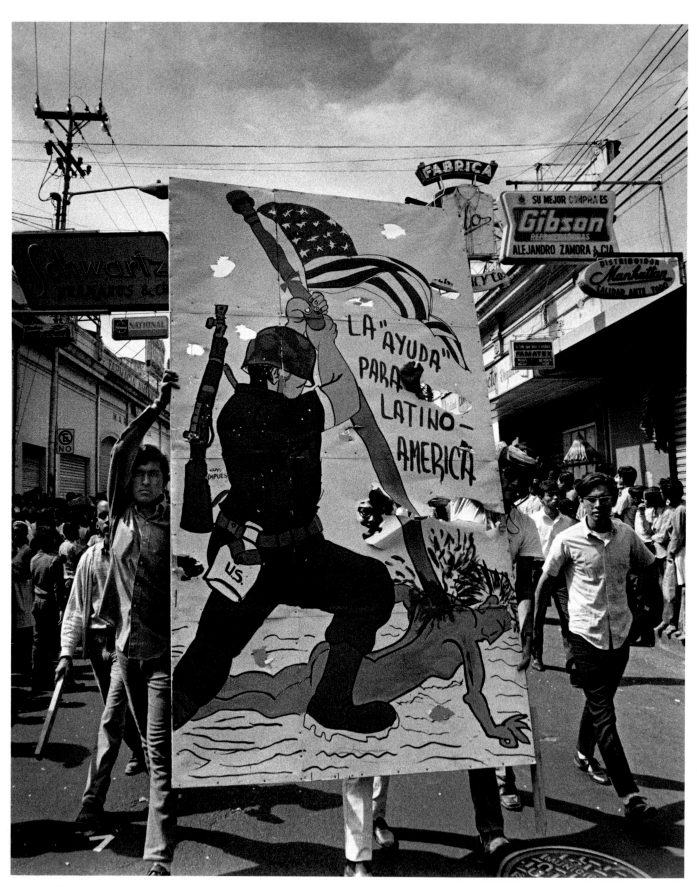

147. El Salvador, 1973.

148. La Paz, Bolivia, 1964.

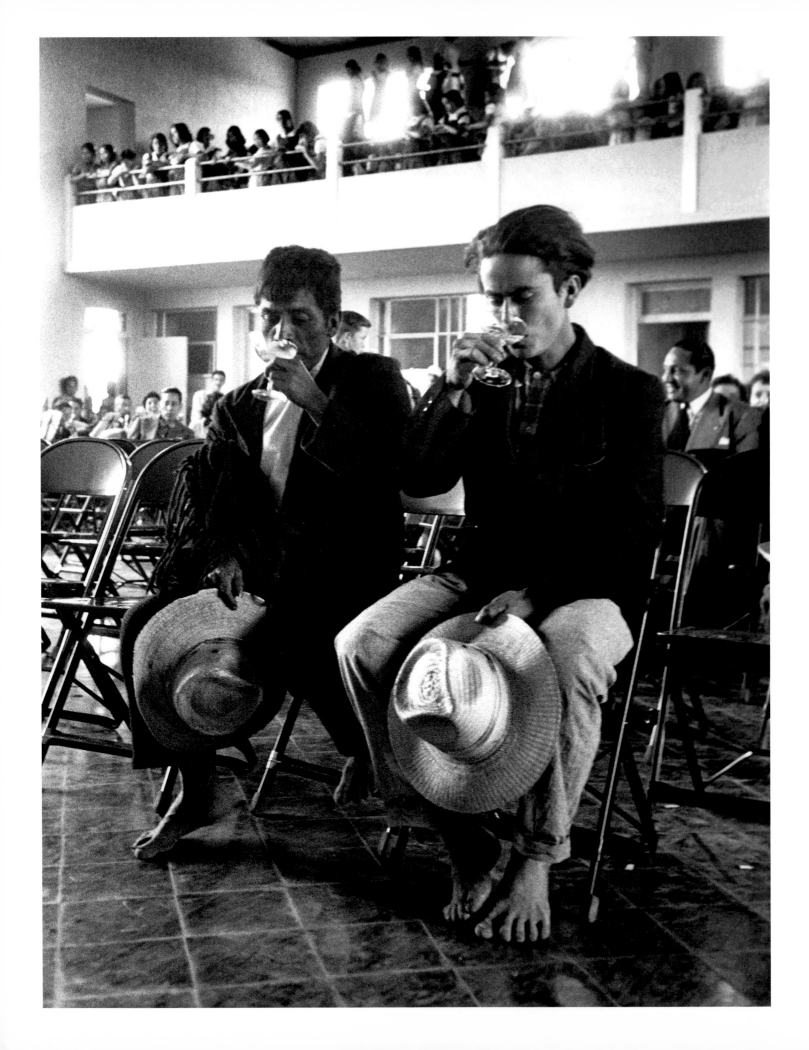

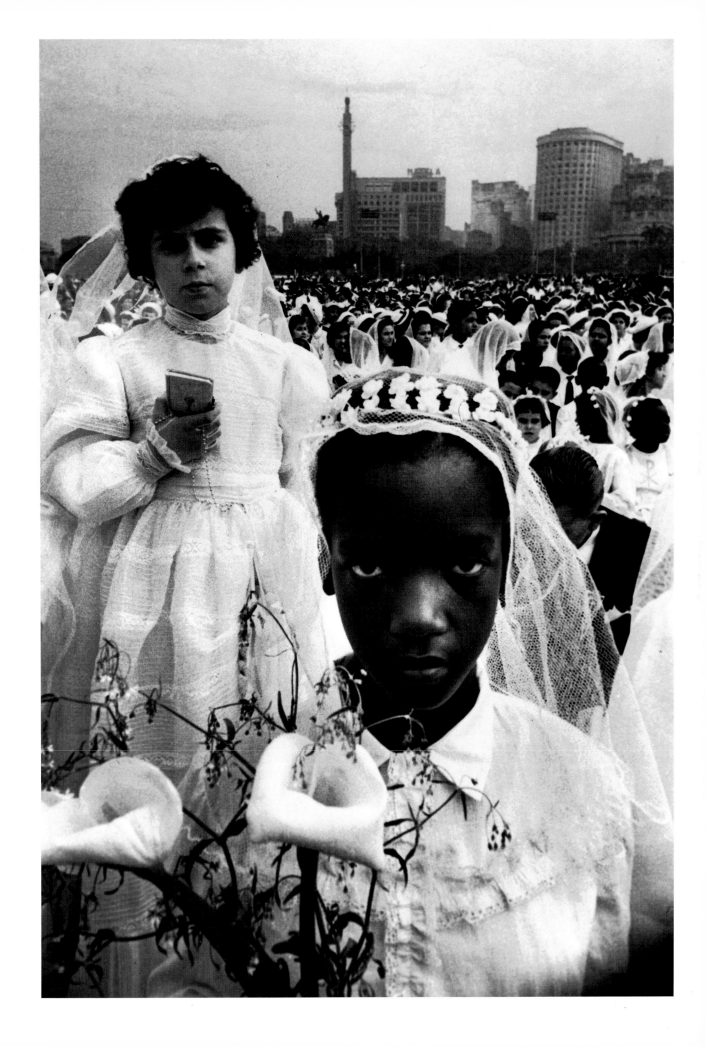

foot peasants drink
pagne at the dedication
school built by the
mist government, which
supported by the Com-
sts, Guatemala, 1953.

national Roman Catholic
aristic Congress, Rio de
ro, 1955.

*151. In the city of Recife, in northeastern Brazil, the infant mortality was so high that children's graves were dug in advance, 1962.

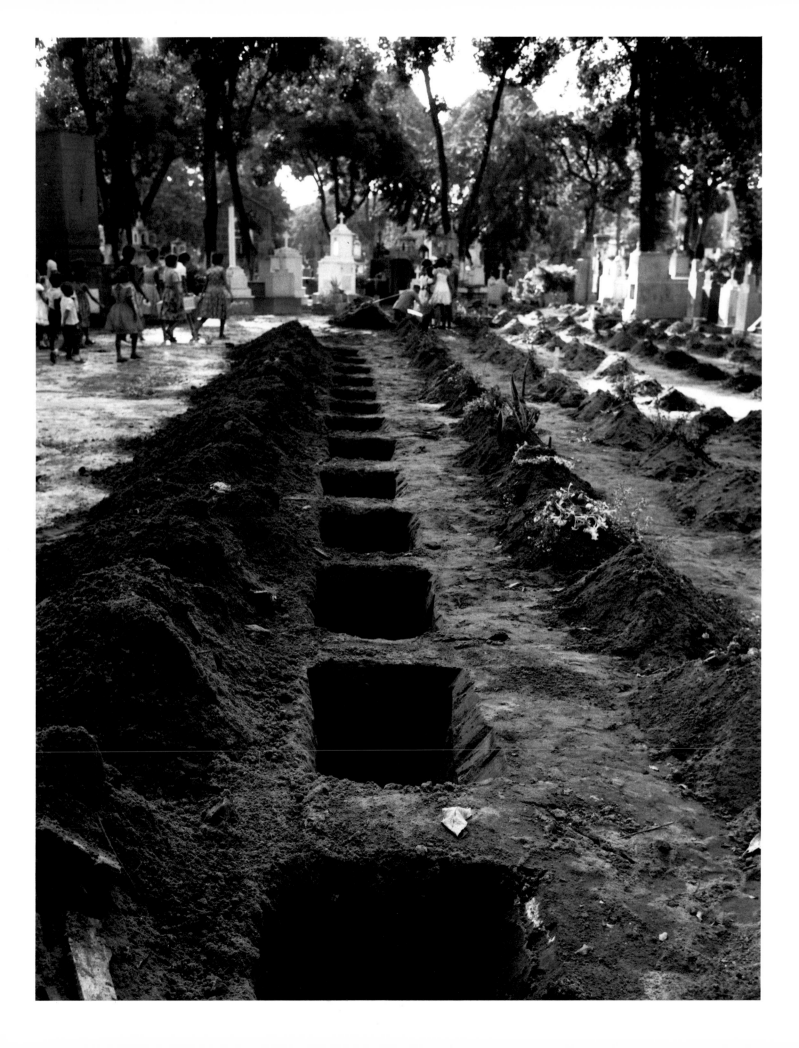

MARGIN OF LIFE

The book *Margin of Life*, with text by sociologist J. Mayone Stycos and my photographs, was published in 1974. It is about poverty and overpopulation in Latin America, particularly Honduras and El Salvador, and about ways of combating it. It is about migrant agricultural laborers, who so greatly outnumber available jobs that they are forced to camp out for weeks in the hope that work may be offered to them—and then it will always be for a pitifully low wage. And it is about birth control programs to reduce such overpopulation. It is about women and children who have no alternative but to sleep in cardboard boxes on city streets or in squalid hovels in the countryside. It is about child labor and infant mortality. And it is about ambitious educational and health care programs. It is about agricultural cooperatives and enlightened priests and angry revolutionaries. In short, it is about the despair and the hope of the people who cry, to quote from a slum dwellers' petition,

It's not the slums that are marginal,
It's the people, it's us . . .
We are on the margin of health,
The margin of education,
The margin of work.
We cry to the four winds
That we don't want to be marginal.

The photographs in *Margin of Life* were made in 1972–73, when it was clear that El Salvador was on the verge of civil war—which did indeed break out soon thereafter, and which was to last nearly twenty years, having finally come to an apparent end in January 1992.

152. El Salvador,

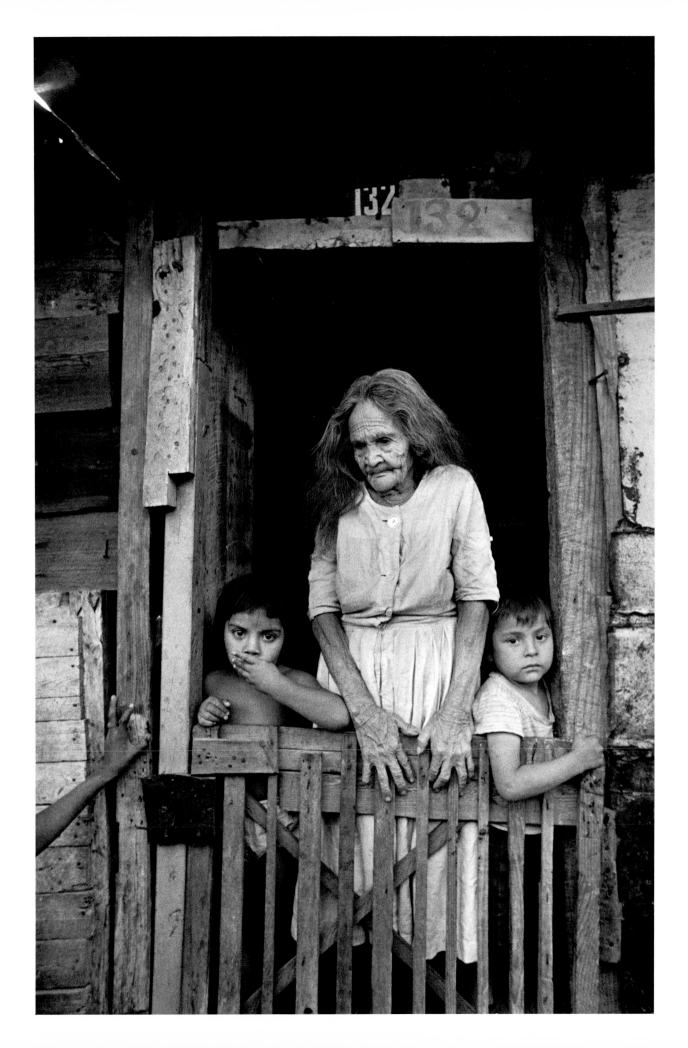

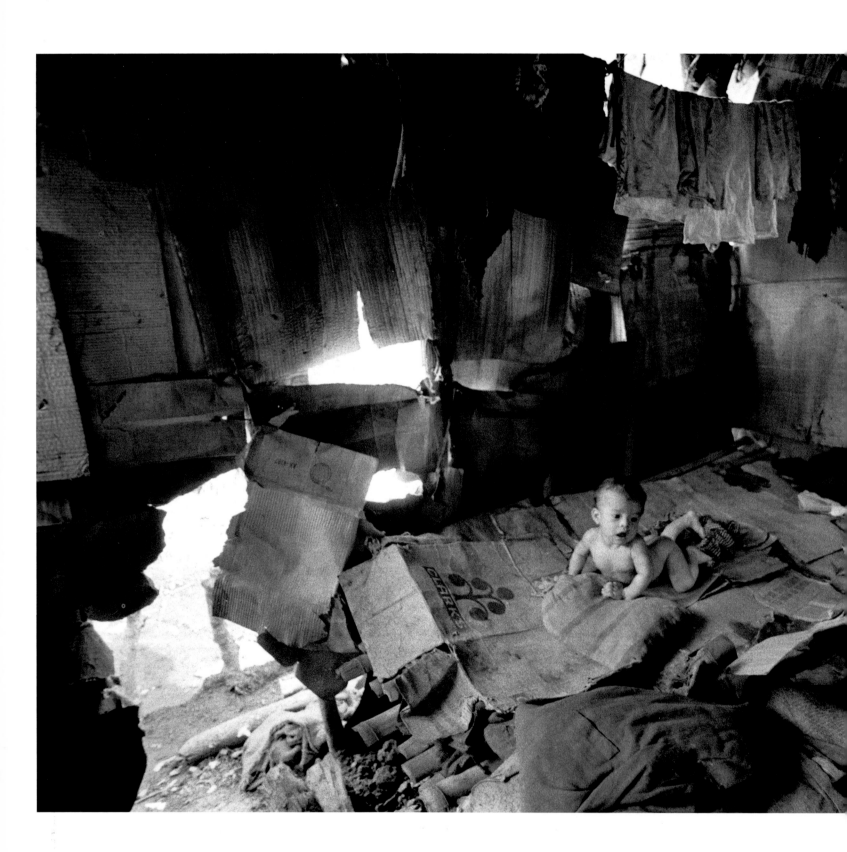

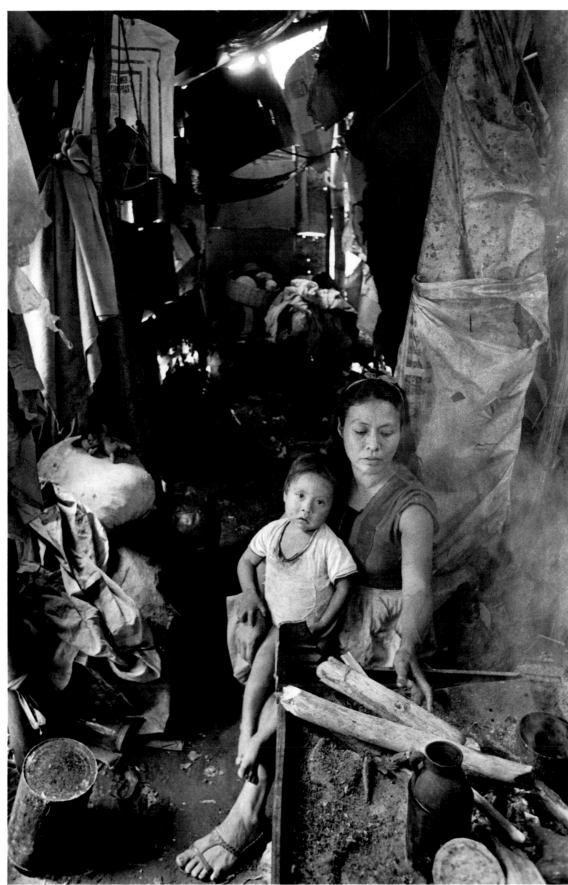

3–154. El Salvador, 1973.

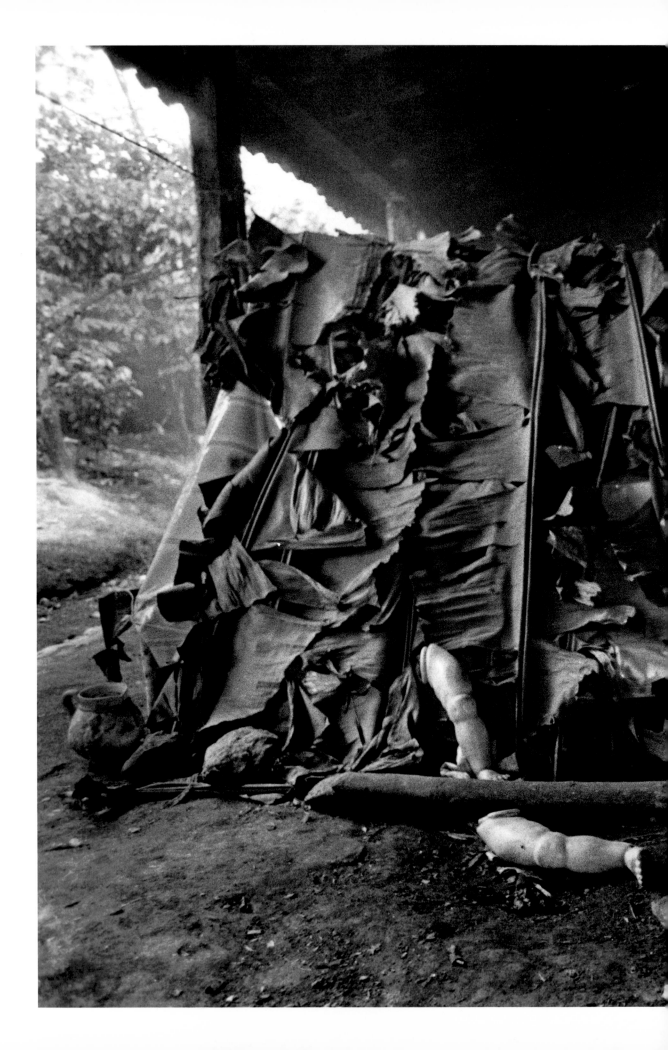

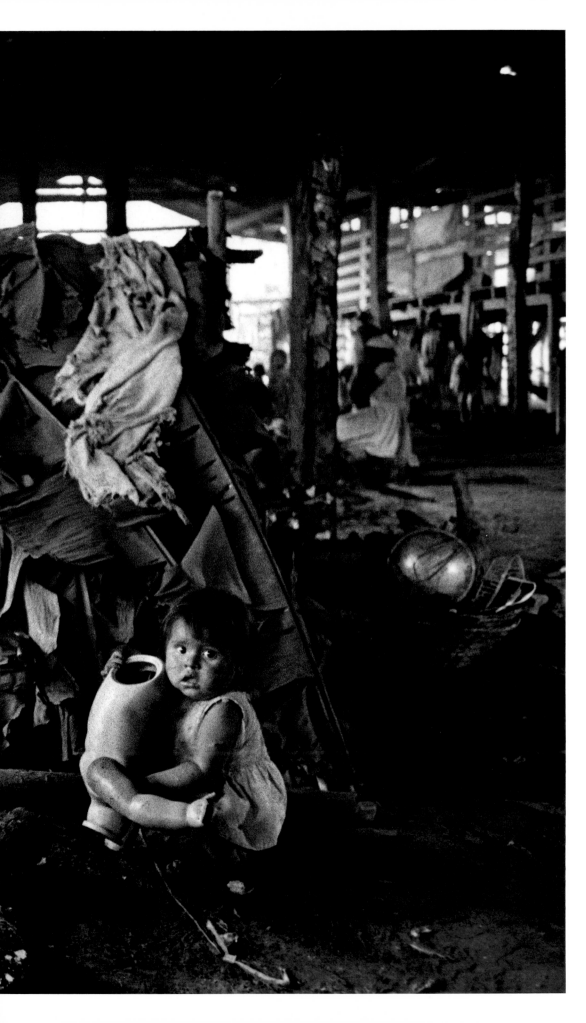

155. El Salvador, 1973.

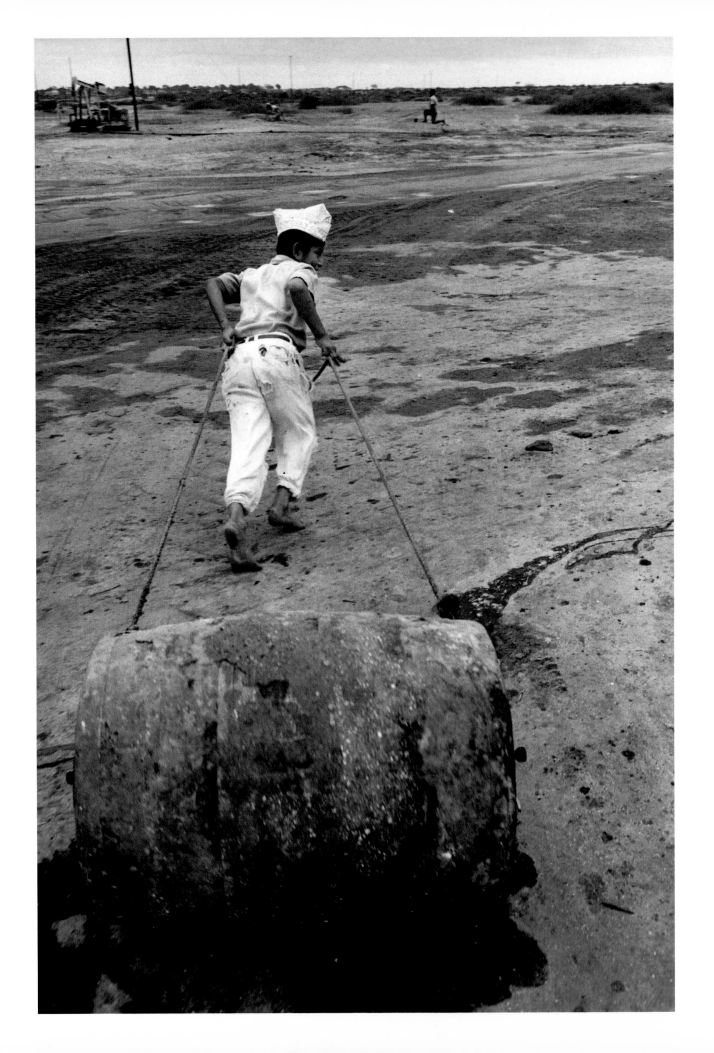

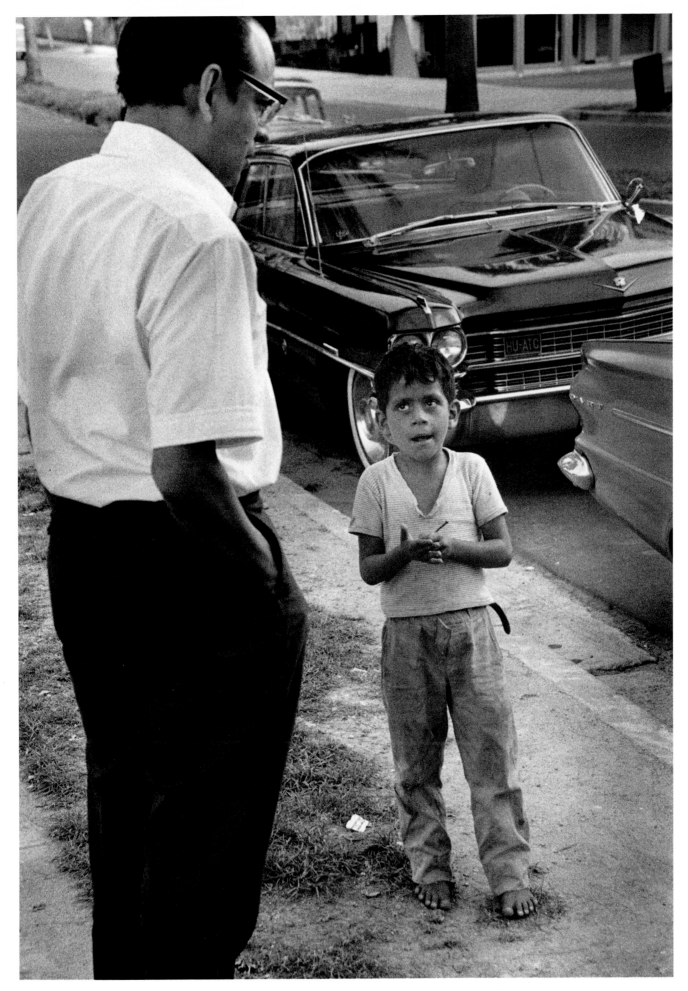

156–157. El Salvador, 1973.

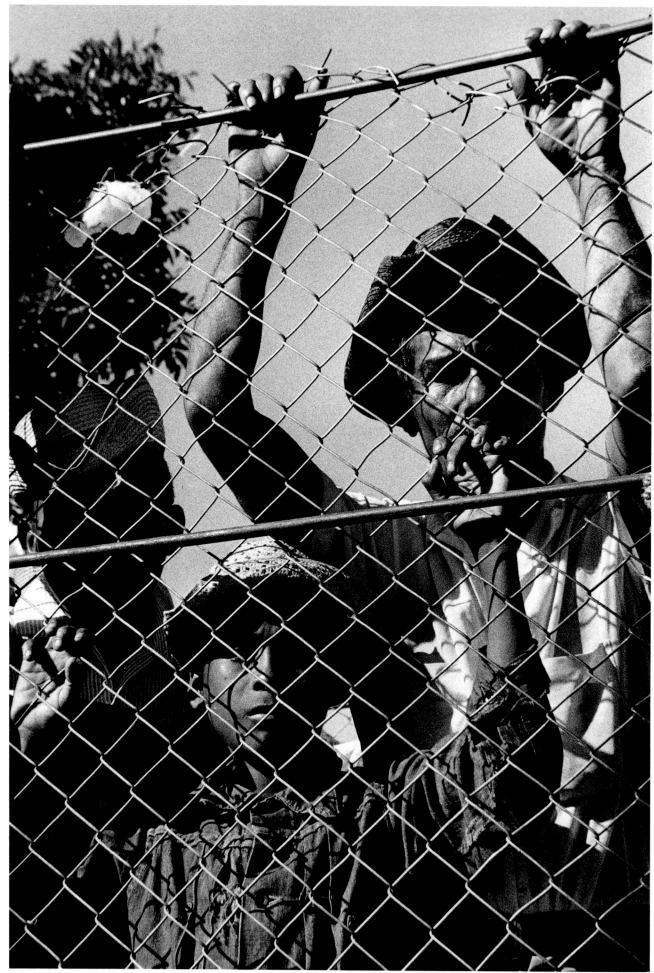

158. Waiting for work, Honduras, 1973.

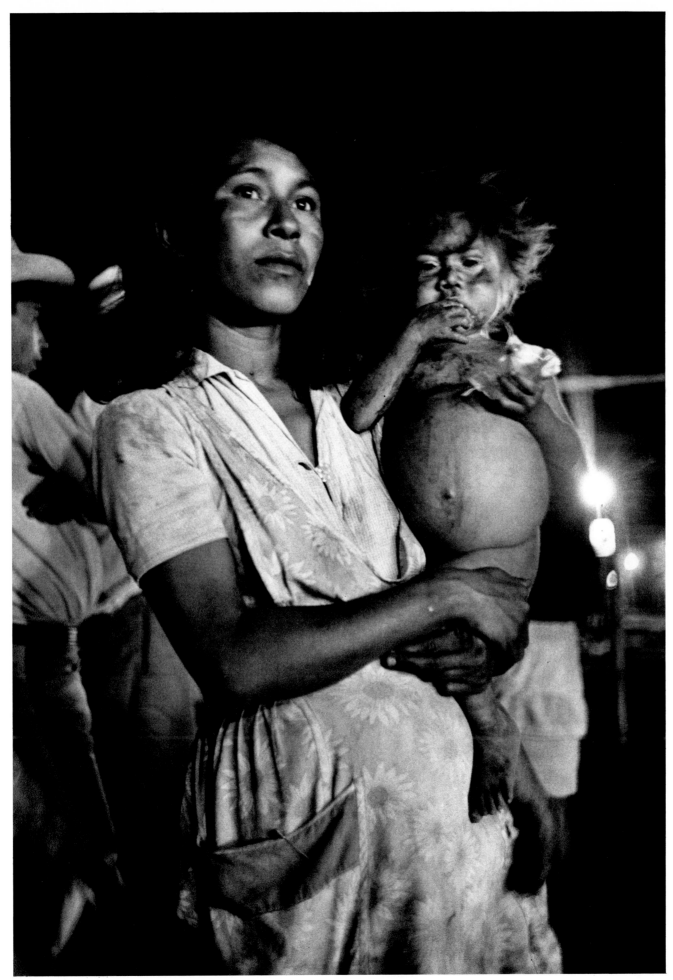

159. El Salvador, 1973.

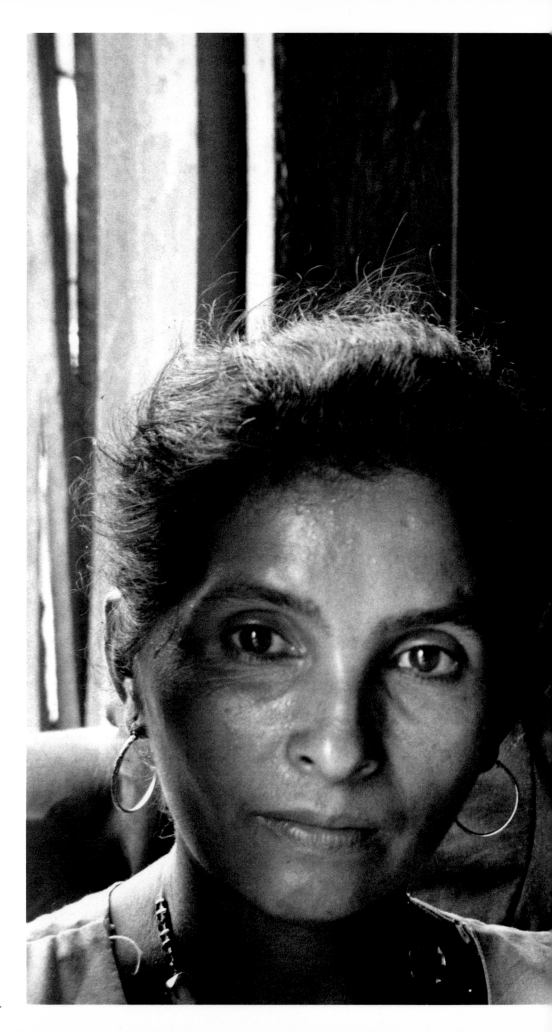

160. Migrant workers, Honduras, 1973.

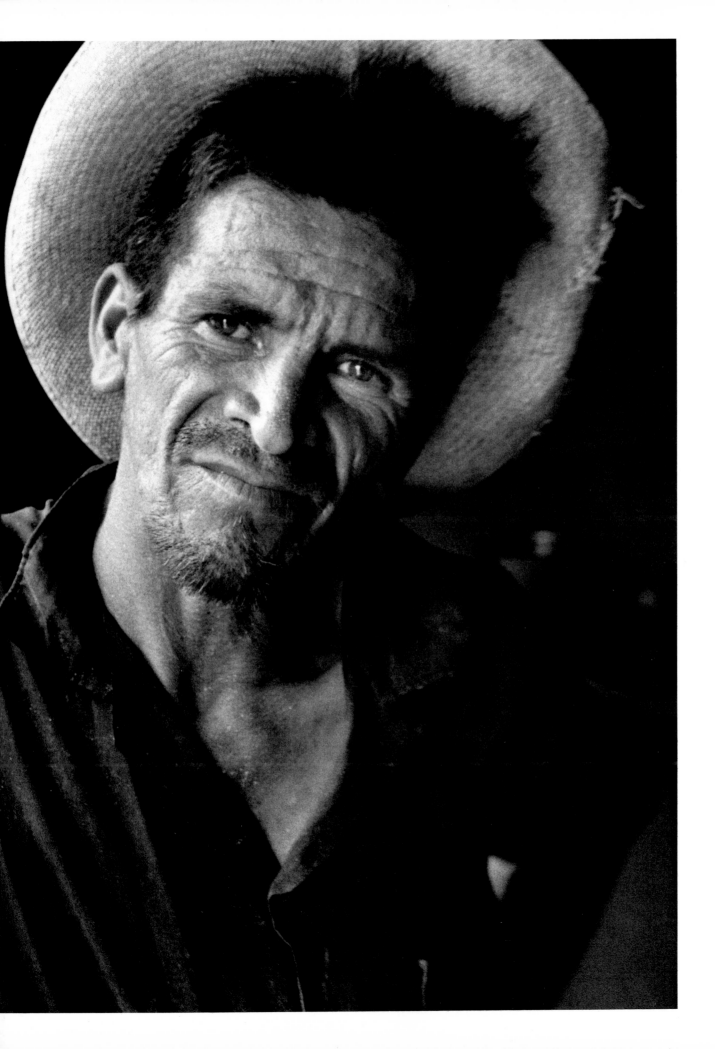

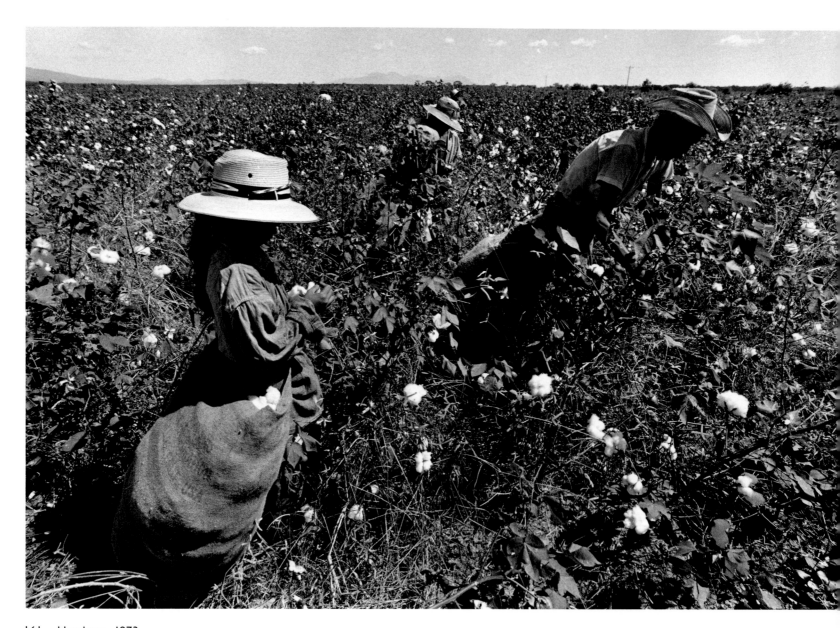

161. Honduras, 1973.

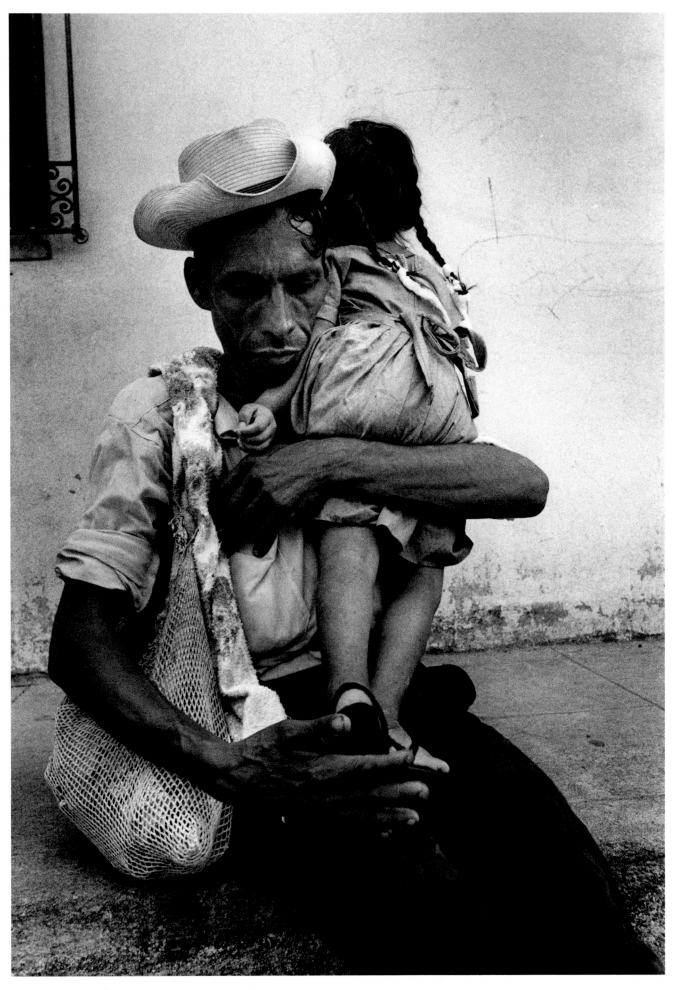

162. Man with his ill daughter, El Salvador, 1973.

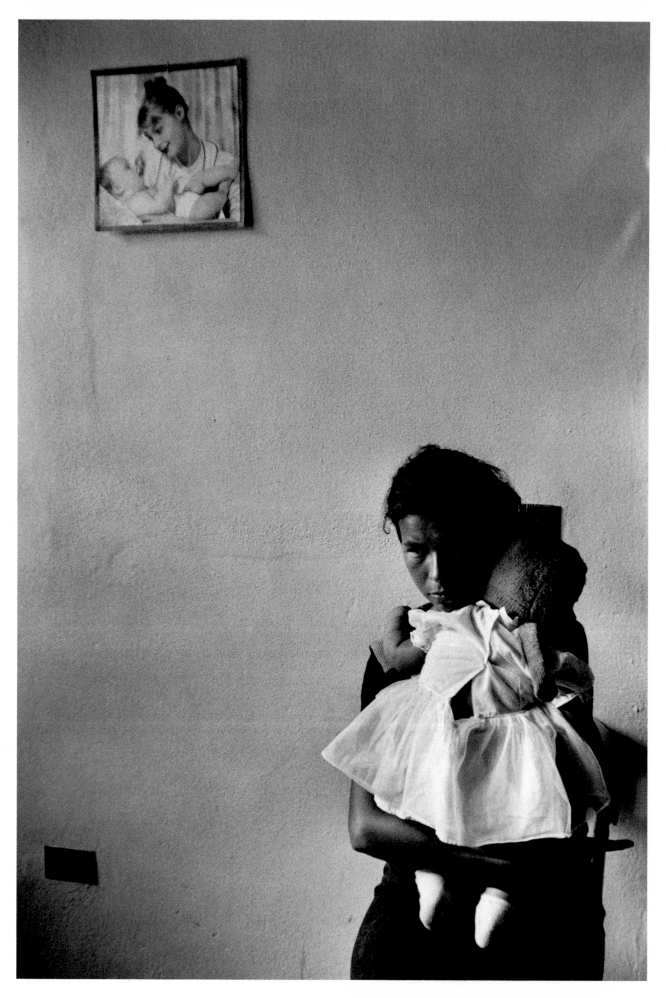

163. El Salvador, 1973.

NOTES TO PHOTOGRAPHS

Frontispiece: Igor Stravinsky, Venice, 1951.
The composer directing the premiere of his opera *The Rake's Progress,* at the Teatro la Fenice. The opera, with a libretto by W. H. Auden and Chester Kallman, was inspired by William Hogarth's series of engravings. Stravinsky was terribly ill with pneumonia at the time of the performance, but he conducted with great élan.

AMERICA

2–6. Savoy Ballroom, New York, 1939.
This story on the Savoy Ballroom in Harlem had its origins in a technical challenge: to stop, or freeze, action. My Contax camera had a curtain shutter that was not synchronized for flash, but I had the camera repairman Marty Forscher install a clutch that would put the mechanism into neutral, so to speak. The shutter could then be opened in synchronization with the flash; the extremely short duration of the flash thus became the duration of the exposure.

Yale Joel worked with me on this story. We chose the Savoy Ballroom because stopping the action of the frantic jitterbuggers would be a tour de force, and because we thought we would get some remarkable pictures of people in strange positions. We knew nothing of the pictures that Aaron Siskind had made a couple of years earlier as part of his *Harlem Document,* and, in any case, our interests could hardly have been further from sociology. We were two boys developing our photographic skills.

Proud of our results, we sent the pictures off to the French magazine *Match,* which was then publishing a lot of my brother's work. *Match* gave the story four pages, and Bob sent a congratulatory telegram saying how much he admired our "American technique" of multiple flash. Never much for the technical side of photography, he still hadn't completely mastered the use of even a single flash.

7. Human cannonball, Texas, 1947.
Protected by an asbestos suit, twenty-six-year-old Egle Zacchini, a daughter of the great family of human cannonballs, is shot from a cannon. The challenge for me arose from the fact that because of the difference in the speeds of sound and of light, I would miss my picture if I snapped my shutter exactly when I heard the bang. Instead, I had to guess at what fraction of a second after the charge was set off the performer would fly out of the barrel. It was an exercise in frustration, and I had to try three times in three different cities before I finally managed to get the shot reproduced here.

8. Rooster-crowing contest, Oklahoma, 1947.
Who would ever imagine such a thing as a rooster-crowing contest? And yet...Americans are wonderful people and do so many odd things.

At the Oklahoma State Poultry Show, Warner-Pathé News was auditioning roosters. The heads of the company were, according to the *Life* caption, "tiring of the rooster whose voice now introduces its newsreels."

In this photograph Mrs. Marjorie Munson of Alva, Oklahoma, is doing her best to inspire her gamecock to new vocal heights. Despite her determined efforts, however, her bird didn't win.

I shot this story with a Rolleiflex, which editors always liked because its negatives are so much larger than those of a 35-millimeter camera. But I always felt that looking down to compose your shot, as you must do with a Rolleiflex, removes you one step from your subject. I never liked working with it.

9. Irénée DuPont, Cuba, 1957.
Irénée DuPont, the family's eighty-year-old patriarch, on the nine-hole golf course on the grounds of his hideaway, Xanadu, in northwestern Cuba. He is greeting an old friend and kindred spirit, an ancient, battle-scarred iguana, one of many on the estate. He regularly fed them papaya from the jar he holds. This photograph was part of a major story I did for *Life* about the DuPonts, prominent in American business and society.

10. Circus, Hugo, Oklahoma, 1947.
Part of the traveling Miller Brothers Circus wintering in Hugo (named after Victor Hugo). Myrtle (*left*) and Daisy exchange funny stories about their previous tour around America.

11. Minister, New Mexico, 1948.
Hunter Lewis was the pastor of six churches in New Mexico. Not having a car, he walked from one church to another. A charming, modest fellow, he was a true itinerant pastor caring for his flocks. His favorite recreation, and the eccentricity for which he became widely known, was knitting.

12. Traveling salesman, St. Louis, 1949.
Early in 1949 *Life* assigned me to spend a week on the road with an umbrella salesman. The postwar buying spree was now over, and salesmen suddenly found themselves having to work hard for their commissions. It turned out to be a journey into a world whose existence I had never suspected—a bleak and exhausting world of hotel rooms, endless train rides, clients to be entertained with lunches and dinners, and everywhere the prostitutes who cater to traveling salesmen. I was seeing for the first time a sad, sleazy underside of America. My subject, Bob Brooks, was a happily and faithfully married man who worked in that world but was not himself characteristic of it. He was my guide, my Virgil, and we became friends—as we have remained ever since. But I never use an umbrella.

On the second or third floor of good commercial hotels all over the country are rooms that serve during the day as showrooms for traveling salesmen and double at night as their bedrooms. Here Bob Brooks, surrounded by his wares, reads himself to sleep in a St. Louis hotel.

13. Billy Graham, New York, 1957.
As I recount elsewhere in the book, I went to Ecuador in January 1956 to do a story about a group of American missionaries who had been killed by the tribal people they were hoping to convert. The story received a great deal of attention and established me as an "expert" on missionaries and evangelists. Accordingly, when Billy Graham brought his crusade to New York City in May 1957, *Life* asked me to cover it.

Graham and his entourage were staying at the New Yorker Hotel, on Thirty-fourth Street. When I arrived, I found Graham wearing a baseball cap, which he used to keep his hair from getting mussed. I convinced him to allow me to photograph him in his cap so that people would see that he wasn't God—since God presumably doesn't wear a baseball cap.

I shot the picture reproduced here at Madison Square Garden, as Graham was opening his first appearance with an impassioned invocation.

14. Spectators at an air show, Nevada, 1959.
The World Congress of Flight sponsored this show at Indian Springs Air Force Base, forty-five miles northwest of Las Vegas. One might well assume that these people were witnessing nothing less than a divine revelation. Indeed, it heralded the advent of the Space Age.

15. Seven thousand Ford Motor Company engineers, Dearborn, Michigan, 1959.
In the spring and summer of 1959, I spent three months in Dearborn, photographing the final stages of designing and producing the Ford Falcon, the first American compact car. Amazed and overwhelmed by the amount of talent that Ford was devoting to the development of the Falcon, I realized that it would be fantastic to take a picture of all 10,700 of Ford's staff engineers. But it was no simple matter to get all of these men in one place at one time—especially since it was just one week before a major production deadline, and everyone was working overtime to meet it. Nevertheless, I was determined, and went before the Board of Governors of the Engineering Department to make my plea for permission and cooperation. It turned out that the department's emergency evacuation plan had never been tested, so getting everyone outside for my shot would provide the perfect occasion for a lunchtime drill.

During the few days before this was to take place, I worked frantically

to get everything set up. I needed five Cirkut panoramic cameras, and when I found them they had to be rebuilt. The film for them needed to be specially ordered. And five towers on which to place them had to be built. Although I called on the Engineering Department to help me, nobody could figure out how high the towers needed to be in order for me to get all of the engineers into the picture.

On the appointed day, all went pretty much according to plan—though I was able to get only seven thousand of the engineers for my picture. Every one of them was wearing the white shirt and dark tie that constituted his uniform. In the very front row I placed the engineering high command. Behind them were the 168 men who were directing and coordinating the Falcon project. They had all been working under tremendous pressure, for only nineteen months elapsed between the initial approval of the project and the day when the first production car came off the assembly line. For the actual shot, my role was more that of a director than that of a cameraman. I was up in a cherry picker, giving instructions and coordinating everything—though sometimes it seemed that my most important function was to keep the engineers amused during the hour and a half it took to get everybody and everything in place, to change the films, and to make several exposures.

At seven thousand times what an engineer is paid for an hour and a half's work, this is certainly the most expensive picture I ever took. The incongruity between the little car and the vast force behind it has always delighted me. The idea evidently appealed to many others as well, for my picture served as the model for a generation of similar setups.

17. Ford Motor Company, Dearborn, Michigan, 1959.
Having some years earlier done a story about an anesthesiologist, I was struck by the resemblance between this scene in Ford's Quality Control Center, where machinery for the welding of the Falcon's side panels was being tested, and a hospital operating room.

18. Elderly woman, Philadelphia, 1959.
When my brother was killed in Indochina, my mother was overwhelmed with grief, from which she never recovered. She lived with my wife and me, and we did all we could for her, but her heart was broken and, in her anguish and anger over Bob's death, she made life very difficult for everyone around her. And so it was—in 1959, two years before my mother's death—that Life, which was running a series on old age in America, assigned me to do a story about an elderly woman living with her son and daughter-in-law in Philadelphia.

Although old Annie Mahaffey was Irish instead of Hungarian, she reminded me of my own mother—both were old-school moralists and matriarchs in the tradition of the European extended family. The daughter-in-law made no secret of her resentment of Annie's presence, but my sympathies were all with Annie. I found myself in the midst of a family drama parallel to my own. Here we were on a closed set, a little duplex house that would have fit on a New York stage as a cutaway. And I, the audience, was photographing right onstage. There wasn't even room for my Life researcher, Maya Pines, so I had to become responsible not only for taking the pictures but also for writing down snatches of family dialogue for the captions. I knew the script by heart.

In this situation I tried to make myself invisible and simply to follow the drama as it ran its course from room to room. I had to begin by putting up floodlights throughout the house, so that they would be in place when the action shifted. As the family went about its business, they quickly got used to my switching the floods on and off, and they pretty much ignored my presence. The final joke was that after seven and a half days, I had defused the family tensions to such a degree that there was nothing left to photograph. The tempest was over, and I left.

19–22. The funeral of William Robinson, known as Bojangles, New York, 1949.
Bojangles was a much admired and beloved African-American entertainer whose style of skip tapping across the stage and up and down a flight of stairs became the most imitated dance routine in show business.

When I was assigned by Life to cover his funeral, I decided that I would—as unobtrusively and inconspicuously as possible—photograph individual mourners (of whom there were forty-five thousand over the course of several days) as they filed past the open casket to pay their last respects. I didn't attach a flash to my camera but instead placed strobe lights, which don't blind or distract as flash does, far from the bier, and I crouched low at the head of the casket.

Later, when I photographed along the route of the funeral procession through Harlem, I felt that the condition of the spectators' shoes summed up the economic plight of the neighborhood, and that the position of the shoes expressed the intensity of feeling that these people had for Bojangles. It was estimated that one million people watched the cortege, the largest number of New Yorkers that had ever turned out for such an event.

23–25. Marilyn Monroe and Clark Gable, Nevada, 1960.
Eventually, my work for Life led me to many brief encounters with extraordinary people. One of the most memorable of those was with Marilyn Monroe and Clark Gable in 1960, during the final weeks of shooting John Huston's film The Misfits on location in the desert near Reno.

Monroe and Gable were doing a scene in the front seat of a station wagon. I was on the tailgate with a 200-millimeter telescopic lens. Between takes, Gable gave Monroe some reassurance that obviously pleased her. Then she rested her head wearily and pensively on the back of the seat. A moment of quiet in the midst of bustling activity—a revealing moment.

Because Marilyn was obsessed with getting enough sleep every night so that she would look her best on camera during the day, she was taking barbiturates at night. And then, to get herself going in the morning after her drugged sleep, she had to resort to amphetamines. The drugs were taking their toll; her marriage to playwright Arthur Miller (who had written the film's screenplay) was breaking up under the strain; and she would soon collapse and have to be hospitalized. The Misfits was the last film that either Monroe or Gable would ever make. These photographs of genuine tenderness remain important to me.

26. Harry Belafonte, New York, 1957.
Singer Belafonte and his two-and-a-half-year-old daughter, Shari, in Central Park.

27. Al Jolson, Brooklyn, 1949.
Jolson was best known for his starring role in the 1927 film The Jazz Singer, the first talkie. (I saw that film in Budapest!) In 1946 a movie about Jolson's life, The Jolson Story, was a tremendous success. Three years later a sequel, Jolson Sings Again, was released, and the sixty-three-year-old Jolson (who was played in the films by Larry Parks, lip-syncing to old recordings) made a series of personal appearances to promote it. Here he is belting out "California, Here I Come" at Brooklyn's Alhambra Theater.

28. Jack Paar, Bronxville, New York, 1959.
One of the funniest people I ever photographed was comedian and late-night talk-show host Jack Paar, known for his dry, sardonic humor. Life used as a cover my picture of him smoking a cigar and wearing a rose tucked behind one ear and a football helmet sporting two bull's horns. At his home in the New York suburb of Bronxville, I photographed him in bed with his wife and dog, watching his show, which had been taped earlier that evening. I stood behind the headboard so that you couldn't see the subjects' faces, only their feet. Paar frequently joked that since most people watched his show in bed, they usually saw him framed by a pair of feet. For his show that day he had even had made a huge pair of painted cardboard feet, which he placed on either side of him on the set in the studio.

29. Ralph Ginzburg, New York, 1966.
Ginzburg had conceived and published Eros magazine, a highbrow, hardcover quarterly (many people assumed it was modeled on American Heritage) devoted to the classics of erotic art and literature. He was brought to trial,

convicted of publishing obscene material, and sentenced to a prison term.

Shortly before he was to begin serving his sentence, I went to see Ginzburg at his office, located at Broadway and Twenty-eighth Street, and found him mopping the dingy, cell-like room. He told me that he was preparing himself for prison life. He obviously still had his sense of humor and cooperated with my idea of holding his eyeglasses far away from his face so that in the resulting picture he would look as though he were on television—a talking head.

30. Harold Ross, New York, 1949.

The founding editor of the *New Yorker* magazine, Ross was something of a recluse and was hardly ever photographed. In 1949 he became very upset by advertising messages that were being broadcast loudly and relentlessly over the public address system in New York's Grand Central Station, since he was assaulted by them every day on his way to his office. In editorials he complained bitterly about Grand Central's "attack on a helpless 'captive' audience." Largely at the insistence of *New Yorker* readers, the New York Public Service Commission held a hearing. I photographed him testifying that the commercials constituted "a brutal invasion of privacy and might lead to mental disturbances in the unwilling, frustrated listeners." He further maintained that he had a right to enjoy silence. The commercials were gradually discontinued, and I had gotten a rare photograph.

31. Brooks Atkinson, New York, 1958.

Atkinson, who wrote for the *New York Times*, was the dean of New York drama critics. When he attended a Broadway opening, he would slip out just before the end and walk the few blocks to the *Times* building. Twenty-five minutes later he would hand his finished copy to the printer. It was a handmade job all the way—a far cry from today's computerized journalism.

32–34. Grandma Moses on her 100th birthday, Eagle Bridge, New York, 1960.

Of all my encounters with the famous, the one that I recall most fondly was that with Grandma Moses on her 100th birthday, when I photographed her at her home in Eagle Bridge, a little town in upstate New York. Born Anna Mary Robertson on September 7, 1860, Grandma Moses had taken up painting in her distinctive folk style at the age of seventy-seven, when arthritis forced her to give up heavy farm work. This tiny woman, only five feet tall, was a bundle of energy, vivacious and flirtatious. "The important thing is keepin' busy," she told me. "Two pictures a week is what I'd like to do now," she declared as she gesticulated with her palette knife, "but the weather's been holdin' me up lately. It's been so damp that everythin' is takin' longer to dry." This wonderful old lady was adored by her family, including her great-granddaughter, Christine, age seven. I, too, fell in love—it was a love affair for a day.

BRITAIN

35. Glyndebourne Opera Festival, Sussex, 1951.
38. J. C. Christie, founder of the festival, Sussex, 1951.

Christie had hated Covent Garden's ostentatiously grand productions of Mozart. In 1931, when he married the soprano Audrey Mildmay, he decided to create a small opera house in which Mozart's operas could be performed as the composer meant them to be. On his estate, Glyndebourne, in Sussex, two hours south of London by train, he built a small theater and, beginning in 1934, brought in the cream of Mozart singers and directors for an annual summer festival. Furthermore, he obliged all ticket holders to come in formal dress. The magic worked: Mozart à la mode.

I spent a delightful week at Glyndebourne during the premiere of the first British production of *Idomeneo*, produced by Carl Ebert and conducted by Fritz Busch. Since Mozart is my favorite composer, the story was a natural for me. The week was a joyous, Mozart-filled fairy tale.

36. Archery contestant, the Forest of Arden, Warwickshire, 1950.

In August every year the Woodmen of Arden, a society of British archers founded in 1785, held their Grand Wardmote, or assembly, in the Forest of Arden, in Warwickshire. An archer, clad in the society's traditional green tailcoat and white trousers, rests on his shooting stick between shots.

44. Alec Guinness, London, 1952.

Perched on a railing along Chiswick Mall, beside the Thames, Guinness learns his lines for a new part.

45–48. Alec Guinness, London, 1952.

In 1952 I had the delight of photographing Alec Guinness, who was then starring in *Under the Sycamore Tree* on the London stage. He played a young scientist who ages dramatically during the course of the play. This was the kind of tour de force for which Guinness was becoming famous. He had first become widely known to American audiences in his 1949 film *Kind Hearts and Coronets*, in which he played eight very different roles.

Backstage, he showed me how he transformed himself with makeup. "My head is like an egg," he told me. "I can do anything with it." Tensing or relaxing his facial muscles and applying a few lines with a grease pencil, Guinness (who was thirty-eight at the time) became first a callow youth and then, gradually, a wrinkled old man. What a performance!

49. Alec Guinness, London, 1952.

The actor studies his lines in a backstage dressing room hung with a picture of himself as Hamlet and a painting of galloping horses by his twelve-year-old son, Matthew.

51. Early morning cold baths, Winchester College, Winchester, 1951.

The boys had to begin every day with a cold bath. The technique was to grab the sides of the tub and then plunge in backwards, bottom down and legs up in the air. When I took this picture, the temperature in the room was thirty-five degrees Fahrenheit.

52. Spectators, Winchester College, 1951.

Several generations of Wykhamites (as Winchester boys are known) watching a soccer match. The school has its own form of soccer, which begins with a scrimmage called a hot.

53. Boys entering chapel, Winchester College, 1951.

I became a well-known character on the Winchester campus, and the boys got used to my turning up with cameras and lights not only on public occasions but also at unexpected times in unexpected places. Of course, I tried to remain as inconspicuous as possible and not to call attention to my presence. But it quickly became one of the boys' favorite games to spot "the ubiquitous Mr. Capa" and to point me out, causing all heads to turn toward me and ruining whatever picture I was trying to shoot. This became a serious problem. I was able to get this picture of boater-wearing boys streaming into chapel only because I was lucky enough that none of the boys happened to look up at the tower from which I was shooting. The older boys are going into the main chapel, in the foreground, while the younger ones enter a smaller building to the left.

56. Queen's Guards, London, 1952.

Advanced parade-ground training for the elite Queen's Guards. A metronome marks the pace, and a huge pair of calipers regulates the precise length of each step. The metronome ticks out 116 steps per minute for the "quick-time" pace that the men were practicing.

57. Officer of the Queen's Guards, London, 1952.

An aide dresses an aristocratic officer of the Scots Guards—who had a properly haughty demeanor in full regalia for a formal occasion.

58. Homecoming, Gloucestershire Regiment, England, 1951.

The survivors of the Gloucestershire Regiment's 1st Battalion, which had fought heroically at the battle of the Imjin River in Korea in April 1951 and suffered extremely heavy casualties, arrived in Southampton just before Christmas of that year for six weeks' leave. The reunions with families and

sweethearts were deliriously happy.

59. Vivien Leigh and Laurence Olivier, London, 1951.
The husband-and-wife acting sensation was performing, on alternate nights, Shakespeare's *Antony and Cleopatra* and George Bernard Shaw's *Caesar and Cleopatra*. Here they are seen during a magical moment in the Shakespeare play, as Cleopatra casts her spell over Marc Antony.

60. Judy Garland, London, 1951.
Another poignant encounter was with Judy Garland, in London in 1951. The twenty-eight-year-old singer had been having a hard time with alcoholism, had made a suicide attempt, and had been through a couple of Hollywood divorces. For seventeen years her film career had kept her off the vaudeville stage, but now she was making a comeback concert tour. I photographed her backstage at the Palladium Theater, and then—perched with my tripod at the front of the balcony, and with a long lens on my camera—I made some shots of her performance. She was doing fine until, at one point in a song, she twirled around, lost her balance, and fell down. Her accompanist gallantly went over to help her up, and the audience reassured her with applause and cheers. Then she went on with the show.

AMERICAN POLITICS

63 & 66. State convention, New York, 1954.
In 1954 I covered a state Democratic convention at the armory on Lexington Avenue and Twenty-seventh Street, in New York. James Roosevelt was hoping to be nominated as the party's candidate for governor. But Tammany boss Carmine De Sapio was backing Averell Harriman, who got the nomination. It was a major triumph for De Sapio, who was the perfect visual prototype of a machine politician, with his carefully combed wavy hair and his dark glasses, which he wore under all lighting conditions. He was the sinister kingmaker—and looked it.

68. Adlai Stevenson, Libertyville, Illinois, 1952.
Stevenson sits under an oak tree on his farm, considering whether to seek the Democratic party's nomination for the presidency.

70. Adlai Stevenson, New York, 1952.
A Stevenson campaign parade along New York's Forty-second Street, past the Public Library.

71. Adlai Stevenson, Lewiston, Idaho, 1952.
Stevenson lassoed by cowboy Montie Montana at a rodeo—one of the indignities to which the American public insists that candidates for high office submit with good cheer.

74. Parade spectators, Washington, D.C., 1953.
These women, who were watching Eisenhower's inaugural parade, caught my eye because they looked so *very* Republican.

75. Frances Perkins, Washington, D.C., 1953.
Frances Perkins had been Franklin Roosevelt's secretary of labor throughout his twelve years in office and the first female Cabinet member in U.S. history. I photographed her on her seventy-first birthday, which happened to be the last day of her twenty years in government service. She was the last of FDR's original New Dealers to leave office. After FDR's death, she had been a civil service commissioner for seven years; she submitted her resignation on the day of Eisenhower's inauguration. When she cleaned out her desk on her last day, she found not only letters from three presidents but also pieces of string that she had saved in anticipation of wartime shortages.

76. John Foster Dulles, Saratoga Springs, New York, 1949.
Dulles working on a speech in his hotel room while he was campaigning for a U.S. Senate seat from New York. The arch-Republican Dulles was making much of the fact that his Democratic opponent, Herbert Lehman, had received the endorsement of the American Labor party, which was

said to be dominated by Communists. Lehman retorted that Dulles was hopelessly conservative as well as anti-Semitic. Dulles lost the election.

77. Richard M. Nixon and his wife, Pat, as he campaigns for the presidency, Oregon, 1960.
I was fascinated by the loving, admiring looks that Pat Nixon gave her husband while he was speaking. It was as if she were transfixed, listening to God. She worked hard on the campaign trail, smiled on cue, and was a real asset to him.

78. The hands of John F. Kennedy, California, 1960.
I took this photograph early in the 1960 presidential campaign. JFK was standing on a flatbed truck in the parking lot of a mall. I was on the truck, on my knees, using a very wide-angle lens. I was trying to get lower and lower so that I could be on the level of people's faces. Before I knew it, I was sitting on Kennedy's shoes. Kennedy didn't *shake* hands; he allowed his hands to be touched.

79. John F. Kennedy and his wife, Jackie, New York, 1960.
Jackie worked hard in the campaign, even though she was already quite visibly pregnant, with her son, John-John.

80. Jackie Kennedy, the White House, 1961.
I was hanging around in the secretaries' room at the White House one early March afternoon when I looked out the window and saw Jackie, outside on the snow-speckled grounds, pushing three-month-old John-John in his carriage. Young, energetic, and proud, Jackie was the perfect symbol for the new administration.

84. Robert F. Kennedy, 1964.
I sat across from Bobby Kennedy on board the Kennedy plane as we were flying to Albany on the first morning of his senatorial campaign. I took this troubled close-up portrait with a telephoto lens.

87. Robert F. Kennedy campaigning in Buffalo, 1964.
Although Kennedy's pose appears to be one of exhaustion or exasperation, he often made such gestures to provide a bit of comic relief and to establish a sympathetic rapport with his audience.

88. Advisers of right-wing conservative presidential candidate Senator Barry Goldwater, 1964.
The man seated with his hands resting on his knees is Goldwater's chief of staff, Denison Kitchel.

89. Senator Barry Goldwater campaigning for the presidency, Phoenix, 1964.
At a rally in his hometown, Goldwater shakes the "hand" of the arm-extension device proffered by a short but determined supporter.

93. Vice-President Hubert H. Humphrey, Democratic National Convention, 1968.
During the 1968 Democratic convention in Chicago, I got the big break—or so I thought—of being in Hubert Humphrey's hotel room during the delegate count. There he was, toting up the delegates on a yellow pad, when we began to notice a horrible smell coming from the streets below. The police were using tear gas against the demonstrators. The street was the place for a photojournalist to be at that moment, and the hotel room was about the worst. The situation struck me as symbolic of HHH's plight. He was always taking the wrong turn. He was a nice man, a great speaker, and a true liberal—but he never seemed to accomplish much.

JUDAISM and ISRAEL

104. Hebrew lesson, Brooklyn, 1955.
This scene, of three boys studying the Torah in a Hasidic *cheder* (a pre-primary Hebrew school) in the Williamsburg section of Brooklyn in 1955, is universal and timeless. The youngsters, who cannot yet read, sway back

and forth as they chant the scriptural verses they have memorized, while the rabbi's right hand indicates the correct rhythm for the chant. I was standing straight up while I framed my shot, but then Josefa Stuart, the *Life* researcher with whom I was working, gently put her hand on my shoulder and pushed me down to take the picture from a lower angle. She was so right.

105. Soldier in prayer, Six-Day War, Negev Desert, Israel, 1967.
Early morning prayers, in the Negev, near Beersheba.

106. Soldiers, Six-Day War, Sinai Desert, 1967.
Micha Bar-am and I had just crossed the border into Egypt. It was about six o'clock in the morning, and the men of this Israeli antiaircraft unit were having their early prayer session. Suddenly several Syrian strafers came over. The Israelis vacillated about whether to go on praying or to shoot at the planes. They prayed, and the planes left without attacking us.

107. Palestinian, the West Bank, 1967.
This Palestinian in the town of Qalqiliya, on the newly occupied West Bank, was furious at the Israelis for having destroyed his house. He was calling down the wrath of Heaven, saying, "God will punish you!"

The Six-Day War had destroyed half of this town, whose name fittingly means "unrest." Because of Qalqiliya's strategic position on high ground, the Arabs have traditionally called it the gate to Palestine. During the war the Jordanian artillery just outside the town shelled Tel Aviv, twelve miles away. When the Israelis took Qalqiliya, they dynamited houses in which they believed snipers were hiding. The Arabs charged that the Israelis had trumped up the claim of snipers as a pretext for inflicting brutal punishment on the town.

108. Egyptian soldiers captured by the Israelis, El Qantara, on the east shore of the Suez Canal, 1967.
Many of these men had walked across 150 miles of desert, their feet wrapped in rags, to reach the canal, where they had surrendered to the Israelis. They were now to be released and were waiting for Israeli-provided ferries to carry them to the Egyptian-occupied bank of the canal.

111. A United Nations relief worker with Palestinian refugees, Jordan, 1967.
Registration for food at a United Nations Relief and Works Agency camp. Papers and more papers. The young girl's face continues to haunt me.

INDIANS and MISSIONARIES

120–121. Expedition to locate missionaries, Ecuador, 1956.
On Thursday, January 12, 1956, a helicopter of the U.S. Air Force Air Rescue Service, based in Panama, spotted the bodies of four of the five missionaries who had been killed by the Aucas. The helicopter team also located what was left of the little plane in which the missionaries had flown to their base ("Palm Beach") on the Curaray River. By radio the helicopter crew directed a ground party of missionaries, tribal converts, and soldiers (led by U.S. Air Force major Malcolm Nurnberg) slowly making its way through the jungle and along the river to bury the bodies. The threat of an Auca ambush haunted every step.

On the morning of Friday, January 13, the ground party kept its rendezvous with the helicopter on Palm Beach. I was in the chopper, which was to swoop in and drop me on the beach. Here is my account of what happened, written soon after the events:

"We floated above the jungle about two hundred feet over the treetops. The naval mission plane circling overhead did not let us out of their sight. Suddenly the sun disappeared and we headed into a tropical storm. The pilot looked grim and wasted not a minute landing on Palm Beach.

"The atmosphere on the beach was fantastic. Everybody's hand was

on the trigger, looking toward the jungle. I did not have to ask why. The rain was coming down in buckets; my handkerchief served no more to clean my water-soaked lenses. Suddenly I saw a struggling group of men carrying the last of the missionaries to his common grave. He was on an improvised stretcher, made out of the aluminum sheets that had covered the tree house where the men had lived.

"It was a terrible sight. The light was eerie. The pallbearers struggled against a muddy bank that led to the grave. I made it in time to see the lifeless legs disappearing into the hole. Grim, weary missionaries looked for the last time at their friends, whom they could no more identify. One said: 'It's better this way. I feel less miserable.' They lingered for a moment, offering up a few words of prayer. At the end, Major Nurnberg, facing the jungle with carbine in hand, turned back toward the small knot of men about the grave and called: 'Let's get out of here!'

"The rain let up a bit, the helicopter was ready to leave, and the time was near for decision. I could either go back with the pilot or stay with the ground party starting the overnight homeward trek. It was an easy decision. To leave now would be cheating. I gave my exposed film to the pilot. The struggle of the living to stay alive had just begun.

"At last, we were off. The canoes were overloaded, and at the slightest movement water poured through the side. This was to be no fun at all, I thought quietly to myself. Major Nurnberg was in front with his carbine and I could see from the back of his head that he had a mean look in his eyes. Nurnberg leaned back on Dee Short (a redheaded, *very* long-legged missionary, in a very small boat), who in turn leaned on me, and I leaned on the dismounted wheel of the ill-fated plane that we had salvaged. My back ached. Like a mother hen, I tried to protect my film pouches and to hide my cameras from the rain. It was futile.

"Soon my rangefinder clouded up. I had to guess the focus. A little later my viewfinder fogged up as well. Now I only aimed the camera and prayed—like a missionary—that it was pointed in the right direction.

"In and out of the canoe...marching with water squelching out of my boots. Anxious eyes everywhere. I unbuttoned my .45 holster. Fortunately, no sign of Aucas. This lasted for about two hours; then it was time to bed down for the night.

"Major Nurnberg, missionary Frank Drown, and the Ecuadorian underofficer picked an open site for the camp. Their aim was to give us a chance to spot the Aucas before they had a chance to throw their spears. Guards were posted all around the perimeter and changed every two hours. We had a meal, cooked by one of the missionaries. Shelters were erected from the metal sheets we carried, and palm leaves formed the side walls and the floor. It was a temporary paradise.

"Missionary Don Johnson, sitting in the darkness of the house, buried his face in his hands, and offered a prayer. He thanked the Lord for helping him to reach and bury their friends. Then, with great feeling, he evoked the modest and loved characters of the departed men. In the darkness of the night, with the firelight flickering on his face, and the sound of the jungle birds and pumas' groans punctuating the air, this clearly spoken 'conversation' with God was of great emotional impact. Don was not expressing sorrow for the departed so much as testifying to his faith in the Lord's will. When he finished only the crackling of the campfire filled the air.

"But there was to be no sleep. All through the night we were in a wakeful readiness. The rushing waters of the river Curaray were always in the background. There was the sound of an occasional tree falling to set off the trigger fingers of the nervous guards. And at intervals came the beams from their flashlights as the guards made their rounds. Slowly dawn came and our nervousness increased, for this was the hour, we had been told, when the Aucas liked to attack. Our Indian guides stirred, particularly when they heard the continuing sounds of a puma. The Aucas are well known for their clever imitations of jungle animals, and the guides were sure that

in the shadows of the early morning light our 'neighbors' were everywhere. Major Nurnberg crawled forward and with a sudden burst of fire silenced the 'puma.'

"Breakfast was oatmeal and coffee. Then we collected our gear and the march was on. Dried socks became wet again. The searching eyes and ready fingers of Nurnberg and Drown brought up the rear. Sudden excitement: the chopper appeared overhead, always watched by its 'big brother,' the navy's R4D. Suddenly the twentieth century descended in the wilderness of the jungle. The helicopter had come for me.... As I took off I was sorry to leave my friends, but, no, not sorry to leave."

122. Missionaries' widows, Shell Mera, Ecuador, 1956.
On Sunday, January 15, the five widows gathered around the kitchen table in the mission house in Shell Mera to listen to Dr. Art Johnson's account of the expedition. From left to right are Marilou McCully, Barbara Youderian, Marj Saint, Olive Fleming, and Elisabeth Elliot. The women accepted what had happened as part of God's grand plan, and they vowed to carry on the work their husbands had begun.

125. Indian and missionary pilot, Ecuador, 1957.
In 1957, I flew with missionary pilot Hobey Lowrance to pay a visit to the Atshuara tribe, a short distance south of the Aucas' territory. Here a tribesman watches with curiosity as Lowrance makes a scheduled radio check-in with his wife, who is back at the missionary base.

126. Indians and missionary in prayer, Peru, 1963.
Robert Russell of the Wycliffe Bible Translators leading a group of Amahuacas in a prayer session. He had made a tape of Christian prayers in the Amahuaca language and played it back. To the Amahuacas, it seemed that God was speaking to them from the magic box.

128. An Amahuaca family, Peru, 1963.
Although the tribe was, for the most part, still maintaining a Stone Age way of life, the modern world was already beginning to make an impact. Note, for instance, that the man in the family portrait is wearing a wedding ring.

132. Indian with a young student, Peru, 1963.
Santos Carion Silvano had left his tribe, the Campas, gone to a mission school to get an education, and then returned to his tribe as a bilingual teacher and minister. "I will lead you to the Promised Land," he told his people, who lived in the community of Mato Veni, on the Rio Tambo, in Peru.

133. Indian minister addressing his tribesmen, Peru, 1963.
Santos Carion Silvano preaches to his people beside the Rio Tambo. The scene looks strikingly like one of nearly two thousand years earlier, when Christ preached on the shores of the Sea of Galilee.

LATIN AMERICA

135. Juan Perón, Buenos Aires, Argentina, 1955.
During a visit to a boys' club he had established, the Argentine dictator hands out wallets containing 1,000-peso notes as prizes for the winners of a basketball tournament.

136. General René Barrientos Ortuño, La Paz, Bolivia, 1964.
Barrientos was the head of the military junta that had seized power in Bolivia in November 1964, about a month before I photographed him. He later led the troops that killed Ernesto "Che" Guevara in the Bolivian jungle in October 1967.

137. Political dissidents, Managua, Nicaragua, 1956.
On September 21, 1956, Anastasio Somoza, the fun-loving dictator of Nicaragua, was celebrating his renomination, and thus his certain reelection,

to the presidency. He was living it up in his characteristic style—dancing the cha-cha at a provincial festival—when he was shot four times by a youth whom the police later called a would-be poet with psychopathic tendencies. Somoza was flown to an American hospital in Panama, and President Eisenhower sent a medical team in an attempt to save the dictator's life, but he died eight days later.

Suspecting a conspiracy behind the assassination and fearing a revolution, the Guardia Nacional arrested about a thousand known opponents to the Somoza regime immediately after the shooting. I went to the prison to see all the suspects and "political undesirables" who had been rounded up. After I had been photographing for a minute or two, a guard on the ramp above yelled, but I didn't realize that he was yelling at me. Jerry Hannifin, a friend and *Time* correspondent, who was with me, grabbed my arm and, calling me by my Spanish nickname, said, "Capita! He says he is going to shoot you if you don't stop taking pictures." The incident gave me good incentive for improving my Spanish.

138. Parading troops, Buenos Aires, Argentina, 1955.
Perón's goose-stepping army, which had recently crushed a revolt, parades in honor of José de San Martin, Argentina's liberator.

139. Bonfire of Peronist propaganda, Buenos Aires, Argentina, 1955.
The army's triumph was short-lived, for Perón was finally overthrown in September 1955. Here, after the coup, some of the long-suppressed opponents of the dictatorial regime are burning Peronist propaganda.

140. Priest addressing a crowd, Macau, northeastern Brazil, 1962.
A radical priest, Padre José Luis, encouraging poor tenant farmers to form a syndicate to protect themselves against the ruthless landlords, who exploited the farmers mercilessly and did not hesitate to expel uncooperative tenants from their home and land.

142. Priest and a peasant family, northeastern Brazil, 1962.
An unjust landlord had driven this tenant family off his plantation. Escorted by armed men, the landlord threatened to kill his tenant if he tried to return.

An activist priest, Padre Paulo Crespo, here reassures the expelled family that he will help them. The padre got in touch with the local tenant-farmers' syndicate, whose legal staff went into action. He also obtained an interview with the state police chief, who issued an order forcing the landlord to reinstate his tenant, to return the tenant's possessions (which had been confiscated), and to guarantee his safety. The situation was resolved without violence.

145. Demonstration, Buenos Aires, Argentina, August 1955.
Supporters of Juan Perón massed in the Plaza de Mayo when the dictator hypocritically announced his intention to resign—precisely in order to provoke such an outburst by his enthusiastic adherents.

146. Anti-Peronists, Buenos Aires, Argentina, September 1955.
Supporters of the coup against Perón climb trees near the harbor to cheer the arriving Argentine naval ship *General Belgrano*. The navy played a decisive role in Perón's overthrow.

151. Row of graves, Recife, northeastern Brazil, 1962.
The infant mortality rate was so high that a row of children's graves was dug in the Recife cemetery every morning to receive the little coffins that would arrive during the day. Since death was commonplace there, neither parents nor priests even bothered to accompany the coffins that bands of children carried from the peasant quarter. Whenever the children encountered friends along the way, they would gaily open the coffin to show off the flower-bedecked corpse inside. Even to young children, death was no stranger.

BIOGRAPHICAL CHRONOLOGY

1918
Born Cornel Friedmann on April 10, in Budapest, Hungary. His parents owned a prosperous dressmaking salon, in which his father worked as the head tailor. The family lived in a large apartment building at Városház utca 10.

1924–32
Attended the Evangelisches primary school, in Budapest.

1936
Graduated from the Imre Madách Gymnasium (high school), in Budapest. Intending to study medicine, joined his brother André (Robert Capa) in Paris. Began printing photographs by Robert Capa, Chim (David Seymour), and Henri Cartier-Bresson.

1937
Moved to New York, where he got a job in the darkroom of the Pix photo agency, which represented his brother Robert.

1938
Began working in *Life* magazine's darkroom. Met many leading photojournalists and was inspired by their work.

1939
Had first photo story published: the New York World's Fair, in the British magazine *Picture Post*. Also shot stop-action flash photos of jitterbuggers in Harlem.

1941–46
Worked in the U.S. Air Force Photo-Intelligence Unit and then for U.S.A.F. public relations.

1944
Became an American citizen and officially changed his name to Cornell Capa.

1946
Became a *Life* staff photographer.

1946–49
Worked on some 300 *Life* assignments, which took him all over the United States and dealt with subjects ranging from a Miss America contest to a rooster-crowing competition, and from a ten-car accident in New York City to tornado damage in the Midwest. From late 1946 to early 1948 was *Life* photographer for the southwestern United States, based in Dallas. His work during this period provided the young photographer with a fascinating education in American culture, but he felt frustrated by the trivial nature of the majority of his assignments.

1950–52
Served as *Life*'s resident photographer in England. CC has called this "one of the most wonderful periods of my life." At this time he was able to begin working consistently on serious and satisfying photo essays. He hoped to complete a trilogy of essays about how English boys are transformed into great Englishmen. The first part dealt with the exclusive Winchester boarding school, and the second with the elite Queen's Guards. The third part, which was to deal with the Foreign Office, never was begun.

1952
Returned to the United States. Covered Adlai Stevenson's presidential campaign. Admired Stevenson greatly and supported his cause enthusiastically. The photographer and the politician became friends, and CC would cover Stevenson's subsequent bids for the presidency in 1956 and 1960. From 1952 until the late 1960s, American politics would remain one of CC's foremost preoccupations; his documentation of politics would range from town meetings to national conventions and from local politicians to most of the presidential candidates.

1953
Made his first trip to Latin America, where he would spend much time—and do some of his most important work—over the course of the next twenty years. On this first trip he did a story about Guatemala's leftist government and one about Venezuela's economic boom.

1954
Worked (in New York and Connecticut) on a *Life* story about the education of mentally retarded children. The story was a breakthrough, for until then the subject of retarded children had been regarded by most American magazines as taboo. The *Life* story, published in two parts, drew such a favorable response from the public that Capa, together with writer Maya Pines, expanded it into a book entitled *Retarded Children Can Be Helped*. During this year, also worked on an extensive story about Judaism for the *Life* series "The World's Great Religions."
Robert Capa was killed in Indochina on May 25. CC resigned from the *Life* staff and joined Magnum, the cooperative photo agency of which his brother had been one of the founders.

1955
Spent six months in South America, mostly in Argentina. Did a major photo story about the Perón government, which was stepping up its efforts to repress the increasingly vocal opposition. Capa remained in Buenos Aires to document the revolution that successfully overthrew Perón.

1956
Went to Ecuador in January to accompany the searchers who went into the jungle to confirm a report that five American missionaries had been killed by the Indians they had hoped to convert to Christianity. After the bodies were found, the searchers returned to the missionaries' base and informed the widows, who vowed to carry on the work that their husbands had begun.
Later in the year CC covered the Democratic National Convention and Adlai Stevenson's presidential campaign.
Became president of Magnum.

1957
Returned to Ecuador to photograph one of the widows of the missionaries, Elisabeth Elliot, who was having great success in working with the Aucas, the tribe that had killed her husband.

1958
Spent six weeks in the Soviet Union, working primarily on a story about Russian Orthodoxy for *Life*. While there, also photographed Boris Pasternak at his country house and did a story on the Bolshoi Ballet School. Because of his constant frustration in dealing with the official bureaucracy and with church functionaries, CC has called his stay in the Soviet Union the most miserable time in his life. Nevertheless, during that trip he shot many of his greatest photographs.

1959
Worked on two major photo stories: one about an elderly woman living with her son and daughter-in-law in Philadelphia and one about the development and production of the Ford Falcon, the first American compact car.

1960
Covered the Democratic National Convention and John F. Kennedy's presidential campaign. Major nonpolitical story: folk painter Grandma Moses on her 100th birthday.

1961
Acted as conceiver of, major contributor to, and photo editor of the book *Let Us Begin: The First 100 Days of the Kennedy Administration*. All photos in the book were taken by Magnum photographers.

1961–64

Spent much time in South America, particularly working on a book (*Farewell to Eden*) of photographs of the Amahuacas, a Peruvian tribe that still maintained a Stone Age culture and that had been visited by very few whites. CC was enchanted by the Amahuacas, who seemed to be living in paradise before the Fall, and he felt that it was vital to document their way of life before it disappeared completely. When CC returned to the United States, he had a fresh perspective on American life; he recognized that "advanced" cultures, just like primitive ones, have their "tribal" rituals—and so he began a project to photograph American customs from that point of view.

1964

Covered Robert F. Kennedy's campaign for the Senate and Barry Goldwater's campaign for the presidency.
Organized the exhibition "The Concerned Photographer," which opened in New York and traveled through the United States, Europe, and Israel.

1965

Covered the important New York City mayoral campaign, in which John Lindsay, William Buckley, and Abraham Beame were running.

1967

Finding himself in Israel at the outbreak of the Six-Day War, CC—who, in deliberate contrast to his brother, was a photographer of peace—decided to stay and cover the war.

1968

Photographed the Democratic National Convention and presidential candidates.

1970–73

Undertook a major photographic documentation of poverty in Latin America, focusing on El Salvador and Honduras. This work was published in 1974 as a book, entitled *Margin of Life*.

1973

Photographed missionaries and tribal life in Papua New Guinea.

1974

Founded the International Center of Photography, in New York City. He remains the director of ICP to the present day.

BIBLIOGRAPHY

Books By and About Cornell Capa

Retarded Children Can Be Helped. Text by Maya Pines. Photographs by Cornell Capa. New York: Channel Press, 1957.

Through Gates of Splendor. Text by Elisabeth Elliot. Photographs by Cornell Capa. New York: Harper and Row, 1957.

Savage My Kinsman. Text by Elisabeth Elliot. Photographs by Cornell Capa and Elisabeth Elliot. New York: Harper and Row, 1959.

Let Us Begin: The First 100 Days of the Kennedy Administration. Cornell Capa, photo editor and contributing photographer. New York: Simon and Schuster, 1961.

Who Brought the Word. Photographs and photo editing by Cornell Capa. Santa Ana, Calif.: Wycliffe Bible Translators in cooperation with the Summer Institute of Linguistics, 1963.

Farewell to Eden. Text by Matthew Huxley. Photographs by Cornell Capa and Robert Russell. New York: Harper and Row, 1964.

Adlai Stevenson's Public Years. Photographs by Cornell Capa, Inge Morath, and John Fell Stevenson. New York: Grossman, 1966.

The Andean Republics. (Time-Life World Library Series.) Photographs by Cornell Capa and others. New York: Time-Life Books, 1966.

The Emergent Decade: Latin American Painters and Painting in the 1960s. Text by Thomas Messer. Photographs by Cornell Capa. Ithaca, N.Y.: Cornell University Press, 1966.

Swift Sword: The Historical Record of Israel's Victory, June 1967. Text by S.L.A. Marshall. Photographs by Cornell Capa and others. New York: American Heritage, 1967.

The Concerned Photographer. Edited by Cornell Capa. New York: Grossman, 1968.

Israel/The Reality. Cornell Capa, editor and contributing photographer. New York: World Publishing, 1969.

New Breed on Wall Street. Text by Martin Mayer. Photographs by Cornell Capa. New York: Macmillan, 1969.

Behind the Great Wall of China. Edited by Cornell Capa. New York: Metropolitan Museum of Art and New York Graphic Society, 1972.

The Concerned Photographer 2. Edited by Cornell Capa. New York: Grossman, 1972.

Language and Faith. Photographs by Cornell Capa. New York: Wycliffe Bible Translators, 1972.

Jerusalem: City of Mankind. Edited by Cornell Capa. New York: Grossman, 1974.

Margin of Life: Population and Poverty in the Americas. Text by J. Mayone Stycos. Photographs by Cornell Capa. New York: Grossman, 1974.

ICP Library of Photographers. Edited by Cornell Capa. New York: Grossman and International Center of Photography, 1974–79. (7 vols.: *Robert Capa, Werner Bischof, David Seymour—"Chim," Lewis W. Hine, Dan Weiner, Roman Vishniac,* and *Lucien Aigner*.)

Great Photo Essays from LIFE. Edited by Maitland Edey. Photographs by Cornell Capa and others. Boston: New York Graphic Society, 1978.

Cornell Capa. (I Grandi Fotografi Serie Argento.) Milan: Fabbri, 1983.

Selected Articles About Cornell Capa

"Cornell Capa." *Camera* (Lucerne), October 1963.

"Cornell Capa l'Universel." *Photo* (Paris), June 1968.

Edelson, Michael. "The Ten-Year Odyssey of Cornell Capa." *Camera 35* (New York), March 1978.

Fondiller, Harvey. "ICP: Photography's Fabulous New Center." *Popular Photography* (New York), April 1975.

Gutman, Judith Mara. "By the Seat of His Pants." *Connoisseur* (New York), November 1986.

Schreiber, Norman. "The Concerns of Cornell Capa." *Camera Arts* (New York), November/December 1980.

Whelan, Richard. "Lighthouse of Photography." *ARTnews* (New York), April 1979.

Selected Published Photo Essays
by Cornell Capa

An asterisk (*) following the issue date indicates that not all of the story's photographs are by Cornell Capa. With a few exceptions, only the first major American or British publication of any story is given. Many photo essays were subsequently published abroad.

1939
[New York World's Fair.] Photographs by CC and Yale Joel. *Picture Post* (London), June 17 (cover date; inside dated June 3).*

[Czechoslovakian government in exile.] *Picture Post* (London), December 9 (cover date; inside dated November 25).*

1946
"Some Veterans Get Temporary Homes as Fight over Permanent Solution Rages." [Quonset hut model home in Springfield, Massachusetts.] *Life*, April 15.*

"William Thon—U.S. artist who became a sailor paints moody pictures of the sea." *Life*, April 29.*

"*Life* Goes to an Ideal Children's Party." *Life*, May 20.

[The first commercial television programs.] *Life*, May 27.

[Production of *Annie Get Your Gun* on Broadway.] *Life*, June 3.*

[Minister in a West Virginia mining town.] *Life*, June 24.

"The Diaper Derby." *Life*, August 5.

"*Life* Visits Cape Cod." Cover and photo essay by CC. *Life*, September 2.

[Rorschach tests.] *Life*, October 7.

[Indian tribe donates Thomas Jefferson letter.] *Life*, December 2.

[Hearing into charges that U.S. senator Theodore G. Bilbo used intimidation to prevent Mississippi blacks from voting.] *Life*, December 16.

[New luxury liner: S.S. *Del Norte*.] *Life*, December 23.

1947
"Paraplegic's Home Is Made to Order." *Life*, January 13.

[A Texas businessman imports bubble gum and corners the market.] *Life*, February 3.

[Clint Hartung, a rookie on the New York Giants baseball team, in his hometown of Hondo, Texas.] *Life*, February 24.

[Father's Day at the Hockaday School in Dallas.] Cover and photo essay by CC. *Life*, March 10.

"Vacationing Elephants." *Life*, April 28.

[Fashion show at the Flying L Ranch, a Texas dude ranch with planes as well as horses.] *Life*, May 26.

"The Executive Bus. It is a land yacht and business office on wheels." *Life*, July 14.

"Brahmin Cattle—U.S. ranchers use the sacred animal of India to improve their herds." *Life*, August 25.

"Kissin' Jim's Busy Weekend: Alabama's Governor Folsom attends Texas festival and every pretty girl in sight knows he is there." *Life*, November 10.

"Amateur Professionals—The Phillips basketball team works for money and plays for recreation." *Life*, December 8.

1948
[Football games and bowl queens.] *Life*, January 12.

"Crowing Contest. Rooster owners coax their birds to strut and cry for the movies." *Life*, January 26.

"Southwest Has a New Crop of Super Rich." *Life*, April 5.

"The Zacchinis. A lively Italian-American family earns its living being shot from cannons." *Life*, April 26.

"G.O.P. Prepares to Name a President." *Life*, June 21.*

"*Life* Visits an Amateur Gardener." *Life*, July 5.*

"The Warren Children." [The three daughters of Republican vice-presidential candidate Earl Warren visit New York City.] *Life*, July 26.*

"Thousands Stand in Rain for Babe Ruth's Funeral." *Life*, August 30.*

"Fuller Brush Girls." *Life*, September 13.

"The World of Mirth." [A carnival.] *Life*, September 13.

"One Engine for Everything. The Army's new small, light motor will power tanks, trucks, and guns." *Life*, October 11.

[A ten-car automobile accident in New York City.] *Life*, November 8.

[Testing a fire engine developed to put out fires of crashed planes.] *Life*, November 8.

[Waiting for presidential election returns at Democratic party headquarters in New York.] *Life*, November 15.

[Displaced persons from Europe arriving at Grand Central Terminal in New York.] *Life*, November 22.*

[Using plastic skulls to test airplane safety features.] *Life*, November 22.*

[Television programs.] *Life*, December 6.*

"Ziegfeld's Girls Hold a Reunion." *Life*, December 13.*

"Hot Stove Topic No. 1. Substitution rule stirs football controversy." *Life*, December 20.

"*Life* Goes to an Office Christmas Party." *Life*, December 27.

1949
"*Life* Goes to the Old Guard Ball." *Life*, February 14.

[Rudy Vallee makes a comeback.] *Life*, March 21.

"Businessman Artist." [Bjarne Klaussen.] *Life*, March 28.

"After Ten Years. C.C.N.Y. alumni gather to read prophecies they made as seniors in 1939, when the future looked black." *Life*, April 4.

[Winston Churchill in Boston.] *Life*, April 11.*

[A Cuban collector buys a manuscript copy of Lincoln's Gettysburg Address.] *Life*, May 16.*

"Traveling Salesman." *Life*, May 23.

"*Life* Visits Palumbo's. In Philadelphia nearly everyone has his wedding party in an Italian restaurant on Catherine Street." *Life*, June 27.

"Jolson Sings Again." *Life*, September 12.*

"Breaking Into Television." [Eva Marie Saint.] *Life*, September 19.

"*Life* Visits the Lydia Pinkham Factory." [Patent-medicine pills.] *Life*, September 19.*

[John Foster Dulles campaigning for one of New York State's seats in the U.S. Senate.] *Life*, October 31.

[Portrait of John Dewey on his ninetieth birthday.] *Life*, October 31.

"Goodbye to Bojangles." *Life*, December 12.*

1950
"Noise Annoys 'New Yorker.' Magazine leads attack on Grand Central commercials." *Life*, January 9.

"*Life* Attends the DuPont Reunion." [One hundred fiftieth anniversary of dynasty founder's arrival in America.] *Life*, January 16.*

[Sunday in the town of Mexico, Missouri.] *Life*, January 23.*

"Women of Steel Give the Top Brass a Hard Time." [Women holding stock in the U.S. Steel Corporation voice strong protests at a shareholders' meeting.] *Life*, March 13.

"Harlem's Debutante Cotillion." *Life*, April 10.*

"*Life* Goes to Queen Charlotte's Ball." Photographs by CC and Larry Burrows. *Life*, June 5.

"*Life* Goes to the Grand Wardmote. Britons draw their longbows at tourney in Forest of Arden." *Life*, September 4.

[Irene Dunne as Queen Victoria in the film *The Mudlark*.] *Life*, September 11.*

[Conference celebrating the fiftieth anniversary of the founding of Britain's Labor party.] *Life*, October 23.*

[George Bernard Shaw's house after his death.] *Life*, November 20.*

1951
[British women buying rationed meat.] *Life*, February 19.

"*Life* Visits the Cincinnati Literary Club." *Life*, March 26.

[Winchester College, an English boarding school.] *Life*, April 2.

[Judy Garland falls onstage while performing in London.] *Life*, April 23.

"British Football." *Life*, May 7.*

[The Festival of Britain.] *Life*, May 14.*

"New Refuge for Amboinese." *Life*, May 28.

[The Glyndebourne Opera Festival.] *Life*, July 23.

[Norwegian regatta.] *Life*, August 6.*

"*Life* Goes to a Palace Warming in Venice." *Life*, September 24.*

"Glum Laborites Face an Election." *Life*, October 15.*

"A Disenchanted Castle." *Life*, October 22.

[Laurence Olivier and Vivien Leigh in Shakespeare's *Antony and Cleopatra* and Shaw's *Caesar and Cleopatra*.] *Life*, December 17.

1952
"The Gloucesters Get Back." *Life*, January 7.

[British faith healer.] *Life*, April 14.

[Eisenhower's farewell to NATO.] Photographs by CC and Robert Capa. *Life*, May 12.*

[Adlai Stevenson's three sons with Earl Warren's three daughters.] *Life*, July 14.

"Adlai Stevenson. Democrats' best foot is reluctant to put himself forward." *Life*, July 21.

[The Democratic National Convention.] *Life*, July 21.*

[Adlai Stevenson.] *Life*, August 4.*

"The Comforter. Anesthesiologist uses medicine's newest weapons to fight pain." *Life*, August 25 (photographs taken in 1949).

[Adlai Stevenson.] *Life*, September 15.*

[Adlai Stevenson.] *Life*, September 22.*

"Melting Pot Politics." *Life*, October 27.

[Adlai Stevenson.] *Life*, November 3.*

[Alec Guinness.] *Life*, November 24.*

[Shirley Booth.] *Life*, December 1.

1953
"*Life* Goes to a Party for Adlai's Sons." *Life*, January 19.*

[Eisenhower's inauguration.] *Life*, February 2.*

[William J. McCormack, the shadowy "Mr. Big" of New York's docks.] *Life*, February 9.

[The Queen's Guards.] Cover and photo essay by CC. *Life*, February 16.

[Adlai Stevenson.] *Life*, March 2.*

[Igor Stravinsky conducting the premiere of his opera *The Rake's Progress*.] *Life*, March 23.

[Mayor Vincent Impellitteri asks Governor Thomas Dewey for financial aid for New York.] Photographs by CC and Yale Joel. *Life*, March 23.*

[Women in Vermont politics.] *Life*, April 6.

[Frances Perkins's retirement.] *Life*, April 20.

"The Red Outpost in Central America. Guatemala's Communists thrive under fellow-traveler government." *Life*, October 12.

1954
"New Latin Boom Land. Mineral riches send Venezuela on a building and buying spree." *Life*, September 13.

"Retarded Children." *Life*, October 18.

"A Future for the Retarded." *Life*, October 25.

[Scottish games.] *Sports Illustrated*, November 20.

1955
"The Cotswolds." *Holiday*, January.

[Judaism.] Cover by CC. Photo essay by CC and Alfred Eisenstaedt. *Life*, June 13.*

[The last days of Juan Perón's regime, in Argentina.] *Life*, September 12.

[The overthrow of Perón.] *Life*, October 3.*

"Life at High Altitudes." [Institute of Andean Biology.] *Scientific American*, December 3.

1956
[The search for the bodies of five American missionaries who had been killed by the Auca Indians in Ecuador.] *Life*, January 30.

[Adlai Stevenson.] Cover and miscellaneous photos inside by CC. *Life*, August 27.*

1957
[Widows of missionaries in Ecuador.] *Life*, May 20.

[Billy Graham in New York.] *Life*, May 27.

[Harry Belafonte.] *Life*, May 27.

[The DuPont family.] Cover and photo essay by CC. *Life*, August 19.*

1959

"The Bolshoi Ballet School." *Harper's Bazaar*, February.

[Jack Paar.] Cover and photo essay by CC. *Life*, March 9.

"World Congress of Flight." *Missiles and Rockets*, April 27.

"The Death of a Missile." *Missiles and Rockets*, May 4.

"Scouting the Fringe of Space…X-15 manned research vehicle rehearses for first flight." *Missiles and Rockets*, June 1.

[Men training for supersonic and outer-space flight.] *Paris Match*, June 13.

"In a Dutiful Family, Trials with Mother." *Life*, July 13.

[The Ford Falcon.] *Life*, September 14.

[Russian Orthodoxy.] *Life*, September 14.

1960

"Politics: A great game and a sight to behold." Cover and photo essay by CC. *Life*, July 4.

"Happy Birthday, Grandma Moses." Cover and photo essay by CC. *Life*, September 19.

[Wives of two U.S. airmen who were in Soviet custody.] Photographs by CC and Grey Villet. *Life*, December 19.*

1961

[Clark Gable during the filming of *The Misfits*.] Cover by CC. *Life*, January 13.

[Airmen return home after being released by the Soviets.] *Life*, February 3.*

[Jackie Kennedy pushing baby carriage.] *Life*, May 12, 1961.

1962

[Speculator Eddie Gilbert, who fled to Brazil to evade prosecution when his financial empire began to collapse.] *Life*, June 29.

[American missionary Will Kindberg in Peru.] *Life*, September 14.

[Northeastern Brazil.] *LIFE en Español*, October 15.

1963

"Education—team teaching." *Life*, March 22.

[Nelson Rockefeller and his wife, Happy, honeymoon in Venezuela.] *Life*, May 17.

[Outrage over the funeral business.] *Life*, September 20.

1964

[Northeastern Brazil.] *Sunday Times Magazine* (London), May 3.

[Robert F. Kennedy's campaign for one of New York State's seats in the U.S. Senate.] *Life*, October 9.

"Men Behind Goldwater." *Look*, November 3.

1965

[New York mayoralty race.] *Life*, October 29.

1966

"The $50 Billion Battle to Build the Giant SST." *Life*, October 28.

1967

[The Six-Day War.] Photos credited jointly to CC and Micha Bar-am. *Life*, June 16.*

[The Six-Day War.] *Life*, June 30.*

"Pawns of War: Arabs Search for a Home." *Life*, September 29.

1972

[Attica prison.] *Life*, April 28.

Designer
Arnold Skolnick

Typographer
Ultracomp Inc., New York

Printer
Balding & Mansell, Wisbech, Cambs., England